D1433780

Singular
Impressions

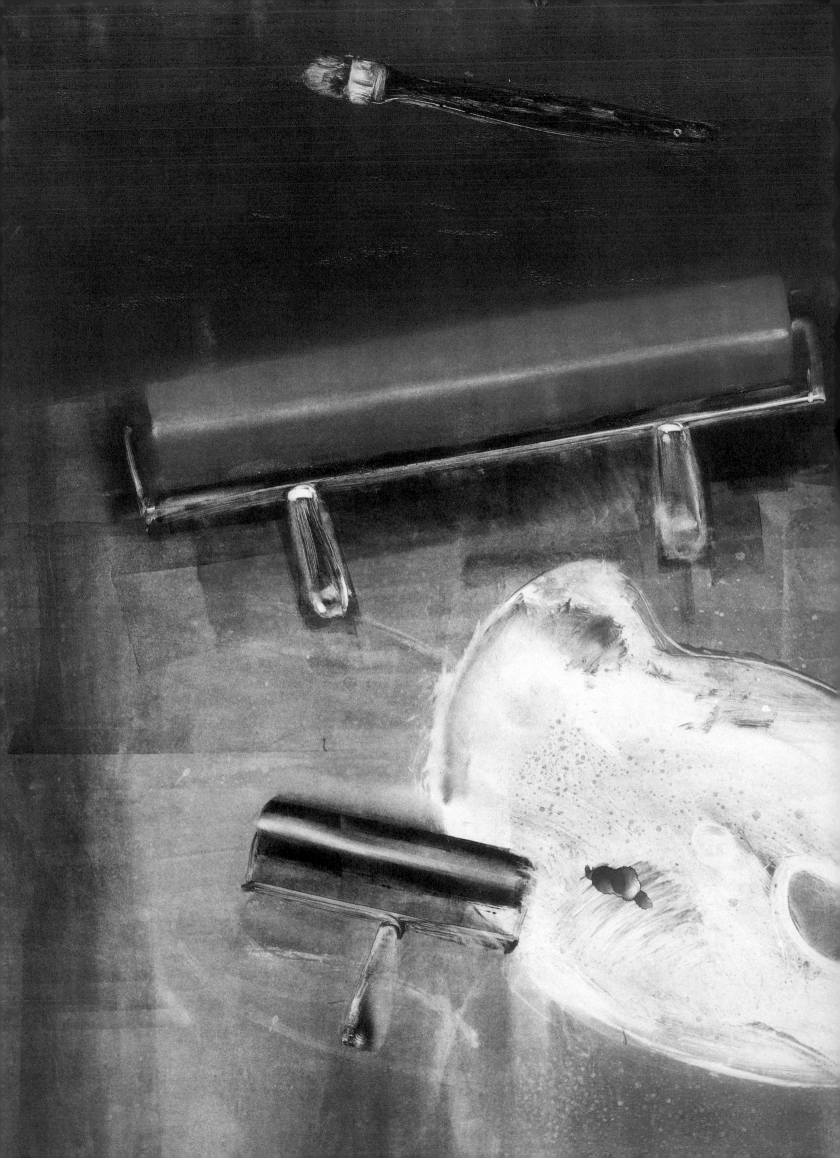

Singular
Impressions

The Monotype in America

Joann Moser

Published for the NATIONAL MUSEUM OF AMERICAN ART
by SMITHSONIAN INSTITUTION PRESS
Washington and London

© 1997 by the Smithsonian Institution
All rights reserved

Published on the occasion of the exhibition *Singular Impressions: The Monotype in America,* organized by the National Museum of American Art, Smithsonian Institution, and presented from April 4 to August 3, 1997. This book and the accompanying exhibition were made possible in part by the Smithsonian's Special Exhibition Fund and the International Fine Print Dealers Association.

Editor: Janet Wilson
Production editor: Jack Kirshbaum
Designer: Janice Wheeler
Production : Martha Sewall

Library of Congress Catalog-in-Publication Data
Moser, Joann.
 Singular Impressions : the monotype in America / Joann Moser
 p. cm.
 Includes bibliographical references and index.
 ISBN 1-56098-737-5 (cloth); 1-56098-749-9 (paper)
 1. Monotype (Engraving), American. I. Title.
NE2245.U54M67 1997 96-39416
769.973—dc21
British Library Cataloging-in-Publication data available

03 02 01 00 99 98 97 5 4 3 2 1

The paper used in this publication meets the minimum requirements of the American National Standard for Permanence of Paper for Printed Library Materials Z39.48-1984. Printed on recycled paper.

Printed in Singapore at no federal expense.

Jacket illustration: Blanche Lazzell, *Petunias II*, 1922, National Museum of American Art, Smithsonian Institution
Frontispiece: Michael Mazur, *Palette Still Life #53,* 1982, National Museum of American Art, Smithsonian Institution, © Michael Mazur

For permission to reproduce any of the illustrations, correspond directly with the sources. The Smithsonian Institution Press does not retain reproduction rights for these illustrations individually or maintain a file of addresses for photo sources.

The National Museum of American Art, Smithsonian Institution, is dedicated to the preservation, exhibition, and study of the visual arts in America. The museum, whose publications program also includes the scholarly journal *American Art,* has extensive research resources: the database of the Inventories of American Painting and Sculpture, several image archives, and a variety of fellowships for scholars. The Renwick Gallery, one of the nation's premier craft museums, is part of NMAA. For more information or a catalogue of publications, write: Office of Publications, National Museum of American Art, MRC-230, Smithsonian Institution, Washington, D.C. 20560. NMAA also maintains a gopher site at **nmaa-ryder.si.edu** and a World Wide Web site at **http://nmaa.si.edu**. For further information, send e-mail to **NMAA.NMAAInfo@ic.si.edu**.

Contents

Foreword

Why make a monotype instead of a painting? If the goal is to produce a single painted image, it would seem pointless extra effort to make that image as a unique print. But monotypes combine the spontaneity of painting with the sensuousness of printed inks and paper, creating a surface that is unlike any other in art. Many people are oblivious to the subtle attraction: they focus on the image and ignore the way that inks pressed and absorbed into paper can pull the viewer in, past the image. Yet artists and others who are sensitized to the particular joys of prints recognize a universe of expressive potential in the dynamic interaction of painted strokes and pressed inks. In a monotype, the brushstroke literally bonds with its support, as if an artist's thought is not only fixed in time but embedded in memory.

In this book, Joann Moser, senior curator of graphic arts at the National Museum of American Art, recovers a lost history. Her years of research turned up dozens of American artists who made monotypes for personal or professional use. This history has been partly obscured because monotypes often do not survive. As works on paper, they are inherently more fragile than most other art forms. And unlike printed editions, which generally ensure that an image will be extant even if several impressions are lost, monotypes enter the world solo. Next to drawings, they are the most intimate of an artist's production, frequently made for private delectation or as gifts to friends rather than for public exhibitions.

By so greatly expanding our knowledge of monotype production in America over the past century, Joann Moser reminds us that works in this medium have often served as a proving ground for new ideas. She shows how they offer a field for interaction of seeming opposites—hand gesture and mechanized production, surface flatness and medium density, freedom and discipline. She includes artists with such disparate approaches that we gain an understanding of how the essential appeal of monotypes transcends stylistic expression. Forcing us to blur our convenient dualistic categories—painter, printmaker—Moser helps us enter the enigmatic and abstract aspects of art.

Elizabeth Broun
Director, National Museum of American Art

Edward Hagedorn, *The Crowd, Two Figures/Blue and Red Eyes* (detail, fig. 116), ca. 1925, color monotype

Acknowledgments

One of the primary challenges in researching and writing about the history of the monotype in America has been the task of discovering which artists have used this medium and where their works can be found. I am deeply grateful to the numerous people who assisted me with this search in the face of very little published information. Key to this undertaking were my three research assistants, Claire Tieder, Mary Lee Corlett, and Laura Baptiste, whose organizational skills, tenacity, and dedication provided the backbone to this effort. I would also like to thank Smith College interns Ashley Roland, Alison Stern, and Sara Marx, as well as Smithsonian interns John Alford, Lisa Donnelly Bowker, Courtney DeAngelis, Ellen Garcia, Lori Johnson, Medha Patel, and Christina Tompkins for their assistance at various stages of the project. I would like to thank my predecessor at the National Museum of American Art, Janet Flint, for her prescient acquisition of monotypes for the permanent collection.

My search for artists and monotypes was aided immeasurably by the generous interest of many art dealers, who brought to my attention prints they had discovered and helped locate others in private collections, suggesting artists to be considered. I am deeply grateful to Irene Falconer, Aaron Galleries; Jane Allinson; Daniel Lienau and Gala Chamberlain, Annex Galleries; Michael Dunev, Aurobora Press; Richard Thompson, Beard Galleries; Derrick Joshua Beard; James A. Bergquist; Johnson Hagood, Carolina Prints; Jane Egan and Cecily Langdale, Davis & Langdale, Inc.; Martin and Harriet Diamond; Peter Falk; John Garzoli; Conrad Graeber; Valerie McKenzie, James Graham & Sons; Julie Heller; Melissa De Medeiros, Knoedler & Co.; Stephen Long; Paul McCarron; Tobey C. Moss; Marilyn Pink; Mary Ryan; Michael Rosenfeld; Alice Simsar; Paula Z. Kirkeby, Smith-Anderson Gallery; Ellen Sragow; Susan Teller; Paula Trotter; Bill and Larissa Goldston, Universal Limited Art Editions; Garner Tullis; and Patricia Weiner.

Among the best sources of information on the history of the monotype are several artists who have devoted a significant part of their creative activity to this medium. I would like to thank Michael Mazur, Matt Phillips, Nathan Oliveira, Roger Crossgrove, and Joseph Goldyne for sharing their knowledge, ideas, and insights. One of the

Maurice Brazil Prendergast,
Roma: Flower Stall (detail,
fig. 43), 1898–99, color
monotype with pencil
additions

pleasures of working with contemporary art is the opportunity it affords to look at and discuss artists' work with them. I would also like to express my appreciation to Idele Weber, Yvonne Jacquette, Alan Magee, Frank Lobdell, Wayne Thiebaud, Joellen Duesenberry, Wolf Kahn, Will Barnet, Tony Vevers, Wendy Mark, Katherine Kernan, Joseph Solman, and William Wiley for the time they spent discussing their monotypes with me. I am also grateful to the numerous artists who sent me slides or brought their monotypes for me to review.

I would also like to extend thanks to the numerous people who responded to my inquiries with special generosity: W. T. Born; Gene De Gruson; Christopher Diebenkorn; Sanford Hirsch, The Adolph and Esther Gottlieb Foundation; Grace Hartley; Catherine Krueger; Catherine Fehrer; Pat Bauer; Folger Brown; Jane Hutchison, University of Wisconsin; Gerard Jackson; Eugenia P. Janis; Patience Kotorman; Jane B. Koopman; Barbara Buhler Lynes; Louise Noun; Carol Osbourne; Herbert Nipson; Raymond Wemmlinger, Hampton-Booth Theatre Library/Players Club; Amy Worthen; Arthur Monroe; and Mrs. Alan E. Schwartz. Similarly, many colleagues in other museums went far beyond the call of duty to respond to my questions, and I would like to express my appreciation to David Acton, Worcester Art Museum; Nancy Findlay and John D. Stinson, New York Public Library; Marjorie B. Cohn, Fogg Art Museum; Shelley R. Langdale, Museum of Fine Arts, Boston; Mark Pascale, Art Institute of Chicago; Carlotta Owens, National Gallery of Art; Jay Fisher, Baltimore Museum of Art; Malcolm Warner, San Diego Museum of Art; Robert Johnson, Achenbach Foundation for Graphic Arts; Kristin L. Spangenberg, Cincinnati Art Museum; Therese Heyman, Oakland Museum; Dr. Gisela Scheffler, Bayerische Staatsgemaldesammlungen; Jennifer Saville, Honolulu Academy of Arts; Dennis Jon, Minnesota Institute of Art; Dr. Richard Campbell, Minnesota Institute of Art; Dina Malgeri, Malden Public Library; Rena Coen, St. Cloud University; and Herr Dr. Eckhard Schaar, Kupferstichkabinett der Hamburger Kunsthalle. I would also like to thank Richard Wattenmaker and Ellen Glavin for sharing their expertise on the work of Maurice Prendergast.

Joseph Goldyne, Jane Glaubinger, Robert Rainwater, and Jack Rachlin were kind enough to read the first draft of this manuscript, and I sincerely appreciate their comments and suggestions. Special thanks go to the Smithsonian for institutional support through the Scholarly Studies Fund and the Special Exhibition Fund, which awarded grants for research and for the exhibition. This publication has been partially funded through the generosity of the International Fine Print Dealers Association, Inc.

Within the Smithsonian, I am grateful to Elizabeth Broun and Virginia Mecklenburg for their support of this project over many years. Pat Lynagh, Kim Clark, and Cecilia Chin of the National Museum of American Art and National Portrait Gallery library have provided excellent guidance in my search for materials. I would also like to thank Sara Spies and JoAnn Fain of NMAA's curatorial office for their dedicated assistance. Paper conservators Fern Bleckner and Kate Maynor have been most helpful in advising me on technical matters relating to monotypes and in mounting several of the works for exhibition. Thanks are also due to Melissa Kroning, Patti Hagar, Michael Smallwood, Hunter Hollins, Courtney DeAngelis, and Gene Young of the registrar's office, who have assisted immeasurably in securing loans and arranging photography. John Zelenik, Martin Kotler, and Charles Booth of the NMAA design and production office have designed and mounted the exhibition with their customary expertise and skill. Janet Wilson provided exceptional sensitivity and expert editorial skills for this book.

I would also like to express my sincere appreciation to my husband and daughter, Nicholas and Sasha Berkoff, for their patience and understanding throughout the preparation of this publication.

Singular
Impressions

Introduction

The American artist Charles Alvah Walker was the inventor of the term "monotype" about 1880–81. Although monotypes were made in Europe as far back as the seventeenth century, the term did not appear in print until November 1881, when it was used in an article in the *Art Journal* to refer to works by American artists Albion Harris Bicknell, Charles Alvah Walker, and William Merritt Chase. Probably the first written description of the process was given in 1821 by the distinguished print cataloguer Adam Bartsch in his discussion of the method used by Giovanni Benedetto Castiglione (ca. 1600–1663/65), who "liberally coated a polished copper plate with oil color . . . [and] had it printed on paper." Bartsch did not give the technique a name, referring to it as "imitating aquatint."[1]

The monotype is a hybrid printmaking process in which a drawing or painting executed on a flat, unworked printing plate or other surface is transferred through pressure to a sheet of paper. In its purest and simplest form, a monotype is made by drawing with printer's ink or oil paint on a smooth surface such as glass or a metal plate, then transferring the image to paper before it dries, using a printing press or other means of pressure, ranging from the back of a spoon, a Japanese baren, or a roller to a palm of the hand or even the wringer of an old washing machine.[2] Because most of the image is transferred in the printing process, only one strong impression can be taken, hence the term monotype (one print). Additional impressions of the residual image are sometimes printed, but they are significantly fainter than the first pull. The residual image can be reworked with additional ink or paint to create another impression related to, but different from, the original image.

In the late nineteenth century Edgar Degas and Paul Gauguin referred to their monotypes as "printed drawings," and a variety of other terms have been used through the years. In reviews published in the 1880s and 1890s, monotypes by American artists were sometimes referred to as monotones or monochromes. Artists in the circle of Frank Duveneck who made monotypes in Florence and Venice in the early 1880s often referred to their impressions as "Bachertypes"

Giovanni Benedetto Castiglione, *David with the Head of Goliath* (detail, fig. 1), 1650–55, monotype

because they were printed by Otto Bacher on his portable press. The prominent American illustrator Will H. Chandlee, who made monotypes on a glass surface, called his prints "vitreographs," signifying glass prints, just as "lithograph" indicated something printed from a stone.[3]

The terms monotype and monoprint cause the greatest confusion. One of the earliest uses of the latter term appeared in 1917 in the catalogue for an exhibition of prints by the American artist Salvatore Antonio Guarino at the Kraushaar Galleries in New York, which stated that the artist preferred this term because he considered it more descriptive of the process.[4] He made no technical distinction between a monotype and a monoprint.

The two terms began to be used interchangeably, depending on the artist's personal preference, although monotype was more commonly used. About 1960, Henry Rasmusen, author of the first important book on the monotype, wrote that some artists preferred the term monoprint as a way to distinguish the process from the commercial typesetting method known as monotype.[5] Although Rasmusen continued to use the terms interchangeably, he indicated that some artists were beginning to apply technical criteria to distinguish them, and that others were inventing new terms to describe their own variations on the monotype process.[6]

The next important book on the subject, *Monoprints for the Artist*, was written in 1969 by Roger Marsh. He stated his preference for this term because it avoided confusion with the commercial monotype process.[7] In 1975 print curator David Kiehl suggested a distinction between monotype and monoprint, using the latter term to refer to a unique image pulled from an engraved or etched plate, a "deliberate limitation of edition, which has nothing to do with the process by which the print is made."[8] The following year, in a catalogue for a London exhibition, artist Joseph Goldyne defined a monotype as a "unique impression printed from a surface . . . which has been painted with printing ink or some other pigment." He differentiated this from a monoprint, which "is intended to be a more inclusive term, for the singularity of the monoprint results from a surface prepared by a combination of techniques [of which] at least one of these techniques must obviously exclude the possibility of producing identical impressions."[9] In 1978 independent curator Jane Farmer reinforced this distinction in a more widely circulated catalogue for a group exhibition of monotypes that she had organized. She described a monoprint as "a unique image where part of the image is repeatable on a fixed matrix and part is not," and defined a monotype as "a unique image where none of the image is from a registered, repeatable matrix."[10] This definition has become the standard for distinguishing the two techniques.

Although these definitions seem to be straightforward, there is still a good deal of confusion. As more artists began to experiment with the technique and as the methods for creating an image became more complex, the simple distinction between a monotype and a monoprint was not always adequate to describe the myriad variations being invented. Moreover, many prints that meet the current definition of the monoprint, such as Whistler's Venetian etchings or the Provincetown white-line woodcuts, are not commonly called monoprints.

Disagreements about the definition of the monotype recall the controversy surrounding the definition of an original print that was developed in the late 1950s and early 1960s. No sooner had this been done by the Print Council of America than it was considered obsolete by artists who were constantly experimenting with new techniques and redefining the parameters of an original print. Similarly, too strict a definition of the monotype will eliminate some of the more interesting uses of the medium that artists have invented.

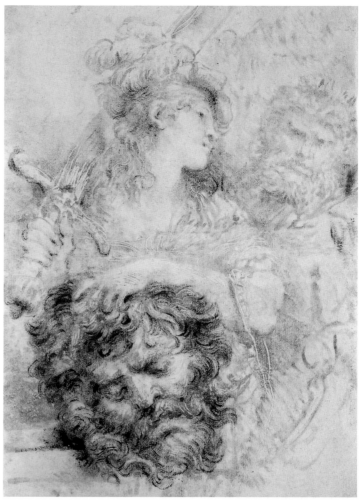

Fig. 1 (left)

Giovanni Benedetto

Castiglione, *David with the*

Head of Goliath, 1650–55,

monotype, 37.1 × 25.4 cm

(14 ⅝ × 10 in.).

Direzione Civici Musei d'Arte e di

Storia, Brescia

Fig. 2 (right)

Giovanni Benedetto

Castiglione, *David with the*

Head of Goliath, 1650–55,

monotype (second pull),

34.8 × 24.8 cm

(13¾ × 9¾ in. sheet).

Andrew W. Mellon Fund, ©1996

Board of Trustees, National

Gallery of Art, Washington

The term monotype is somewhat misleading because some ink or paint remains on the smooth surface from which the proof has been pulled, so that a second or even a third impression can often be printed from the residual image. These additional impressions are known as "ghosts," "cognates," or "second pulls," and they are usually much less intense than the first impression.[11] Although they are fainter, artists do not necessarily consider them to be less desirable than the first pull, since the images are sometimes more subtle and atmospheric.

Still another variation on the process of printing from a unique image is the counterproof, a process not usually associated with the monotype. A still-wet proof of a print was sometimes passed through a press, covered by a wet sheet of paper to which the image was transferred in reverse. Printmakers sometimes used the counterproof as an intermediate step between states, viewing the composition in the same direction as the image on the plate. In the eighteenth century, such masters as Hubert Robert and Jean-Honoré Fragonard sometimes made counterproofs of chalk drawings, which were then retouched with chalk or enhanced with different media. For purposes of definition, counterproofs are not monotypes, but they indicate the longstanding inclination of artists to transfer an image from one surface to another.

Spontaneity and experimentation have always characterized the monotype. Castiglione was one of the first artists to create a body of work in this medium.[12] Most of his monotype compositions were composed directly on the plate; only a few of them were based on previous drawings or etchings. What is thought to be his earliest monotype, *God Creating Adam* (1640–45, Art Institute of Chicago), was created by the subtractive process of wiping away ink from a polished copper-plate surface entirely covered with ink, which is known as the

"dark-field," or "dark-manner" method. A sharp tool, probably of wood, incised white lines in the dark background, and a stiff brush appears to have created some gray areas of the design. In later monotypes Castiglione used rags, fingertips, and possibly swabs, as well as a blunt tool like a reed or bamboo pen, to create white lines or to wipe away the ink.

Castiglione also began to print drawings made with a brown oil pigment brushed on a white field, called "light-field" monotypes, which resemble many of his drawings.[13] Then why not content himself with making drawings? In his monotype *David with the Head of Goliath* (fig. 1), he combined the light- and dark-field techniques by scratching white highlights into some areas of the brushed oil pigment. He also recognized the possibility of making a variation of an image by printing a second pull from the plate (fig. 2).

Taking advantage of the additive process by which a light-field monotype is made, Castiglione used more oil pigment to strengthen some of the lines left on the plate after the first pull. Although the figure of David and the head of Goliath have equal emphasis in the first pull, the retouched head of Goliath is clearly the focal point in the much lighter second pull. Castiglione worked on both impressions with a brush to accent and model certain forms, suggesting that he recognized each pull as an independent image despite their strong relationship to each other.

Experimentation continued to characterize the monotype as later artists explored its possibilities. In the late eighteenth century William Blake invented a form of monotype as a means of printing book illustrations in color. Using a tempera medium on thick cardboard used for book covers, he outlined the composition in one color and printed it up to three times on a screw press. He then painted colors on the board and printed them on top of the printed outline. Sometimes he scratched white lines into the printed pigment, often finishing the composition with pen and watercolor.[14]

Almost one hundred years later in France, Paul Gauguin made watercolor monotypes that resemble those of Blake in several important ways, although there is no indication that he was familiar with Blake's monotypes. Like Blake, he used a water-based paint printed from a paper surface and created forms defined by strong contour lines. However, Blake used a heavy millboard surface with little character of its own, whereas the texture of the paper Gauguin used for his painted image was often transferred to the paper on which he printed. Also, Blake relied more heavily on ink and watercolor to rework the printed image.[15] It has been suggested that Gauguin did not print from a single surface, preferring an assemblage of pieces—fragments of board, cloth, paper, or wood—that transferred their own textures to the printed image.[16]

After creating a group of watercolor monotypes in 1894, Gauguin invented still another method of transferring an image from one surface to another. As he described it, "First you roll out printer's ink on a sheet of paper of any sort, then lay a second sheet on top of it and draw whatever pleases you. The harder and thinner your pencil (as well as your paper), the finer will be the resulting line."[17] He referred to these works as printed drawings because he began with a pencil sketch, which he laid upon inked paper and continued drawing. At this point the ink picked up was allowed to dry, and the pencil drawing remained visible on the verso of the monotype. Because they resemble the process of tracing, they have been called trace, or traced monotypes, although some would question whether this term is really applicable.[18]

At the other end of the monotype spectrum are etchings with such sparely etched lines and heavily manipulated plate tone that they might accurately be called monoprints. In the seventeenth century Rembrandt varied the inking of his plates dramatically from one proof to the next, sometimes transforming a day scene into a night scene or changing the emphasis of a

Fig. 3 (above)
Ludovic Napoléon Lepic,
*Vue des Bords de l'Escaut:
La Neige*, ca. 1870–76,
etching with monoprint
inking, 34.1 × 74.4 cm
(13½ × 29¼ in.).

The Baltimore Museum of Art:
Garrett Collection, BMA
1984.81.34

Fig. 4 (below)
Ludovic Napoléon Lepic,
*Vue des Bords de l'Escaut:
Saules et Peupliers*, ca.
1870–76, etching with
monoprint inking, 34.2 ×
74.2 cm (13½ × 29¼ in.).

The Baltimore Museum of Art:
Garrett Collection, BMA
1984.81.25

Fig. 5
Edgar Degas, *The Bath*,
1880–85, monotype, 31.2
× 27.7 cm (12¼ × 10⅞ in.).

The Art Institute of Chicago,
Clarence Buckingham Collection,
1951.116. Photograph ©1996
The Art Institute of Chicago. All
rights reserved

composition simply by leaving more ink on the plate. Rembrandt's etchings were well known
to artists of the nineteenth-century etching revival in France and England, many of whom
were inspired by his experimentation with variable wiping of the plate.

Consider, for example, a series of uniquely wiped etchings, *Vues des Bords de l'Escaut*,
executed in the early 1870s by Vicomte Ludovic Napoléon Lepic, using a process he called
l'eau-forte mobile (variable etching) (figs. 3 and 4). Beginning with a modest etched land-
scape with a small figure, Lepic created a series of eighty-five dramatic variations on the basic
composition simply by the wiping of his plate. Selectively wiping ink from the etched lines and
adding such compositional elements as trees, clouds, and a moon, Lepic transformed the basic
landscape into scenes depicting storm, rain, daylight, moonlight, and mist, in which the
etched lines are clearly secondary to the forms and effects created by manipulated ink on the
plate's surface. Through these inked "theatrics of light and time," he also altered the focus of

attention, changed the perspective of the composition, and shifted the emphasis of the subject from one plane to another.[19]

A tour de force, Lepic's prints are, however, of less interest as works of art than they are as revelations of the attitude toward etching and their influence on other artists. In order to print as Lepic did, it was necessary for the artist to ink and wipe his plate instead of relying on a professional printer. As Lepic explained, "The artist who used etching should be a painter or draughtsman who uses the needle *and the rag* as another uses paintbrush and pencil. . . . With a stroke of the finger or a dirty rag full of ink, I make a beautiful proof where the consummate practician only produces a dry, graceless plate. . . . The painting in engraving is in printing alone which gives it life and charm, without which etching is only a metier like any other."[20] Lepic and others who practiced creative manipulation of plate tone blurred the traditional distinctions between painting, drawing, and printmaking, preparing the ground for the hybrid medium of monotype to emerge.

Despite the significance of his experimental work, Lepic's historical importance derives primarily from his role as the printer who introduced Edgar Degas to the practice of creating images directly on the plate with ink alone.[21] Degas made more than three hundred monotypes, which represent the earliest large body of monotypes by a major artist (fig. 5).[22] Beginning in the 1880s, artists began to discover the monotype at an accelerated pace. Small groups of monotypes by Camille Pissarro and Henri de Toulouse-Lautrec were almost certainly inspired by their contact with Degas, as was the much larger body of monotypes by Gauguin. However, the latter's approach to the medium and his technique were significantly different from those of Degas. Until well after his death, Degas's monotypes were not readily available to other artists or to the public. He exhibited three black-and-white monotypes at the Impressionist exhibition of 1877 and a group of color landscape monotypes at the Durand-Ruel Gallery in Paris in 1893. Otherwise, only his close friends, to whom he dedicated several, and a few favorite artists were permitted to see this work.

At the sale of prints from Degas's studio held in November 1918, after the artist's death, the monotypes were bundled together in lots, not catalogued individually.[23] Although the artist's pastel compositions drawn over monotypes were more widely exhibited and available, few people recognized them as monotypes because so little of the monotype underdrawing was visible. The monotypes were not included in Loys Delteil's catalogue of Degas's prints. The general public's first opportunity to see them was as reproductions in several novels published in the mid-1930s.[24] Gradually more of them entered the market, but it was not until 1968, when Eugenia Parry Janis's exhibition of Degas's monotypes, with accompanying catalogue, was presented at the Fogg Art Museum, that the scope of the artist's achievement in this medium became apparent. A surge of interest in the monotype in America during the late 1960s and early 1970s can be traced to this revelation of Degas's work, subsequently reinforced by *The Painterly Print* exhibition in 1980, organized by the Metropolitan Museum of Art and the Museum of Fine Arts, Boston, which reviewed the history of the monotype from Castiglione to the present.

Exposure to great monotypes of the past is one reason why an increasing number of American artists have turned to the monotype during the past two decades, but other factors have also been crucial. Why did American artists with little or no knowledge of earlier monotypes experiment with the process for almost a century before these two important exhibitions?

The monotype did not enter the technical repertoire of American artists as the result of a

single discovery or even a cohesive set of circumstances, nor did it develop as a coherent movement with a continuous history. Instead, artists in various locations discovered the monotype on their own, showed it to their friends or students, and used it for a time in conjunction with other painting or printmaking activities. Some artists treated it as a vehicle for casual amusement, while others took it quite seriously as an important means of creative expression. Some artists used the monotype in its purest and simplest form, while others extended its traditional boundaries of size and complexity. Since the 1980s, many artists have chosen the monotype as their principal medium. Moreover, many prominent painters and sculptors have created significant bodies of work in monotype, recognizing special qualities in the medium that complemented or extended their ideas.

Unlike most other printmaking techniques, which have a more or less continuous history since being introduced, the monotype has been reinvented numerous times by artists in various countries over a period of several centuries. Technically very simple and direct, the medium has appealed to both painters and printmakers. However, its very simplicity has led some artists to question its suitability as a medium for serious art. As a 1937 article in *Prints Magazine* stated, "The process is so easy that anyone can make one, therefore it is often assumed that such 'child's play' deserves little consideration. It has been called a 'tricky medium'—given over to superficial effect. It has been accused of owing its successes to the fickle hand of 'happy accident.'"[25]

In contrast to etching or lithography, both of which require instruction from an experienced practitioner, an artist can informally learn to make a monotype with no previous printmaking experience. Merely watching another artist make a monotype or even seeing a finished impression can provide sufficient introduction to the medium. It is even possible to make a monotype based solely on a written description of the process. As early as 1900, it was touted as a technique simple enough for children to use; instructions were published on how to copy a drawing placed beneath a glass plate and then print the image with a spoon.[26] Although this information appeared in *St. Nicholas*, a magazine for children, it was referred to ten years later in an article published in an art magazine on how to make a monotype.[27]

Other articles in art journals gave an overview of the process, as well as very specific information about personal variations. A. Henry Fullwood liked to print his images with an ivory paper knife, and J. R. Miller painted his images on a zinc plate, using worn-out flat bristle brushes with only five or six bristles left in them.[28] The most notable message in the various articles was the sense of spontaneity and discovery characterizing the process, which had few rules to be followed and ample opportunity for improvisation. The relative merits of chance and control were addressed; some artists insisted that, with sufficient practice, they could completely control the resulting image, while others relished the appearance of accidental effects during the printing process.

By the late 1930s art educators had discovered the monotype and began to publish descriptions of the process specifically directed to teachers and art students. By the early 1950s articles on the monotype were again emphasizing its possibilities for children, referring to the process as "finger paint for print-making," "blot printing," or "brayer printing."[29] Henry Rasmusen's 1960 studio manual on the monotype included a brief history of the medium and examples of work by contemporary artists, as well as detailed instructions on diverse materials and procedures.

Not quite a print and not quite a drawing or painting, the monotype has often been overlooked in general surveys of art, as well as in books on drawings and prints. Monotypes were frequently excluded from print exhibitions, and as late as 1970, Ralph Mayer, an acknowledged expert on technical aspects of art, questioned whether the monotype was even a print.[30] With the increasing popularity and dramatic changes that characterized the medium during the 1980s, it is timely to consider the history of the monotype in order to understand its contemporary appeal and the role it has played in American art.

Throughout the history of printmaking, artists have tended to favor one technique over others for their creative work or for reproducing their paintings. Their reasons have been both practical and aesthetic. Etching offered a more fluid, spontaneous line than engraving. Aquatint and mezzotint developed in response to the need for techniques permitting richer blacks and a greater range of tonalities than the more linear intaglio media could offer. Lithography began to flourish in the nineteenth century because it provided a more autographic means of creating an image and also allowed for a larger edition size. Technical developments in printmaking were often motivated by a perceived need on the part of the artist or the professional printer.

As a result of the rather haphazard way in which the medium developed, many earlier monotypes are now lost, either destroyed or yet to be discovered in public and private collections. Some have been misidentified as drawings or other types of prints, many are unsigned, and most are undated. Many are by artists with modest, regional reputations. As works on paper, monotypes have disappeared over the years through neglect and the ordinary ravages of time. Nonetheless, it has been possible to assemble a sufficiently coherent body of work from which to reconstruct the history of a medium that received little scholarly attention before Janis's research on Degas's monotypes.

During the past one hundred fifteen years, hundreds of American artists have made monotypes. During the past fifteen years, more artists have made monotypes than did so during the entire previous century. No single book or exhibition could possibly consider all of the American artists who have worked in this medium. Especially in the area of contemporary monotypes, only a small part of the tremendous amount of work can be considered here.

One of the major challenges in writing the first history of the monotype in America has been to strike the appropriate balance between inclusiveness and depth. Quality alone could not be the sole criterion for selection, since too many first-rate works of art had to be excluded because of space limitations. Instead, once a large selection of excellent monotypes had been considered, individual artists and works were chosen to make specific points about the development of the monotype. Some attention has been paid to the variety of techniques used, but technique has rarely been the sole criterion for inclusion, especially in a medium so conducive to experimentation and personal variation.

The monotype has been transformed dramatically over the past one hundred fifteen years, and interest in the medium continues to be strong in the 1990s. This book will explore the path from the monotype's tentative beginnings to its current popularity, which has added a new chapter to the history of modern American printmaking.

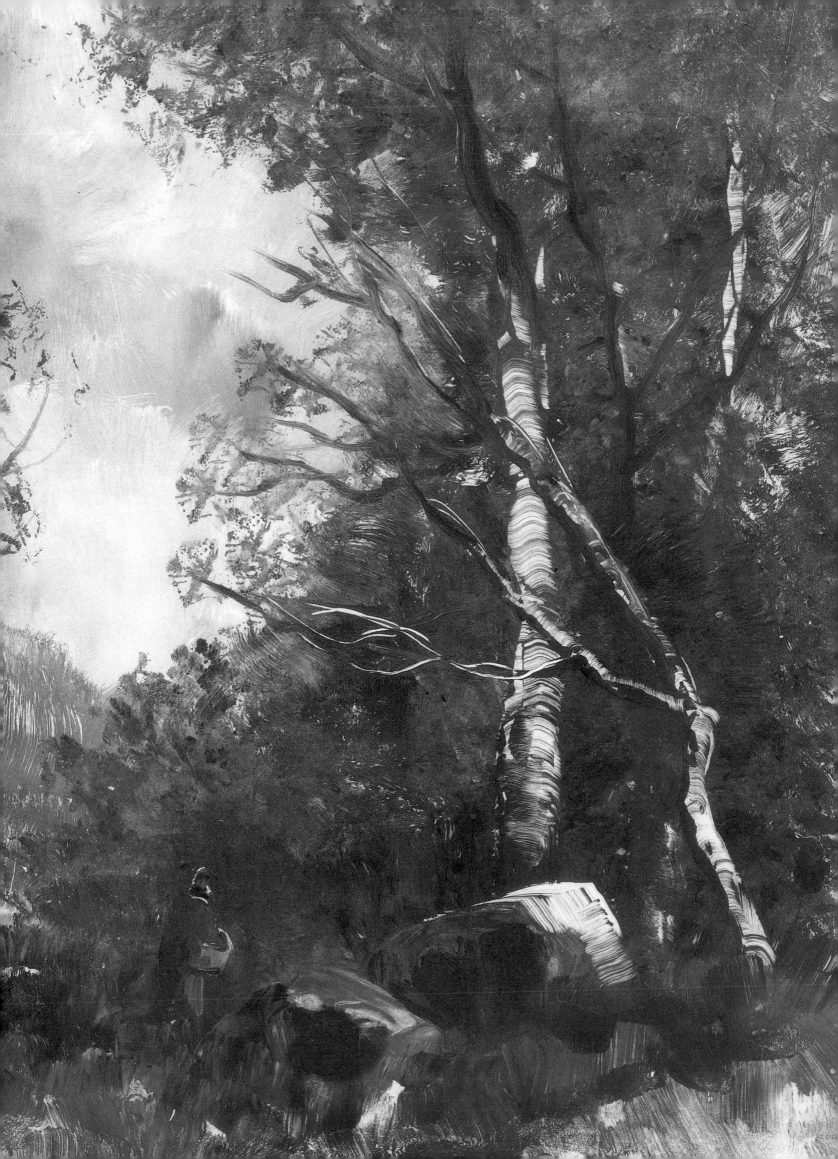

1

What earthly merit there is in a printed squashed oil painting, it would be hard to discover. — Joseph Pennell, 1919[1]

American Artists at Home and Abroad

American Artists in Europe

When Joseph Pennell published his disdainful pronouncement on the monotype in his book *Etchers and Etching,* American artists had been making monotypes for almost forty years. Among the first of them to have experimented with the monotype were Frank Duveneck and William Merritt Chase. Their initial experience with monotypes probably dates from their association in Munich during the mid-1870s, although none of Chase's monotypes can be definitively dated to this time. A monotype portrait of a man who resembles the young Duveneck (fig. 6) might date from this early period, but, according to Chase scholar Ronald Pisano, probably dates from 1912–14. The British artist Hubert von Herkomer, who was introduced to the monotype by Chase in 1885, recalled that Chase first worked in this medium in Munich.[2] No monotypes by Duveneck dating from his years in Munich have been located, and it is possible that he did not begin working in this medium until he moved to Florence in 1879. After Chase returned to the United States in 1878 to teach at the Art Students League in New York, the two artists remained friends but settled in different cities. They rarely worked together again until 1897, when Chase took a leave of absence from the Pennsylvania Academy of the Fine Arts to teach

(Opposite)

Joseph Jefferson, *Untitled* (detail, fig. 24), ca. 1885, color monotype

Fig. 6 (right)

William Merritt Chase, *Portrait of a Man,* ca. 1912–14, monotype, 20.2 × 15.1 cm (8 × 6 in.).

The Art Museum, Princeton University. Museum purchase, gift of Leonard L. Milberg in honor of his daughter, Sandra L. Milberg

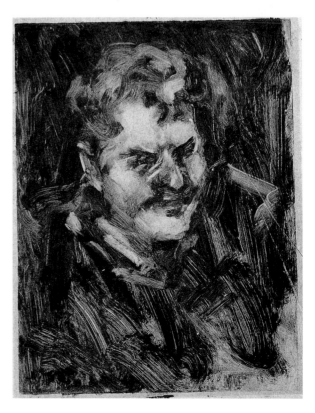

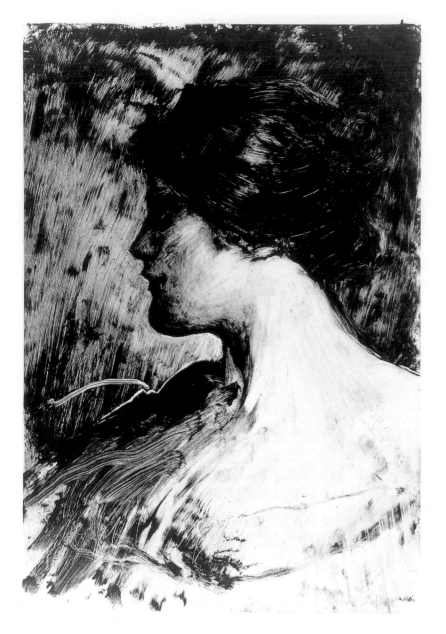

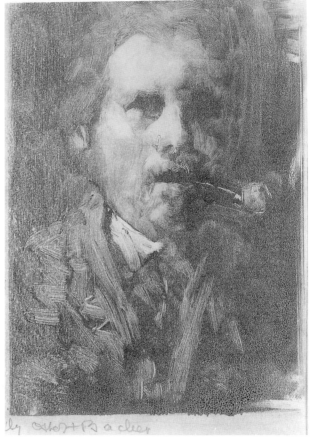

a life class with Duveneck at the School of the Art Institute of Chicago, which was also presenting a major exhibition of Chase's work.

Duveneck and two of his students moved to Florence in October 1879, in part to be near the American artist Elizabeth Boott, who had come to study painting with him in Munich the previous summer. By the end of that year more of his students joined him. During the winter of 1879–80, Duveneck and the American artists in his circle—called the "Duveneck Boys"—began making monotypes on Otto Bacher's portable etching press.[3]

Elizabeth Boott assembled a group of female art students to study with Duveneck and possibly obtain commissions for him as well. As the women's class was oversubscribed, Duveneck enlisted the young John White Alexander to be his assistant. Just as Boott and Duveneck continued their friendship outside the classroom and later married, the "Boys" and the female students also socialized. Some of them formed a club, known as the Charcoal Club, which met every Monday. "It certainly would have been impossible in any other nation for the ladies to associate with art students as we did with these last winter," Boott recalled. "Last winter we organized a club which met once a week at the different houses for drawing in charcoal,

Fig. 7 (left)
John White Alexander,
Profile: Head of a Woman,
ca. 1880, monotype, 38.7
× 26 cm (15¼ × 10¼ in.).
Virginia Tobeason

Fig. 8 (right)
Otto Henry Bacher,
Portrait of a Man,
ca. 1880, monotype, 17.6
× 12.4 cm (7 × 4¾ in.).
Library of Congress, Fine Print
Collection, Gift of Mrs. Mary
Holland Bacher, LC-USZ62-13844

modeling, etching, etc., combined with music and tea. We banished all parents quite in the American fashion and the meetings turned out to be very pleasant."[4] Although Bacher was not a regular member of this group, he did participate from time to time, and it was probably on these occasions that members of the group made monotypes. The participants used their thumbs or a rag wrapped around a stick to paint on a copper etching plate, and the women found it to be a lively way to learn about composing with light and shade.[5]

The subject of John White Alexander's monotype *Profile: Head of a Woman* (fig. 7) may well have been one of the young ladies at these gatherings, and Bacher's monotype *Portrait of a Man* (fig. 8) is perhaps an image of one of the male participants.[6] His signature on this impression, "by Otto H. Bacher," is unusual, since artists rarely include the word "by" as part of their signature. This anomaly suggests that Bacher did so to emphasize that he had made the image, perhaps an indication that he rarely made his own monotypes but printed for other artists.[7] Bacher described some of the group's early experiments with monotype:

While in Florence, Mr. Duveneck and his class . . . used to spend their evenings in a social way in the homes of the American and English colony in that city. As a means of amuseument, we often painted a face or landscape upon a plate with some pointed instrument or thumb, using burnt sienna or ivory black and a medium. This would be run through my press—hence the term Bachertype. One print only could be made from one plate because the squashing through the press absorbed all color. These would be numbered and raffled for by those present. Some wonderful impressions were made, and many are still in existence.[8]

Fig. 9

Frank Duveneck, *Tuscan Landscape,* 1883–84, monotype in sepia ink, 31.2 × 43.5 cm (12¼ × 17⅛ in.).

Cincinnati Art Museum, Gift of Frank Duveneck

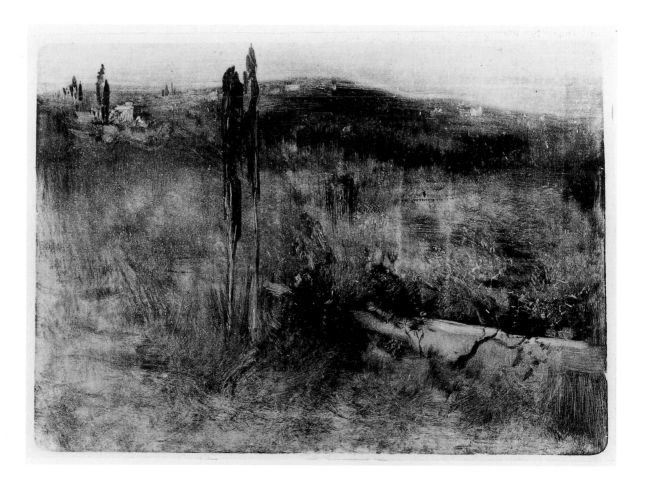

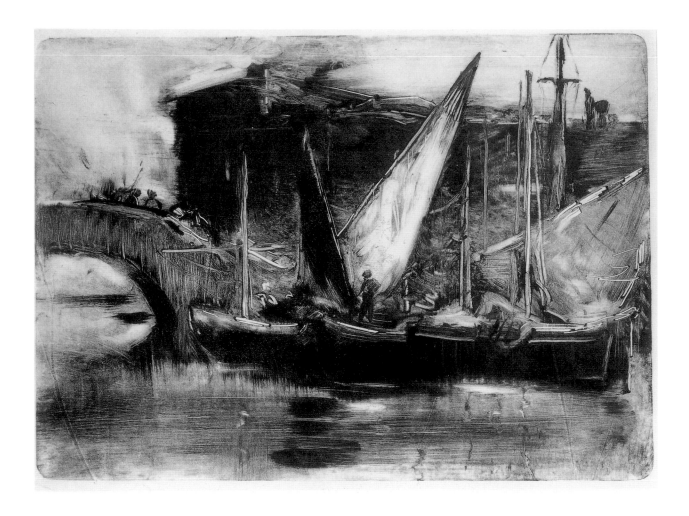

Fig. 10 (above)
Frank Duveneck,
*Fishing Boats Anchored to
the Right of an Arched
Bridge—Florence,*
1883–84, monotype,
33.3 × 43.5 cm
(12⁵⁄₁₆ × 17⅛ in.).

George R. Nutter Fund, Courtesy,
Museum of Fine Arts, Boston

Fig. 11 (right)
Charles Abel Corwin,
Portrait of Whistler, 1880,
monotype, 22.4 × 15.4 cm
(8¹³⁄₁₆ × 6¹⁄₁₆ in.).

The Metropolitan Museum of
Art, The Elisha Whittelsey
Collection, The Elisha Whittelsey
Fund, 1960. All rights reserved,
The Metropolitan Museum of Art

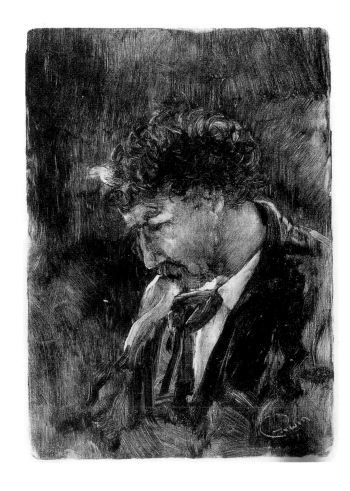

Duveneck's monotype views of Florence, *Tuscan Landscape* (fig. 9) and *Fishing Boats Anchored to the Right of an Arched Bridge – Florence* (fig. 10), probably date from the early 1880s and may well be among the landscape monotypes made at these social gatherings.

During the summer of 1880 Duveneck and some of the "Boys," including Bacher, moved to Venice and took up residence at the Casa Jankovitz. Bacher met James McNeill Whistler, who had come to Venice earlier that year to work on a commission from the Fine Art Society of London. At Whistler's request, Bacher obtained a supply of fine old Venetian paper for his etchings, and Whistler began to work with Bacher, proofing his plates on Bacher's press with the German etching ink he had supplied. Within six weeks of their meeting, Whistler moved to the Casa Jankovitz. Charles Abel Corwin's masterly monotype *Portrait of Whistler* (fig. 11) was undoubtedly made during the summer of 1880 when the Duveneck group lived and worked in such close association with him. In contrast to more typical portraits of Whistler in which his flamboyant personality is apparent, this private view of the artist captures a quiet, reflective moment in the company of other artists at the Casa Jankovitz.

The extent to which Whistler's association with the Duveneck group influenced his own etchings is debatable. Bacher believed that Whistler's strong reliance on delicately manipulated plate tone in his Venice etchings, with only the sparest of etched lines, was directly inspired by monotypes made by members of the Duveneck group.[9] However, Whistler's interest in the expressive qualities of ink had already been aroused by his study of Rembrandt's etchings and the strong emphasis on expressive inking by the French artists of the etching revival.[10] Whistler's interest in etching was surely an important influence on Bacher, Duveneck, and the other artists involved with etching that summer. The Duveneck group returned to Florence in the fall, but Bacher continued his friendship with Whistler through subsequent visits to England and correspondence.

The Charcoal Club disbanded after two winters, and the Monday get-togethers moved to the home of the American sculptor Thomas Ball, where making monotypes continued to be one of the group's amusements. After Bacher returned to America in December 1882, taking his portable press with him, the group obtained a heavy wooden press, which they kept in rented space and carted in a wheelbarrow to the Villa Ball in order to make monotypes while listening to music. The painter Julius Rolshoven recalled the gatherings with great fondness:

Splendid improvised monotypes were made during delightful evenings at Villa Ball. The press through which the copper plates were run for printing had been made by [George Henry] Clements. We sat at small tables improvising while Giuseppe Buonamici's touch on a Chickering grand gave us the key to what *we* could not express. . . . Whenever a successful monotype had been printed there was spontaneous shouting—when a Duveneck was printed Buonamici left the piano to look at [the result from an] equally fine master of a sister art.[11]

The mood of the gatherings was lighthearted, and the spontaneous nature of monotypes was the perfect complement to the evening's entertainment. They required no previous experience and had to be completed quickly before the ink dried. The act of printing added an element of chance, and the surprise of seeing the printed image pulled off the plate lent the activity the air of a party game.

On one of these evenings Duveneck displayed his virtuoso drawing skills by making caricatures of the other artists and musicians. Among his subjects were the young pianist and

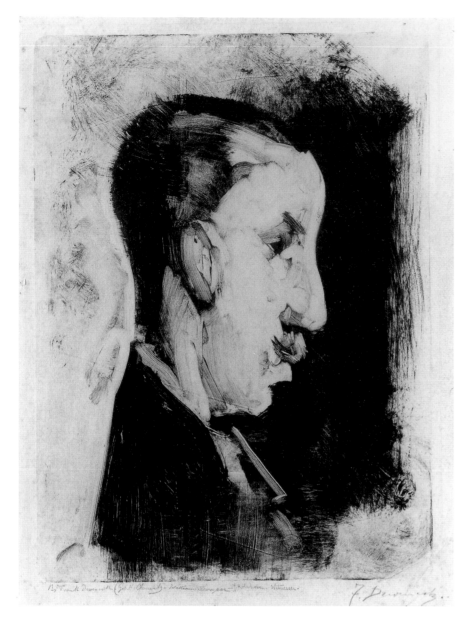

Fig. 12 (left)

Frank Duveneck, *Caricature of Thomas Shields Clarke,* ca. 1883–84, monotype, 43.2 × 31.2 cm (17 × 12¼ in.),

©Sterling and Francine Clark Art Institute, Williamstown, Mass.

Fig. 13 (opposite)

Frank Duveneck, *Head,* 1884, monotype, 31.4 × 43.5 cm (12⅜ × 17⅛ in.).

Collection of the Corcoran Gallery of Art, Museum Purchase

composer Arthur Battell Whiting, pianist Giuseppe Buonamici, painter William Gedney Bunce, art patrons Thomas Shields Clarke (fig. 12), William L. Whitney, and Louis Mason. Several of the images are also signed "George H. Clements, William Couper, and J. Rolshoven, Witnesses," suggesting that the group gathered around Duveneck as he worked on capturing the sitters' likenesses. Monotype portraits of the women at the gathering were made as well, but in keeping with the decorum of the times, they were not caricatures. A *Head* (fig. 13) by Duveneck created during the winter of 1883–84 sets the idealized profile portrait of the woman in a natural setting as the focus of a complete composition.[12]

Artist John White Alexander recalled his experience in Italy with great fondness:

The student days in Italy were all too short but while they lasted were more significant, probably than a similar period in the lives of most students, because more intensified, more concentrated. . . . The advantage of the intimate association and constant companionship we enjoyed not only with our leader but also with his acquaintances and fellow artists, men and women from many lands, was unique and perhaps quite as valuable as any . . . school work. We lived in adjoining rooms . . . and played together with an intimacy only possible to that age and such a community of interests.[13]

Faculty of Continuing Education Library
Birkbeck College

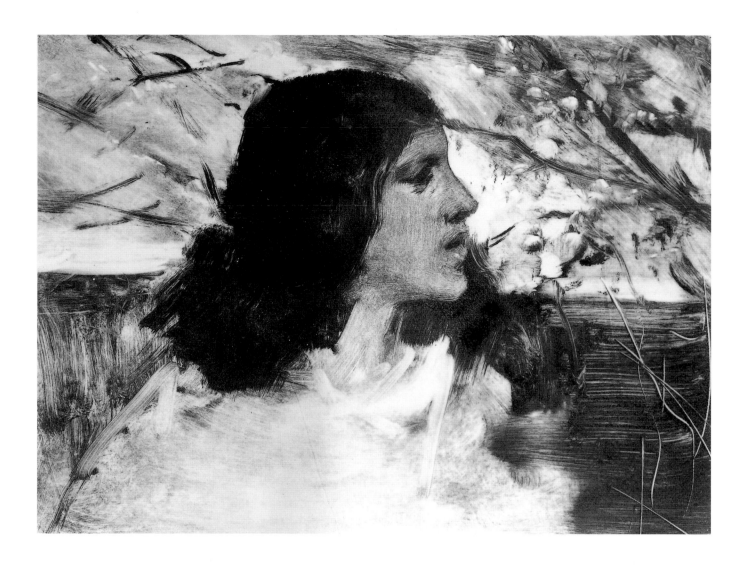

Munich and Italy continued to be popular destinations for American artists and art students during the 1880s and 1890s, but Paris lured more American art students than any other European city. French art dominated American taste, and the Paris Salon's acceptance of a painting was a highly desirable mark of achievement. Aspiring young artists vied for admittance to the Ecole des Beaux-Arts or to the *ateliers des élèves* of such prominent French artists as Thomas Couture, Léon Bonnat, and Carolus-Duran. Independent art schools also attracted students, especially the Académie Julian. As many of the young American artists who studied at Julian's made monotypes in Paris, it has been suggested that the process may have been part of the curriculum.[14] However, there is no indication of this, nor of the availability of a press at the school. Instead, it appears that the American artists who made monotypes in Paris did so at the American Art Association or at individual artists' studios, perhaps after having been introduced to the medium there or in New York, Florence, or Venice.

The American Art Association was founded in 1890 for the benefit of American art students in Paris.[15] It is not known when monotypes were first made there or who introduced them, but in the March 1899 issue of the association's publication, *The Quartier Latin,* an article stated:

Monotypes have suddenly become "the rage" among the students in the Quarter. So much so that the Art Talk Club of the A.A.A. accordingly decided to vary its programme of art talks with a monotype party for Tuesday, February 1. It proved quite the success anticipated, and a surprisingly large number

were initiated into the mysteries of this profitable (we do not say lucrative) pastime; and judging from the enthusiasm with which everyone takes to it and the fascination there always is in work or play of any kind where much depends on "luck," we venture the opinion that the meetings have been devoted to little else ever since. An exhibition of monotypes is among the possibilities in prospect.[16]

The same publication referred to a recent address at the association by John White Alexander and a previous talk by William Merritt Chase. Perhaps one of them introduced the monotype to the organization, but it is also likely that other artists initiated the activity at an earlier date.[17]

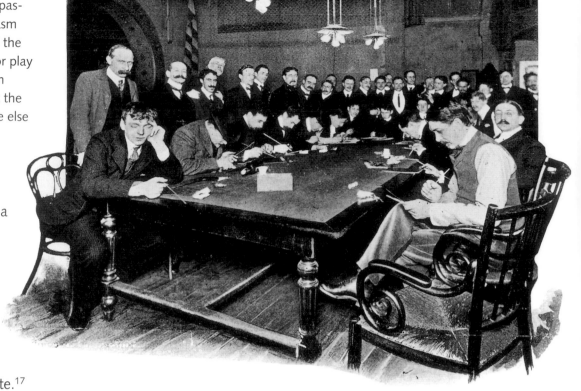

By the early 1890s monotypes were exhibited and known among artists in major art centers. In an article about the American Art Association published in 1904, the lead photograph shows more than two dozen artists gathered around a large table making monotypes (fig. 14).[18] The author explains that the artists were given a specific amount of time in which to create monotypes, which were then auctioned among themselves for the benefit of the organization.

The American Art Association was not the only place in Paris where American artists could learn about monotypes. In October 1898 Robert Henri visited the studio of his friend Augustus Koopman and discovered his monotypes. Koopman exhibited three monotypes at the Paris Salon of 1898. About 1899 Alexis Jean Fournier and his friend Herbert Waldron Faulkner organized a monotype club at the latter's studio, where members dropped by informally to use his press, usually on a Saturday evening. The group included Fournier's friend the British novelist Israel Zangwill, Zangwill's artist brother, and the American artists Louis Loeb, J. Francis Murphy (fig. 15), Albert Sterner, and others. Fournier continued the practice when he went back to America, first to Minneapolis, then to East Aurora, New York, where he hosted monotype parties for his friends and neighbors (fig. 16).[19]

With the encouragement of the aging French artist Henri Harpignies, Fournier submitted one of his monotypes to the Salon jury, and it was accepted in the Salon of 1901. Monotypes were rarely shown at the Paris Salon, but the fact that those by Koopman and Fournier had been accepted suggests that the medium, if not encouraged, was at least not frowned upon by the academic establishment. Although the technique was not taught at the Ecole des Beaux-Arts or at any of the art academies that prepared students for admission to the Ecole, the monotype as created by most artists of the time was not far removed from the academic practice of making an *ébauche*—an underpainting in which broad areas of light and dark, as well as the general composition, are laid in quickly with thinly washed oil paint. Executed in earth colors, the *ébauche* was later refined and usually served as the basis for a more finished

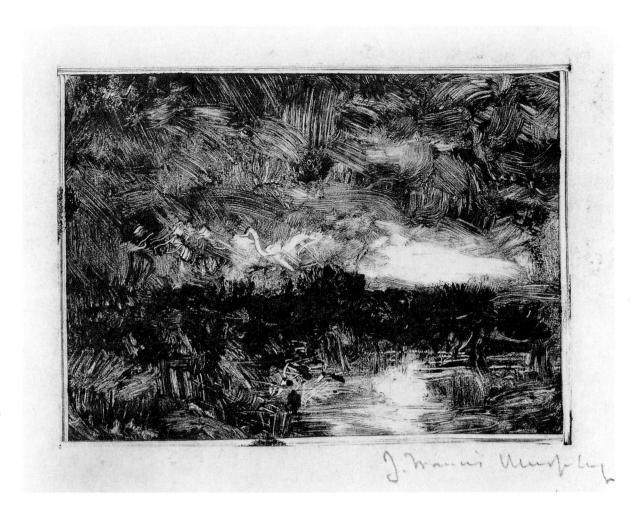

Fig. 14 (opposite)
Une soirée de monotype
(A monotype party at the
American Art Association,
Paris), *Revue Illustré* 19
(15 September 1904)

Fig. 15 (right)
J. Francis Murphy,
Landscape, ca. 1899,
monotype, 7.3 × 9.8 cm
(2⅞ × 3⅞ in.).

Los Angeles County Museum of
Art, Gift of Jack H. Skirball,
M.83.77

Fig. 16 (below)
Alexis Jean Fournier,
Passing Storm, 1907–12,
monotype, 17.2 × 22.2 cm
(6¾ × 8¾ in.).

M. and P. Bauer

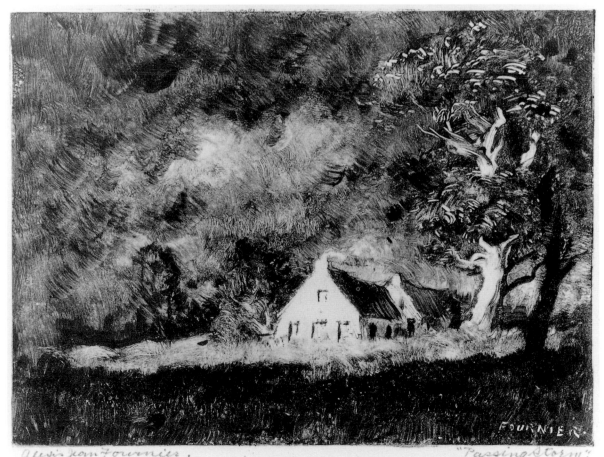

painting. The *ébauche* was emphasized in the
ateliers because of its spontaneity of execu-
tion. Since models changed poses every week,
most student work never went beyond this
stage.[20] While the *ébauche* was not consid-
ered a finished product by academic artists, it
embodied the qualities of directness, pictorial
expressiveness, and spontaneity that were so
highly valued by the Romantics and indepen-
dent artists by the late nineteenth century.
Degas's practice of reworking many of his
monotypes and most of his cognates with
pastel, often to the point of obscuring the
underlying monotype, suggests that he per-
haps considered the monotype a form of
ébauche.[21] As an unfinished work, the
ébauche was not accepted in Salon exhibi-
tions, but the monotype, exhibited as a print,
was considered a finished work.

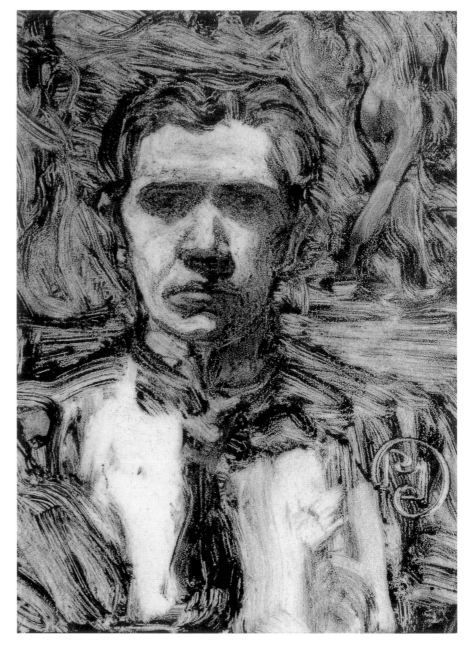

By the 1890s enough American artists in
Paris were making monotypes to enable a
newcomer to learn the process simply by so-
cializing with them. Among the American
artists who made their first, and sometimes
only, monotypes in Paris during the 1890s
and early years of the twentieth century were
the painters Charles Sprague Pearce, Alfred
Maurer, Arthur B. Davies, Ernest Peixotto,
Louis Loeb, Gustave Verbeek, Frank C. Pen-
fold, Eugene Higgins, Ernest Haskell, and the
sculptor Robert Ingersoll Aitken (fig. 17). In-
spired by the ideals of late-nineteenth-century Romanticism, Aitken's haunting self-portrait
with the suggestion of a nude female figure at the upper right is much more enigmatic and
suggestive than any of his sculptures. Working in the intimate medium of monotype, Aitken
revealed a sensibility that was less apparent in his sculpture, which was by its very nature
more public. Several American expatriates, such as Parke C. Dougherty in France and Ed-
ward Ertz in England, completed substantial bodies of work in monotype during the early
decades of the twentieth century.

American Artists at Home

Few of these artists made significant bodies of work in monotype, and most of them discon-
tinued the practice after returning to the United States. Some of the artists sought to "keep
alive the comradeship and pleasant associations of former days" by establishing a Monotype
Club in New York City, which met once a month.[22] The president was Leslie Cauldwell, and
some of the more active members were Albert Sterner, Ernest Peixotto, and Louis Loeb. Most

Fig. 17 (opposite)

Robert Ingersoll Aitken,
Self-Portrait, ca. 1905,
monotype, 17.9 × 13 cm
(7 1/16 × 5 1/8 in.).

Cooper-Hewitt, National Design
Museum, Smithsonian Institution,
Gift of Mrs. Robert I. Aitken

Fig. 18 (right)

Corwin Knapp Linson,
A Monotype Party, 1897,
monotype, 19.6 × 20 cm.
(7¾ × 7⅞ in.).

The Fine Arts Museums of
San Francisco, Achenbach
Foundation for Graphic Arts,
Gift of the Graphic Arts Council,
1992.32

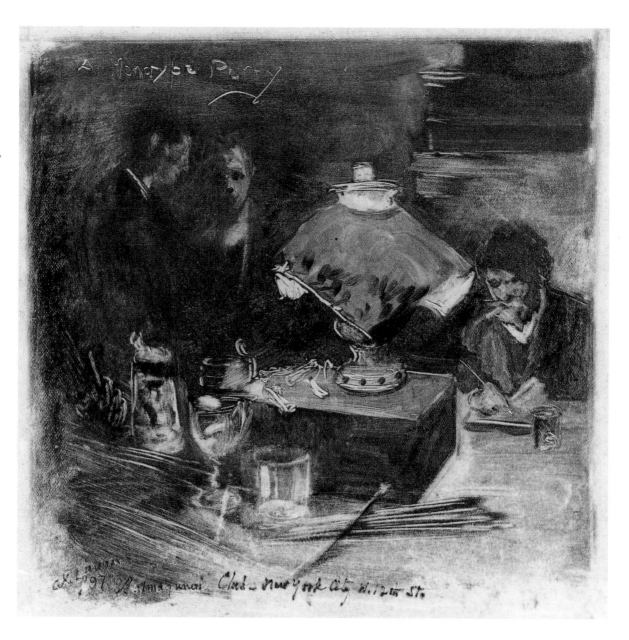

of the participants had made monotypes in Paris, but several new artists were introduced to the process. They sketched from models and also improvised compositions. The club was apparently quite informal and short-lived, with no attention given to it in the press.

The place to make monotypes in New York that most closely resembled the American Art Association was the Salmagundi Club, which had shown some of the earliest American monotypes in its "Black and White" exhibitions. Originally established as a sketch club in 1871, the club held its first "Black and White" exhibition in 1879, a show presented annually through 1887. As early as December 1881, monotypes were included in the catalogue as a small but separate category, consisting of seven works by J. M. Falconer, Joseph Lauber, and Charles Alvah Walker. It is possible that some, if not all, of the monotypes in the 1881 "Black and White" exhibition were printed on the club's press.

Corwin Knapp Linson's monotype of 1897 (fig. 18) depicts one of the monotype parties at the club's Twelfth Street location, where it had moved in 1895. A former student at the Académie Julian and the Ecole des Beaux-Arts, Linson carefully noted the date and location.

The two figures in the background are conversing, and the drinking glasses in the foreground emphasize the social nature of the event. Only the figure at the right is working on a monotype, with his drinking glass nearby.

The large number of artists who belonged to the Salmagundi Club and made monotypes suggests that this activity may have begun in the early 1880s and continued well into the twentieth century. Among them were William Merritt Chase, Joseph Lauber, Charles Warren Eaton, J. Francis Murphy, George Inness, Jr., Harry Fenn, Herbert W. Faulkner, Ernest Peixotto, Corwin Knapp Linson, Addison T. Millar, Edward Potthast, Irving R. Wiles, Rufus Sheldon, F. Luis Mora, James Henry Moser, Albert Sterner, Salvatore A. Guarino, Gifford Beal, Oscar Berninghaus, E. Martin Hennings, Jay Hall Connaway, Colin Campbell Cooper, Eugene Higgins, Paul Dougherty, Ernest Lawson, Alfred H. Hutty, A. Henry Nordhausen, and Xavier J. Barile. Few of these artists made a significant number of monotypes.[23]

One of the first American artists to devote a significant effort to the medium was the Boston painter and printmaker Charles Alvah Walker, who did not study abroad and claimed to have made monotypes as early as 1877.[24] According to Walker, he discovered the technique accidentally while proofing an etching on his press. The piece of paper slipped in the press and produced a blurred print that resembled a rough landscape. It occurred to him that he could make an image on a blank copper plate with printer's ink, using his fingers and a rag and printing it on his press. Walker soon switched to making images on zinc plates, which he considered a better surface on which to paint. His earliest monotypes were monochromatic compositions in black ink, but by 1883 he had made a group of color monotypes with oil paints.

In 1881 Walker invited the print collector and managing editor of the *American Art Review*, Sylvester Rosa Koehler, to see his new invention, which he called the monotype.[25] Walker exhibited a group of his monotypes at the Doll & Richards Galleries in Boston during the fall of 1881 and also at Knoedler's in New York in December of that year. Three of his monotypes were included in the December 1881 "Black and White" exhibition at the Salmagundi Club.[26] He showed two monotypes in the 1882 "Black and White" exhibition, which also included monotypes by Albion Harris Bicknell and William Merritt Chase. Walker exhibited two monotypes in the first annual exhibition of the Philadelphia Society of Etchers presented at the Pennsylvania Academy of the Fine Arts from December 1882 to February 1883 and had a solo exhibition of his monotypes at Doll & Richards in February 1884.

In 1881 in Malden, Massachusetts, near Boston, Bicknell also began to make and exhibit monotypes. Walker and Bicknell undoubtedly knew each other, as Bicknell had painted a smaller study of his panoramic painting *Lincoln at Gettysburg* in 1879 so that Walker could make an engraving of it.[27] Although the two artists cooperated in this venture, a rivalry seems to have developed over their monotypes.[28]

In the 12 November 1881 edition of the *Malden City Press,* Bicknell was given credit for inventing the monotype: "A new discovery in the possibilities of black and white work has been made in our midst by an artist who has been working so quietly that the results thrill Boston art circles with an electric surprise. This is the new prints of Mr. A. H. Bicknell, Malden's talented artist." This article may have angered Walker, who insisted that he had not only invented the monotype completely on his own but also claimed to have coined the term. Although Bicknell was known primarily as a painter, he had made etchings in the 1860s and 1870s. An article in the 11 February 1882 issue of the *Malden Mirror* stated that Bicknell had "a fine press to do his own printing."

While Walker was exhibiting his monotypes at the Doll & Richards Galleries in Boston in late 1881, Bicknell's eighty-two monotypes were shown at the J. Eastman Chase Gallery in Boston in November of that year. In a catalogue published for the latter exhibition, Chase acknowleged in a carefully worded statement that Bicknell did not invent the technique, but he asserted that Bicknell had achieved more successful images than those of other artists working in this medium: "The process by which the Bicknell Prints are produced, like many new inventions, may be traced to more than one source, but it is believed that the present collection bears out the assertions that while others have made experiments, Mr. Bicknell, with the instincts and training of the painter, has shown for the first time the resources and possibilities of this new art method."

By November 1881 the well-known art connoisseur and dealer John A. Lowell had collected a portfolio of fifty monotypes by Bicknell, possibly from the exhibition at the J. Eastman Chase Gallery, which he planned to take to exhibit at the Union League Club in New York and then sell at auction. In 1882 he appears to have gone to London to sell the remaining monotypes.[29]

Both Walker and Bicknell showed their monotypes actively during the next few years. Despite their rivalry, the monotypes of the two artists had much in common. Both worked primarily in monochrome, making monotypes that were quite large and finished compared with those of Chase, Duveneck, and the artists who studied in Paris (figs. 19 and 20). A monotype by Walker made in 1894 was three feet in width and almost two feet in height, rivaling the size of many paintings on canvas.[30] Both artists favored landscape subjects, wooded and pastoral, composed in a manner strongly favored by French artists of the Barbizon School, whose paintings were greatly admired by many Boston artists of the late nineteenth century (fig. 21).[31] A review of Walker's monotypes exhibited at Knoedler's in 1881 stated that "there are several wood interiors, with dense, interlacing foliage, an open space and white birches, which instantly recall [Narcisse] Diaz, and an equal number of delicate, tender landscapes which immediately suggest Corot."[32] These comments could also have been made about Bicknell's monotypes. Both artists were especially concerned with subtleties of light and atmosphere, and many of their subjects show a particular season or time of day, as was common among artists associated with the Barbizon, Tonalist, and Impressionist traditions.

Both artists apparently worked from drawings rather than creating their compositions directly on the plate. This procedure is indicated in a review of Walker's 1881 exhibition at Knoedler's, and is also suggested by Bicknell's eighty-two monotypes depicting a variety of locations, including at least one scene of France, which were shown in 1881 at J. Eastman Chase's gallery. This is not altogether surprising, since the artists needed to print their images before the ink dried on the plate. However, the practice of working from drawings does distinguish Walker and Bicknell from Chase, Duveneck, and the American artists in Paris, who either worked directly from a model or approached the monotype as an opportunity for spontaneity and experimentation.

Although Walker did not acknowledge the influence of any other artist as a source of inspiration for his monotypes, the reviewer of his exhibition at Knoedler's in 1881 indicates that the method was not new, having already been used by artists in France, England, and the United States. In his history of the early years of the monotype published in 1897, Walker reported that in 1879 the American artist Charles H. Miller had purchased in Rotterdam a monotype by "Ciconi of Milan" and showed it to his friends in New York.[33] According to Walker, William Merritt Chase and some of his friends experimented with the monotype in

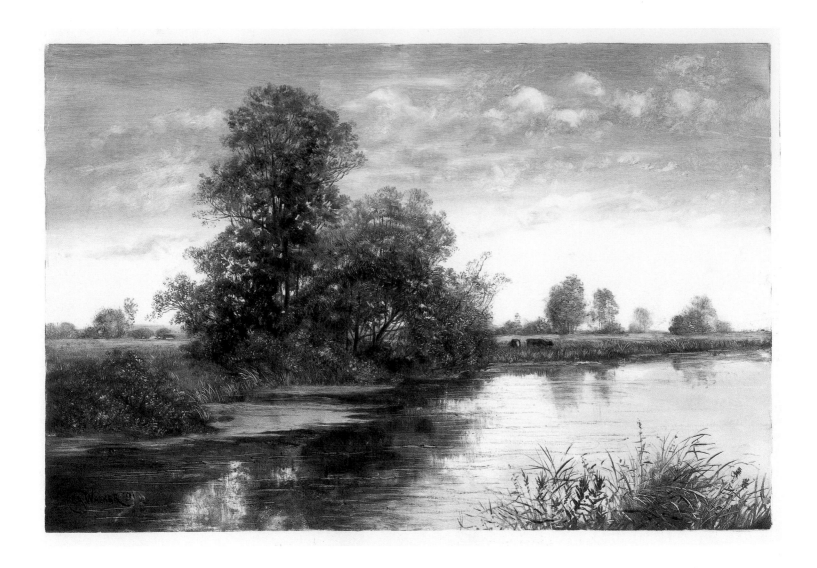

Fig. 19

Charles Alvah Walker,

Pastoral Landscape, 1891,

monotype, 40.5 × 60.8 cm

(15¹⁵⁄₁₆ × 23¹⁵⁄₁₆ in.).

National Museum of American
Art, Smithsonian Institution,
Museum purchase, Robert Tyler
Davis Memorial Fund

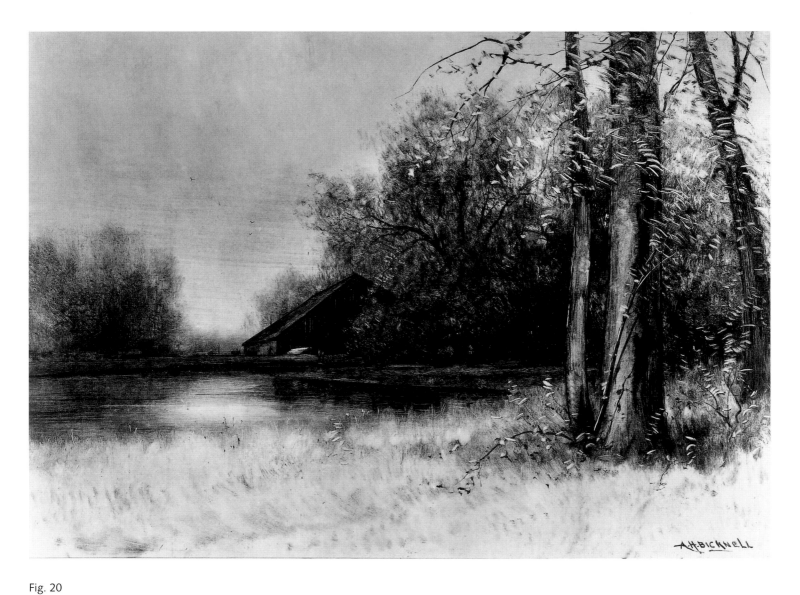

Fig. 20

Albion Harris Bicknell,

Mill Pond, 1880–85,

monotype, 35.4 × 50.8 cm

(13^{15}⁄$_{16}$ × 20 in.).

National Museum of American
Art, Smithsonian Institution, Gift
of Brian A. Higgins and Jane
Edgington Higgins

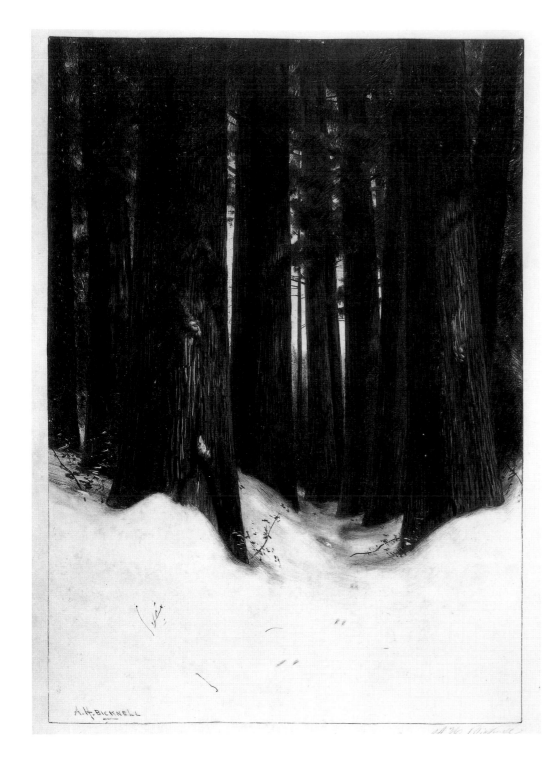

Fig. 21 (left)
Albion Harris Bicknell,
Forest in Snow, ca. 1881,
monotype, retouched in
ink, 51.9 × 35.5 cm
(20 × 14 in.).
Lucy Dalbaic Lucard Fund,
Courtesy, Museum of Fine Arts,
Boston

Fig. 22 (opposite)
Joseph Pennell, *Under
the Hill,* 1881, monotype
with ink additions,
18.6 × 23.3 cm
(7 3/8 × 9 1/8 in.).
The Art Institute of Chicago, Gift
of Mrs. Bernie Schulman,
1970.905. Photograph ©1996
The Art Institute of Chicago. All
rights reserved

1879, possibly after seeing this work. Chase showed two monotypes at the "Black and White" exhibition of the Salmagundi Club in December 1880. Because the term monotype was not yet in use in 1880, it does not appear in the catalogue. Instead, Chase's monotypes were identified as "Copper Plate Impressions" (nos. 129, 609).[34]

It is also possible that Walker saw a good selection of Lepic's *eaux-fortes mobiles* before he began to make monotypes. In August 1880 the Knoedler Gallery in New York imported twenty impressions from Lepic's *Vues des Bords de l'Escaut* series, which were soon acquired by the important Philadelphia print collector James L. Claghorn (1817–1884). The number of people who saw the prints at Knoedler's is unknown, but once they entered Claghorn's collection, it is likely that they reached a wide audience, especially artists.[35] Lepic's prints would

have attracted attention not only by virtue of their unusual technique but also their unusually large size: the plate measures more than two feet in width and more than one foot in height.

In 1880 the Philadelphia Society of Etchers was founded. In addition to active artists such as Peter Moran and Joseph Pennell and nonresident artists such as Thomas Moran, the organization welcomed honorary members such as Claghorn and Sylvester Rosa Koehler, who wrote the introduction to the organization's first exhibition catalogue. At the society's first annual exhibition in December 1882, Claghorn lent more than six hundred etchings from his private collection, including five impressions from Lepic's *Vues des Bords de l'Escaut* series. Members of the organization could make regular visits to Claghorn's collection and were probably among the first to see the Lepic prints he had acquired from Knoedler's.

Reaction to them was swift. Joseph Pennell recalled "going over the prints at Claghorn's . . . in the corner of his upstairs print room, Sunday after Sunday afternoon."[36] In 1881 he executed a series of monotypes based on a series of drawings he had recently made in the region of the Luray Caverns of Virginia at the time of their opening.[37] At this time Pennell was working as an illustrator for *Scribner's* (which became *Century* with the November 1881 issue), and he made these monotypes in the *Century* offices, drawing them directly on metal plates with ink.[38] Because he was a printmaker and illustrator who expressed himself primarily through line, his attempt to translate a line drawing into a tonal monotype resulted in an indistinct image that he clarified by adding flowers, grasses, and details of trees in inks. This series of landscapes appears to have been Pennell's only foray into monotypes, for which he could see no use or merit (fig. 22).

Fig. 23
Peter Moran, *Landscape with Sailboat at Sunrise (Figure Sitting by Stream)*, ca. 1880–85, monotype, 18.7 × 24.9 cm (7⅜ × 9¾ in.).
The Baltimore Museum of Art, BMA 1977.39

In the first annual exhibition of the Philadelphia Society of Etchers, Peter Moran showed eleven monotypes and a substantial group of etchings. Several were New Mexico scenes, suggesting that they were based on drawings he had made during trips to the West during the summers of 1879 and 1880. The titles of the other landscapes indicate East Coast scenes. Claghorn's estate included at least one monotype by Moran, *Landscape with Sailboat at Sunrise (Figure Sitting by Stream)* (fig. 23), a subject that strongly recalls Lepic's series with its strong emphasis on varying times of day suggested by dramatic light effects.[39]

One of the most enthusiastic practitioners of the monotype was the famous actor and amateur artist Joseph Jefferson. According to Walker, he taught the process to Jefferson, who later acquired his own printing press expressly to make monotypes. Fellow actor Francis Wilson recalled that Jefferson "became restless if long without a brush in his hand, and when he travelled professionally he carried an artist's outfit and daily applied himself with gleeful, almost feverish enthusiasm to 'monotyping'"[40] (fig. 24). Since he did not always have access to a real printing press, Jefferson improvised: "He had a gigantic wash-wringer made, and it was a conspicuous article of furniture in his parlor at the various resting-places throughout the country. It took him only a few minutes to lay in a composition, using fingers, palette knife, rags, and often a brush—the skilful use of the knife making the birch tree which is especially characteristic of his paintings. His initials, 'J. J.,' were put in last, with a piece of leather. The tin containing the painting and a piece of paper were rolled together through the wringer, the paper receiving the impression." Like most artists of his time, Jefferson began making mono-chromatic monotypes and later, in his case about 1900, began making them in color.[41]

Fig. 24
Joseph Jefferson, *Untitled,*
ca. 1885, color monotype,
35.7 × 50.7 cm
(14¹⁄₁₆ × 20 in.).

National Museum of American
Art, Smithsonian Institution,
Museum purchase and gift of the
Reverend Dewolf Perry

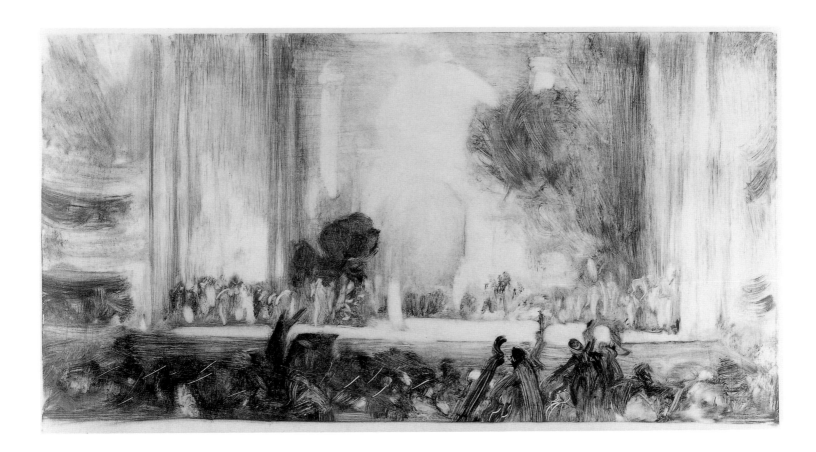

Fig. 25
John Singer Sargent, *Opera
Scene,* ca. 1890, monotype
in sepia ink, 31 × 58.5 cm
(12¼ × 23 in.).

The Fine Arts Museums of San
Francisco, Achenbach Foundation
for Graphic Arts, Gift of Mrs.
Hamilton J. Vreeland, Jr. and
Achenbach Foundation for
Graphic Arts purchase

Jefferson's enthusiasm for the monotype was not matched by all who tried it. John Singer Sargent was shown the process while visiting Jefferson at his country home in Buzzards Bay, Massachusetts, and made what appears to be his only monotype (fig. 25).[42] As a mature and talented painter at the peak of his career, Sargent was able to create a fully developed composition in tones of black and gray that take advantage of the monotype's propensity for dramatic light effects. Working in the dark-field manner, Sargent created an entire scene in an opera house, complete with orchestra, conductor, stage set, singers, and box seats with occupants, distinguishing the artificially lit stage from the darkened theater. With only the slightest allusion to individual figures in the string section of the orchestra, he indicated the instruments by a repetition of quick diagonal lines that suggest individual bows and create a rhythmic cadence appropriate to the musical subject. Known for his technical virtuosity and bravura brushstroke, Sargent translated these skills into another medium with little hesitation.

The Etching Revival

Interest in the monotype among American artists developed soon after the etching revival in this country. Although the etching movement in Europe had begun in the 1860s, this did not occur in the United States until the late 1870s, inspired by the autographic quality of etching that had gained popularity in France and England. With the establishment of the New York Etching Club in 1877 and the Philadelphia Society of Etchers in 1880, and the dedicated support of critic and scholar Sylvester Rosa Koehler in Boston, American artists were encouraged to transform a medium previously used for reproductive purposes into one of original artistic expression. As managing editor of the *American Art Review,* Koehler promoted etchings by American painters. From 1880 to 1881 he published a series of "Original Painter-Etchings by American Artists," accompanied by articles on each of them that included biographies and appreciations as well as catalogues of their work.[43] In 1876 the second edition of Philip Gilbert Hamerton's influential *Etching and Etchers* was published in Boston, and in 1880 Koehler published an English translation of Maxime Lalanne's second edition of *Traité de la Gravure à l'eau-forte* (*A Treatise on Etching*). By 1886 etching had become so popular in the United States that J. R. W. Hitchcock wrote a book titled *Etching in America* to document the movement.

One of the key tenets of the renewed interest in etching was the importance of having the artist create an image directly on the plate. Although it was acceptable for someone else to print the plate, artists should have the opportunity to ink and wipe the plate themselves and to watch it being proofed. As an amateur artist and printer, Koehler demonstrated the making and printing of a plate when he lectured to various groups. At the end of his translation of Lalanne's treatise, in an effort to encourage artists' involvement with the process, he added a chapter describing how to improvise etching equipment from everyday materials such as monkey wrenches, rattail files, and knitting needles.

Artists could learn to make etchings at the studios of several artists who had acquired presses or at the meetings of the New York or Philadelphia etching clubs.[44] In the fall of 1881 the Salmagundi Club in New York hired part of the large studio of Robert Minor in the old University Building in Washington Square, where Charles Volkman, one of the founders of the club, gave a series of lessons. An etching press was set up, and lectures and demonstrations of various art techniques were presented for members and their friends.

In Koehler's introduction to the catalogue of the first annual exhibition of the Philadelphia Society of Etchers, he indicated a direct link between the emergence of monotypes and the practice of *retroussage*—a method of printing etchings in which a small amount of ink is pulled up from the etched lines, leaving a very thin film of ink on the surface of the plate. This method became popular in France after 1880, and many American artists preferred it to cleanly wiped plates. Koehler himself favored "artificial" printing, as this method was called, suggesting that it was more artistic than clean wiping. He justified the inclusion of monotypes in an exhibition of etchings by stating that "the artificial method of printing has led to the production of a species of works which have lately attracted some attention, and have been introduced to the public as monotypes. Although prints, these monotypes are neither engravings nor etchings, and the fact that they are seen in this exhibition . . . is defensible only on the ground that they grew out of etching, and are produced, for the present at least, by painter-etchers only." Koehler enumerated the advantages of the monotype, noting "the ease with which a picture in light and shade can be produced. . . , the peculiar textures that can be obtained, and the facility of picking out lights and making corrections."

Reflecting the change of opinion that had taken place in France in the mid-1870s, Koehler was not concerned that only a single, or possibly a second, impression could be pulled from a monotype plate. The emphasis had shifted from the ability of the printing surface to yield an edition to a greater interest in the many techniques of working the surface and to a preoccupation with the richness of the individual impression—*la belle épreuve*. This latter concept was advanced by Philippe Burty in his preface to the album *L'Eau-forte en 1875,* in which he cited Rembrandt's etchings as justification for small editions and uniquely wiped plates.

Although Burty did not mention the monotype, his ideas were adopted by Richard Lesclide, editor of the illustrated periodical *Paris à l'eau-forte,* who published one of the earliest descriptions of the monotype process in an account of his visit to the studio of the etcher Henri Guérard in 1875:

We entered his studio unexpectedly and found him busy covering a copper plate with a layer of black printer's ink. This pastime surprised us all the more since the plate didn't bear the slightest trace of drawing. . . . But Guérard's answer was simple: I am trying out a new method of printmaking, printmaking with a muslin rag. And as soon as his plate was evenly blackened he grabbed several oily and dirty rags, some rolled in balls, others folded in points, and worked them over the copper plate. After a good half hour, the plate was beginning to shine here and there; lighter areas were appearing, as well as gradations of light and shade; heavy pillars were beginning to emerge in the dark, supporting the arches of an imposing crypt; rays of light were filtering through the small windows, rising only to die slowly in the gloom. At last, when the artist judged his work ready, he took the plate . . . and put it through the press, covered with a sheet of paper. . . . I anxiously awaited the outcome of this operation. Triumphantly the proof emerged from its felt covering. It was a marvellously tormented image of a cavern.[45]

With Rembrandt's etchings serving as a principal source of inspiration for the etching revival, the velvety shadows and expressive chiaroscuro of dark-field monotypes were seen as a logical extension of variable inking.

The monotype process embodied the characteristics that promoters of etching most valued about the medium: direct involvement of the artist in the creation and printing of the image, spontaneity, expressiveness, and originality. Even those who favored the cleanly wiped plate valued these special qualities of etching. For those, like Koehler, who preferred the artificially wiped plate with manipulated plate tone, the absence of a repeatable matrix—an etched

image—was not a major concern. For admirers of the *belle épreuve,* a single exquisite impression was sufficient justification for a print.

Although the monotype was most closely associated with etching in the 1880s, artists who experimented with monotypes often worked with watercolor and pastel as well, at times combining the various techniques. For example, in his dark-field monotype *Trees* (fig. 26), Charles Alvah Walker lightened some of the more densely inked areas by scratching the surface of the impression with the edge of a knife, recalling the contemporary practice in watercolor of selectively scraping the painted surface to reveal the white of the paper as highlights.[46]

Like the monotype, the pastel is also a sort of hybrid medium, a method that combines qualities of both drawing and painting. In the 1880s and 1890s some artists used pastel or watercolor to further develop their monotype compositions. Degas frequently reworked his monotypes with pastel, especially ghost impressions, often until the monotype itself was no longer visible.[47]

American pastellists were strongly influenced by the work of Whistler, Jean-François Millet, and the Italian artist Giuseppe de Nittis; the latter had an especially striking impact on William Merritt Chase and other Americans.[48] Chase was one of the founders of the Society of Painters in Pastel in 1882 and the principal contributor to its first exhibition in 1884. The show received critical acclaim, and Chase was singled out for special mention. One critic noted that "Mr. W. M. Chase . . . flits from oils to monotypes and from water-colors and etchings to charcoals."[49] Shortly after the artist's death, a memorial exhibition at the Metropolitan Museum of Art included forty-five of his paintings, as well as drawings, pastels, etchings, and monotypes.

Chase was least interested in making etchings, probably because their execution was based

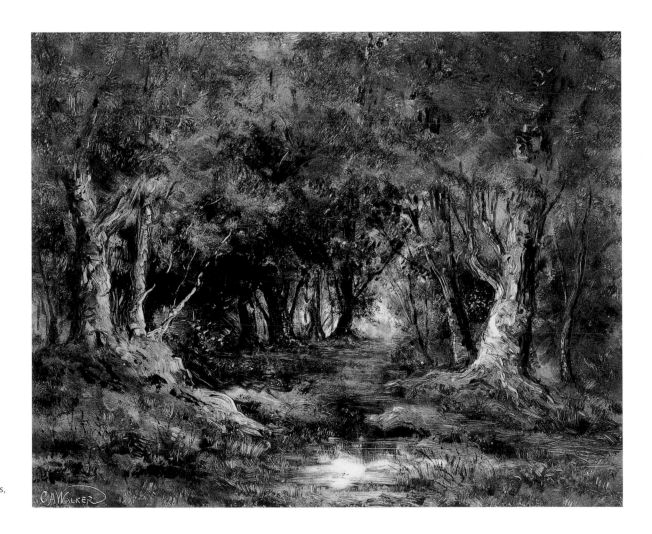

Fig. 26

Charles Alvah Walker,

Trees, 1881, monotype,

34.2 × 42.8 cm

(13½ × 16⅞ in.).

Bequest of Frank C. Doble,
Courtesy, Museum of Fine Arts,
Boston

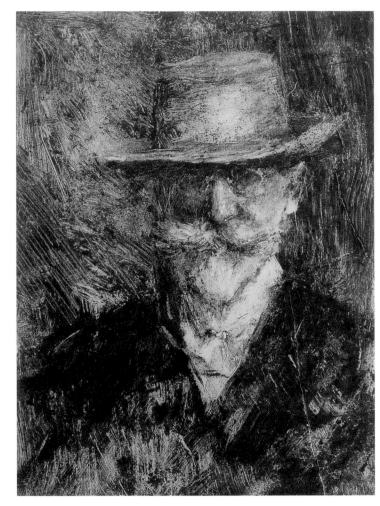

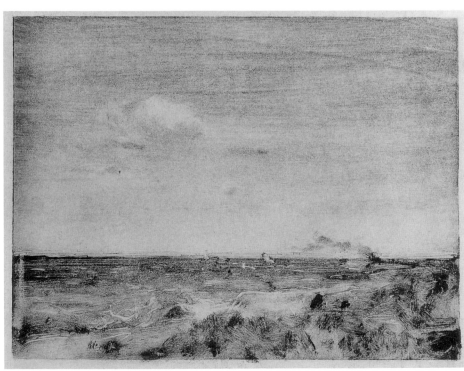

Fig. 27 (above)
William Merritt Chase,
Untitled Landscape,
1912, monotype,
15.8 × 12.2 cm
(6¼ × 4¾ in.).

The Fine Arts Museums of
San Francisco, Achenbach
Foundation for Graphic Arts,
Anonymous gift and Achenbach
Foundation for Graphic Arts
purchase

Fig. 28 (above, right)
William Merritt Chase,
Self-Portrait, ca. 1911–14,
monotype, 20 × 15.2 cm
(7⅞ × 6 in.).

Terra Foundation for the Arts,
Daniel J. Terra Collection,
1987.18. Photograph ©1996
Courtesy of Terra Museum of
American Art

Fig. 29 (right)
William Merritt Chase,
Shore Scene, ca. 1885,
monotype, 15 × 19.5 cm
(5⅞ × 7¹¹⁄₁₆ in.).

Los Angeles County Museum of
Art, Graphic Arts Council Fund,
M.90.62

on line, with tone introduced in the process of printing. The monotype, on the other hand, allowed the artist to compose strictly in terms of light and dark, without the need for acids or a professional printer. Like the pastel, the monotype was conducive to experimentation and innovation, and mistakes could easily be corrected. Both allowed for quick, spontaneous execution, a quality Chase also sought in his painting.[50]

Chase made monotypes over a period of at least thirty-four years, beginning with his first efforts in the 1870s through at least 1914, when he gave demonstrations of the process while teaching a summer class in Carmel, California. A small landscape with signatures of members of the class he held in Bruges, Belgium, during the summer of 1912—possibly intended as a memento for one of the students—is the only one of his monotypes that can be dated with certainty (fig. 27). A self-portrait of the artist wearing a straw hat (fig. 28) suggests the casual dress he probably favored in Carmel, where he made several monotypes that he sent home to his wife. The creases in many of his monotype impressions indicate that they were printed either by an inexperienced printer or on a makeshift press, such as the wringer washing machine he purchased in Carmel.

Fig. 30

William Merritt Chase, *Reverie: A Portrait of a Woman*, ca. 1890–95, monotype, 49.2 × 40 cm (19⅜ × 15¾ in.).

The Metropolitan Museum of Art, Purchase, Louis V. Bell, William E. Dodge, and Fletcher Funds, Murray Rafsky Gift, and funds from various donors, 1974. All rights reserved, The Metropolitan Museum of Art

In his comments on Chase's monotypes shown in the 1880 "Black and White" exhibition at the Salmagundi Club, Koehler noted that his subjects were "heads, landscape sketches, and the like," which characterized Chase's later monotypes as well.[51] Some attempts have been made to date Chase's monotypes based on comparisons with his other works and external factors. For example, a date of ca. 1885 has been suggested for the landscape monotype *Shore Scene* (fig. 29) because of its similarity to a painting from the early 1880s.[52] A rural landscape including a house with thatched roof appears to be a scene in the European countryside and may date from Chase's visit to Bruges during the summer of 1912.[53] *Reverie: A Portrait of a Woman* (fig. 30) probably dates from the early 1890s; Chase's several self-portraits (fig. 31) probably date from 1911–14, based on his physical appearance.[54]

Most of Chase's monotypes are relatively small in size, approxi-

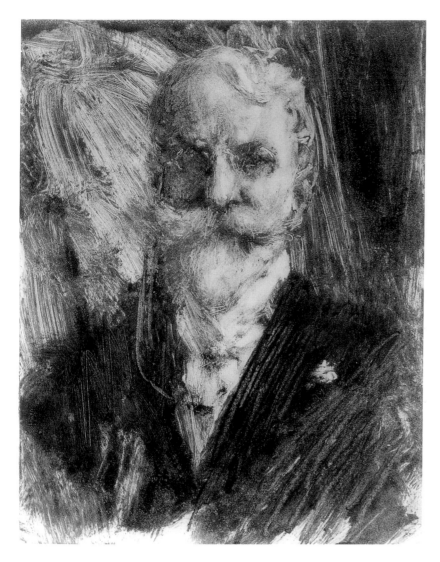

Fig. 31 (left)
William Merritt Chase, *Self-Portrait*, ca. 1911–14,
monotype, 20 × 15.2 cm
(7 ⅞ × 6 in.).
Bowdoin College Museum of Art,
Brunswick, Maine. Museum
purchase with anonymous gift

Fig. 32 (opposite)
Charles Warren Eaton,
Landscape, ca. 1890–95,
monotype, 17.2 × 27.3 cm
(6 ¾ × 10 ¾ in.).
Charles T. Clark

mately 6 by 8 inches, but *Reverie* is significantly larger and more finished than the others.[55] The sensitively modeled face and hand, as well as the attention given to the woman's rings and hair ornament, contrast with the freer, more bravura handling of the dress and background, where ink was applied and wiped away with greater vigor. Traces of the artist's fingerprints are visible in the soft textures of the sitter's skin and clothing. Most of Chase's monotypes have the feeling of a sketch, but *Reverie* has the presence of a finished work without sacrificing the directness and spontaneity so highly valued by those trained in the Munich academy.[56] In Munich more emphasis was placed on the manner of painting rather than the subject, and artists began to exhibit their sketches and studies as well as their paintings. Paint was applied wet-on-wet in *alla prima* fashion. Little or no underdrawing was used, and overpainting was discouraged. It is easy to see why the monotype process would appeal to artists trained in this manner.

During the 1890s Charles Warren Eaton made a substantial body of landscape monotypes, of which at least fifty are extant. Like many of his contemporaries, he was trained in the French Barbizon tradition, which dominated American painting by the 1880s. The legacy of French Romanticism was transmitted to American artists largely through American followers of the Barbizon School of landscape painting.[57] In the paintings of William Morris Hunt and George Inness, among others, American artists and audiences were introduced to the melan-

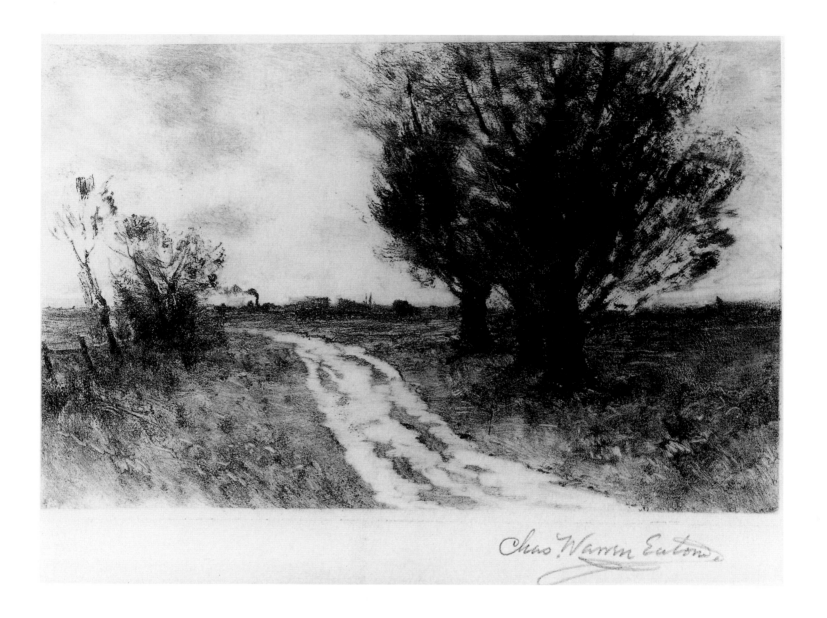

choly mood, painterly technique, attention to the humble life of peasants and their animals, and the intimate, wooded landscapes that characterize paintings of the French Barbizon artists. Their brown-dominated palettes placed greater emphasis on the poetry and mood of a scene than on descriptive colors, while specific details were subsumed by broad, atmospheric generalizations of form.

Unlike the artists who participated in the etching revival, Eaton came to the monotype primarily as a painter and watercolorist. A protégé of George Inness and close friend of George Inness, Jr., Eaton occasionally shared a studio with both of them in New York City and also in Montclair, New Jersey, near Eaton's home in Bloomfield. Although Eaton's monotypes are not dated, stylistically they most closely resemble his work before 1900. During the 1890s his painting style was characterized by an atmospheric softening of edges, a dark palette of greens, browns, and grays, and limited surface effects. For the most part he chose intimate wooded scenes and transitional times of day suggested by the moody effects of light (fig. 32). His low-key palette and vague, suggestive moods reveal the strong influence of the evocative Tonalism of his mentor George Inness. Eaton's monotypes share the aesthetic concerns of his paintings, pastels, and watercolors. They are small in scale and intimate in feeling, with forms

Fig. 33

Charles Warren Eaton,

Niagara Falls, 1890–95,

monotype, 17.8 × 22.9 cm

(7 × 9 in.).

Mr. and Mrs. Frank A.

Polkinghorn, Jr.

that are generalized and edges softened by the process of transferring the image from one surface to another. Most of them are black-and-white, although some of the images were created in the muted, low-key colors that typify Eaton's Tonalist paintings. Some of his compositions are directly related to a specific painting, while others, such as numerous monotypes of Niagara Falls, appear to have been based on his own photographs (fig. 33).[58]

By the mid-1890s enough artists had presses or access to them to be able to make monotypes without the participation of a professional printer. In his diaries F. Luis Mora mentioned making monotypes several times, especially in 1906. On Monday, March 19, he noted a monotype party at which the participants experimented successfully with a new type of paper. The following Monday he mentioned making another monotype, but on Monday, May 7, he recorded going to a San Francisco relief sale instead of making monotypes, as if the latter were his usual Monday-evening activity, possibly at the Salmagundi Club. On Tuesday, August 28, he described a "delightful evening at the Kitchels making monotypes," and in mid-December he mentioned making monotypes for Christmas presents on several different days of the week, indicating that he may have been working in his own studio.[59] In his entry for November 15 Mora recorded that he began a painting of a subject previously used for a monotype and a watercolor, suggesting that his monotypes sometimes served as studies for paintings.[60] Some of his monotypes, such as *Farm Wagons* (fig. 34), were carefully developed compositions, fully realized as independent works of art rather than mere sketches or studies. At a special exhibition of his work at the Cincinnati Art Museum in 1925, Mora showed forty-eight works, of which twelve were monotypes, indicating that he considered them a significant part of his oeuvre.

A Legacy of Romanticism

Just as the monotype may be seen as the embodiment of qualities most admired by proponents of the etching revival, it may also be understood as a consummate expression of lingering Romanticism. As Koehler noted in 1882, "With the rise of the romantic school and of the modern school of landscape art in France, based as they are upon the development of individualism and a better understanding of the charms of color and chiaroscuro, the conditions

Fig. 34
Francis Luis Mora, *Farm
Wagons,* 1908, color
monotype, watercolor, and
gouache, 17.5 × 23.5 cm
(6⅞ × 9¼ in.).

Hirschl & Adler Galleries, Inc.,
New York

were favorable once more to the advancement of etching."[61] Even more than etching, which remained primarily a linear medium, the monotype depended entirely on the "charms of color and chiaroscuro."

In their rejection of the Neoclassical tradition, Romantic artists attempted to abolish the hierarchy of genres and art media. Beginning in the early nineteenth century, according to Charles Rosen and Henri Zerner, "minor or marginal phenomena become essential to an understanding of the period, because an inescapable aspect of the art of that time is the undermining of the main tradition and of the centers of power."[62] Immediacy of expression was prized, and sketches and studies assumed greater importance than they ever had in the history of art. Correspondingly, the proponents of the etching revival emphasized the autographic and expressive qualities of the etched line and the variably wiped plate. By virtue of the speed with which a monotype had to be completed before the ink or paint dried on the plate, the monotype epitomized the Romantic ideals of immediacy and spontaneity, as well as its philosophical emphasis on originality.

Although the French Barbizon artists did not make monotypes, several of them made etchings, and some experimented with the cliché-verre—a newly invented technique that combined characteristics of etching and photography. A hybrid medium like the monotype, the cliché-verre developed directly from the invention of photography. As early as 1839, William Henry Fox Talbot described "photogenic drawings," or "shadow pictures," made by drawing on a glass plate covered by an etching ground, placing the plate on photogenic paper, and exposing it to light, which passed through the drawn lines to reproduce them on the paper. Introduced to America in 1859 by John W. Ehninger, who published twelve clichés-verres by various American artists in an album called Autograph Etchings, the technique attracted few artists and met with little critical or financial success.

Although Ehninger and other proponents of the cliché-verre emphasized its autographic nature, namely its ability to reproduce an artist's drawing directly, without the intervention of another hand, its reproductive function was of primary importance to them. As Ehninger observed, "Thus you see that the artist in the act of drawing, literally engraves his own design which strikes me as being the perfection of faithful reproduction."[63] By contrast, the etching revival of the 1860s and 1870s in England and France championed the expressive quality of the etched line rather than its reproductive function. Before this revival, etching had often been used in conjunction with engraving as a technique of reproductive printmaking, especially in the United States. The artist supplied the image, usually a painting, and a craftsman or another artist transferred the composition to the plate and printed it in a large, uniform edition. The names of the artists and engravers were routinely engraved on the plate. As the reproductive function of etching was superseded by chromolithography and photography during the mid-nineteenth century, those who promoted the etching revival emphasized its value as a medium of original expression. According to J. R. W. Hitchcock, "Now the painter's etching, a free-hand drawing upon a grounded plate, autographic in character, expressing the individuality of the artist in lines directed by the immediate brain-impulse of the man, suggestive rather than elaborated, is obviously a very different thing from the engraver's etching."[64]

The monotype gained popularity at the same time that signed proofs and limited editions were becoming more common for etchings. Although pencil signatures and limited editions

were inspired in part by the commercial concerns of art dealers, who promoted them as assurances of rarity and authenticity, they also functioned as symbols of the artist's direct involvement in creating the plate. Even more explicitly than in etching, the artist's direct presence was evident in the monotype. While a skilled printer such as Auguste Delâtre could print an entire edition of etchings with variable inking and *retroussage,* the wiping of a monotype plate had to be done by the artist, since the process of creating the image and the act of wiping the plate were identical. Many artists manipulated ink on the plate with their own fingers, consciously or inadvertently leaving their fingerprints visible as testimony to their personal involvement in creating the image. Long before the fingerprint achieved legal recognition and semi-scientific status as a mark of identity, in the late nineteenth century it was understood as being equivalent to a handwritten signature.[65]

Concurrent with the etching revival in America, the watercolor and the pastel gained popularity and stature among American artists, moving from the margins of artistic practice to a more central role. In 1884 a leading critic wrote:

The time is not long past when, if the average educated American spoke of pictures, he meant oil paintings alone; if of prints, steel engravings only. Art—true art, "high art"—was confined for him to these two methods; and he would not have understood that certain so-called minor branches, of whose existence he was dimly conscious, might properly be ranked beside them. . . . No painter, however great his mastery of oils, can do everything by their sole aid. . . . Great as has been our advance in oil painting within recent years, I think our most notable evidence of progress lies in the fact that these minor branches [etchings, watercolors, and pastels] are no longer either unfamiliar or despised; that we have turned with eagerness to many methods of interpretation our fathers did not touch. . . . I think we failed to appreciate these arts in other days partly because they were comparatively unfamiliar to our eyes, but chiefly because we felt no desire for the expressional facilities they offer. Absolutely unknown they were not, but their germs lay dormant till we awoke to a wider wish for self-expression.[66]

In the late nineteenth century monotypes never achieved the popularity among artists or the public that etchings, watercolors, and pastels attained. Their emergence in the 1880s and 1890s can be attributed to many of the same forces that encouraged a revival of interest in these other media. Their intimacy of scale, spontaneity of execution, and potential for experimentation distinguished the minor media from the more formal, finished approach to drawing and painting taught in the academies. Although the fun and novelty of making monotypes in a group setting encouraged many artists to try the medium, it probably also discouraged them from considering it as an avenue for serious artistic expression. Because the emergence of the monotype was so closely associated with the etching revival, few artists recognized its potential for making images in color. It remained for Maurice Prendergast and the next generation of artists to develop the color monotype.

2

Who can say wherein lies the charm of the monotype—that unique print from a painted plate, which stands in the half shadow between painting and print-making? . . . Its spontaneity and freshness, its directness and freedom place it apart from other traditional print media as a means of artistic expression that should not be overlooked. —Ida Ten Eyck O'Keeffe, 1937[1]

Color Prints and Printed Sketches

As familiarity with the monotype grew, the medium became less closely associated with the ideals of the etching revival and late-nineteenth-century Romanticism. Although American artists who followed the academic and Barbizon traditions continued to show interest in the monotype, Impressionists, Post-Impressionists, modernists, and urban realists experimented with the process as well. Several artists made substantial bodies of work in monotype, and many began to explore the possibilities of color images. Some artists began to work with oil paint rather than printer's ink, which greatly expanded their palette.

Maurice Prendergast

The largest and most distinguished body of monotypes made by an American artist during the 1890s was created by the Bostonian Maurice Prendergast, whose first work in this medium was done in 1891 or 1892, within the first year or two after he arrived in Paris with his brother Charles.[2] By January 1891 Prendergast had registered for classes at the Atelier Colarossi, and in October of that year he also enrolled at the Académie Julian. Before going to Paris, he had received little formal art instruction. Perhaps introduced to drawing and design in the Boston public school he attended, Prendergast appears to have studied drawing in free evening classes at the Starr King School in Boston in 1873 and 1877.[3] At first he worked for a dry-goods firm wrapping packages, and later he learned lettering, graphic design, and illustration while working in a show-card shop. In 1879 he is listed in the Boston directory as a "designer." Because of his interest in art, it can be assumed that he saw exhibitions at Boston's Museum of Fine Arts and various commercial galleries and read about art in the popular journals. It is possible that he saw monotypes by Walker and Bicknell exhibited at the Doll & Richards and J. Eastman Chase galleries in Boston in the early 1880s.

Prendergast's monotypes were radically different from those being made in Boston, New York, Philadelphia, Paris, and Florence. From the beginning, he worked in color, creating forms with flat areas of

Albert Sterner, *Woman with Mask* (detail, fig. 47), color monotype

43

paint, at times highlighted with white lines created by wiping away ink with the tip of the brush handle. Figures are a central feature in his compositions—not the portrait heads created by some members of the Duveneck circle or the small incidental figures in landscapes by Walker or Bicknell, but large-scale, full figures that recall the shape and placement of the figure in a Japanese print or groups of figures in a landscape. Prendergast's monotypes were printed by hand rather than on a press, a distinction suggesting that he may have been familiar with the monotypes of other artists but chose to employ the process for his own artistic purposes.

What, then, did the process offer Prendergast that painting in oil or watercolor did not? Since the artist never revealed why he chose to work in this medium, the answer must be found in the works themselves. The monotypes represent a significant departure, both stylistically and technically, for Prendergast. Before going to Paris, he had made some drawings and paintings in the countryside around Boston and also during a trip to Wales in 1886. What little work remains from this time is awkward and tentative. The few extant watercolor landscapes and portraits recall the dominant influence in Boston during the 1870s and 1880s of William Morris Hunt and the French Barbizon painters. Prendergast's earliest paintings and watercolors created after arriving in Paris were traditional, academic portrait and landscape studies.

By 1892 his work had changed dramatically. One of the few works that can be definitely dated to Prendergast's early years in Paris is the monotype *Bastille Day (Le Quatorze Juillet),*

Fig. 35 (left)

Maurice Brazil Prendergast, *Bastille Day (Le Quatorze Juillet),* 1892, color monotype, 17.4 × 13.1 cm (6⅞ × 5⅛ in.).

©1996 The Cleveland Museum of Art, Gift of The Print Club of Cleveland, 1954.337

Fig. 36 (right)

Maurice Brazil Prendergast, *Esplanade,* ca. 1891, color monotype, 16.5 × 14.6 cm (6½ × 5¾ in.).

Daniel J. Terra Collection, 18.1983. Photograph ©1996 Courtesy of Terra Museum of American Art

dated 1892 on the plate itself (fig. 35). A skillfully executed image with subtleties of color and composition, this work suggests that Prendergast had already become adept at the medium. Indeed the two monotypes identified by Charles Prendergast as his brother's first monotypes reveal the slight awkwardness one might expect from an artist's first attempts in a new medium (fig. 36). Both show a full-length, fashionably dressed woman whose figure seems to merge with the surrounding space by virtue of close tonal values and the highly absorbent paper used for these images. This distinct departure from his traditional, conservative style suggests that during the time he was learning academic techniques, he was also looking elsewhere for ideas. Prendergast's sources of inspiration were diverse, but the most important at this early stage of his career were Japanese woodcuts, contemporary French color lithographs, and the work of James McNeill Whistler.

Although William Morris Hunt and his followers dominated the Boston art world during the 1880s, Japanese art and the work of Whistler were also receiving attention, especially from artists and collectors who had been in Europe and Japan. As early as 1881, an exhibition of Japanese prints from the collection of William Sturgis Bigelow was shown at the Museum of Fine Arts, Boston, and beginning in mid-1888, Siegfried Bing's magazine, *Artistic Japan,* was widely distributed in French, German, and English editions. When Ernest Fenellosa became curator of Japanese art at the Museum of Fine Arts in 1890, *ukiyo-e* prints were featured in many of the exhibitions he organized. Although Prendergast was not directly involved in Boston artist circles, he was probably aware of Whistler and Japanese prints even before going to Paris. Once he had arrived in France, their influence became evident, especially in his monotypes.

Japanese prints were even better known and more influential in Paris than they had been in Boston. Since 1856, when Félix Bracquemond first saw them, these prints had served as a source of inspiration for both traditional and avant-garde French artists. The first comprehensive exhibition of Japanese art in the West was held in 1883 at the Paris gallery of Georges Petit, and in 1887 Vincent and Theo van Gogh organized an exhibition of Japanese prints from the collection of Samuel Bing in Montmartre. The following year Bing showed a more extensive selection of Japanese prints in his shop, and in 1889 a major display of Japanese art was presented at the Universal Exposition in Paris. In 1890 an exhibition of 725 Japanese prints was held at the Ecole des Beaux-Arts.

Their impact on artists was direct and immediate. Auguste Lepère and Henri Rivière made their first color woodblock prints in 1889, clearly inspired by the Japanese technique, style, and subject matter. Similarly, Mary Cassatt attempted to duplicate the Japanese system of color printing in her remarkable series of ten color etchings that were exhibited at the Durand-Ruel Gallery in 1891. Japanese prints were an important influence on the color lithographs of Henri de Toulouse-Lautrec, Pierre Bonnard, Edouard Vuillard, Maurice Denis, Eugène Grasset, and others. As an artist with a background in graphic design, Prendergast was probably cognizant of these developments in color printing and posters, even though he had not made prints. At a time of great ferment and activity in the realm of color printmaking, Prendergast appears to have devised his own response to Japanese prints in his color monotypes. The artist's selection of Japanese paper for most of his monotypes testifies to the strong attraction of its delicate surface.

His most specific reference to Japanese art can be seen in an early monotype in which a

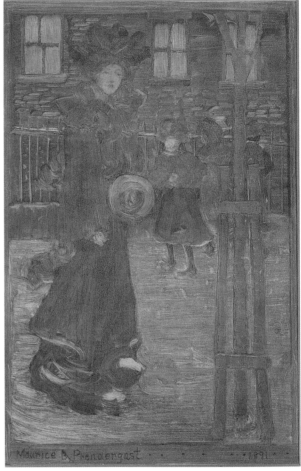

single full-length female figure fills each of three contiguous panels that suggest a Japanese print triptych (fig. 37).[4] The garments of the three figures overlap the boundaries of the individual panels, as if the figures were about to step out of the panel into the surrounding space. Three additional female figures below them appear to have already stepped off the prints into the blank space that characterizes many of Prendergast's monotypes of single figures. Despite their fashionable Western attire, hats, capes, and boas, the figures move with the same sinuous elegance as their Japanese counterparts, suggesting that all the single female figure monotypes of his Paris years have literally stepped out of Japanese prints. Moreover, Prendergast's elaborate, decorative monogram, composed of his initials, is strongly reminiscent of the seals used by Japanese artists. His monogram in each of the three panels strengthens the reference to individual prints mounted together to form a triptych.[5]

Le Quatorze Juillet recalls the Japanese love of fireworks and pageants, while the many bridges and umbrellas recall popular motifs in Japanese art. By 1892 Prendergast had developed a monogram that combined the calligraphic design of the Japanese woodcutter's ideogram and the decorative elegance of Whistler's famous butterfly monogram. The strongly vertical composition, based on the intersecting diagonals in many of his earliest monotypes,

Fig. 37 (opposite, left)
Maurice Brazil Prendergast,
Six Sketches of Ladies, ca.
1891–94, color monotype
with pencil additions,
39.5 × 28.1 cm
(15½ × 11 in.).
Courtesy of the Fogg Art
Museum, Private collection, Loan
to the Harvard University Art
Museums

Fig. 38 (opposite, right)
Maurice Brazil Prendergast,
Fall Day, 1895–1900, color
monotype, 25.4 × 16.2 cm
(10 × 6⅜ in.).
Collection of Roy and Cecily
Langdale Davis

such as *Lady with Umbrella* (Williams 1572), is directly related to the design principles of Japanese art. *Fall Day* (fig. 38) displays some of the characteristics of Japanese prints most admired in the nineteenth-century literature in English and French: their abstract compositional qualities, especially a stylized beauty of line, and the uniqueness of each impression. However, unlike the clear, distinct colors of Japanese color woodcuts and most of Cassatt's color prints, the muted autumnal colors in a limited tonal range suggest the influence of Whistler, who also had been greatly impressed by Japanese prints. The large-scale, fashionably dressed female figure was an important element in Whistler's painting repertoire, as were the grayed, mid-range tonalities unifying the figure and surrounding space.

One of the strongest links to Japanese prints, however, is the manner in which Prendergast printed his monotypes. In his only description of how he made monotypes, written in a 1905 letter to his student and friend Esther (Mrs. Oliver) Williams, the artist instructed her: "Paint on copper in oils, wiping parts to be white. When picture suits you, place on it Japanese paper and either press in a press or rub with a spoon till it pleases you. Sometimes the second or third plate is the best."[6] The writer Van Wyck Brooks related an account of Prendergast's procedure, told to him by the artist's brother, Charles:

He could not afford a regular press and his quarters in Huntington Avenue were so cramped that he had no room for a work-bench. So he made his monotypes on the floor, using a large spoon to rub the back of the paper against the plate and thus transfer the paint from the plate to the paper. As he rubbed with the spoon, he would grow more and more excited, lifting up the paper at one of the corners to see what effect the paint was making. The clattering of the big spoon made a great noise on the floor; and soon he and Charles would hear the sound of a broomstick, pounding on the ceiling below. That meant the end of the day's work.[7]

With few exceptions, European and American prints were printed on a press, while Japanese woodcuts were printed by hand with a baren, with which the printer applied pressure to the back of the paper to transfer from the block to the paper. Prendergast used a big spoon to print his monotypes simply as a convenient substitute for a Japanese baren.

Even though Prendergast's monotypes have much in common with Japanese color woodcuts, they are in no sense imitations. On the contrary, they represent a remarkably original adaptation of this art form. The color in Japanese woodblock prints often varied considerably from one impression to the next, but they could be printed as a relatively consistent edition. A few additional impressions of a monotype could be printed, as Prendergast sometimes did, but he seemed more interested in variations from one proof to another rather than duplicating an impression or printing an edition.

While Japanese prints are characterized by clear, distinct colors and crisp, black outlines, Prendergast's monotypes usually have more muted colors, often with one dominant tone, highlighted by small areas of contrasting color. The soft edges, muted colors, and overall unity of his compositions were a deliberate choice, strongly reminiscent of Whistler's manner of painting. The colors Prendergast chose were frequently within a narrow tonal range, further unifying the entire composition. Although the Japanese tissue he chose for most of his monotypes was less absorbent than the paper he used for his earliest monotypes, such as *Esplanade* (fig. 36), the process of transferring wet paint from one surface to another naturally muted its intensity, and the pressure on the back of the paper fostered an overall unity of the surface. When Prendergast wanted a sharp line, he used the back of a brush or other pointed object to wipe away the paint from the surface of the plate, as he did to suggest highlights on the

water in *Esplanade* or to separate forms in *Circus Band* (fig. 39). While Whistler sometimes painted his watercolors on wet paper in order to blur the edges between forms, Prendergast could achieve the desired softness by transferring the paint from one surface to another.

Whistler's work was well known in the United States by the 1880s. Several of Duveneck's "Boys," who had been influenced by Whistler, had close ties with Boston artists. Joseph DeCamp, who had been with Duveneck and Whistler in Venice in 1880, settled in Boston in the mid-1880s and became an influential portraitist and teacher. An exhibition of Whistler's work, including his Venetian etchings, opened in New York in the autumn of 1883 and traveled to Baltimore, Boston, Philadelphia, Chicago, and Detroit. Among the works on view was his notorious painting *Nocturne in Black and Gold: The Falling Rocket* (Detroit Institute of Arts), which was hung in a room by itself.

Whistler's work was perhaps even better known and admired in Paris, especially in English-speaking art circles, with which Prendergast quickly became associated. One of his fellow lodgers in Paris was the young English sculptor Robert Stark. Shortly after his arrival in Paris, Prendergast made friends with the Canadian artist James Morrice and the English artist Charles Condor. Prendergast and Morrice worked together in Paris and its environs, and Condor joined them during the summer of 1891 for a trip to Dinard, Saint-Malo, and Concarneau. Both Prendergast and Morrice painted in a Whistlerian manner during their early years in Paris, as did English artists Walter Sickert and Philip Wilson Steer and others in their circle.

Whistler had incorporated many elements of Japanese composition and design into his paintings, possibly reinforcing, or even kindling, Prendergast's interest in Japanese prints. The explosion of lights against a dark background in *Le Quatorze Juillet* recalls Whistler's *Nocturne in Black and Gold: The Falling Rocket,* which Prendergast perhaps saw when it was exhibited in Boston. After his return to Boston in the mid-1890s, Prendergast continued to look to Whistler for inspiration. *Afternoon* (fig. 40) and a group of related monotypes strongly suggest Whistler's shop fronts and street scenes of Chelsea while also showing Prendergast moving in a new direction with more vigorous brushwork.[8]

Throughout the 1890s, Prendergast made oil paintings, but most of his work from this first decade of his career consists of sketches, watercolors, and monotypes. The subjects, formats, and compositions in all of these media were closely related. Only two subjects—circus scenes and ships, depicted in a group of works executed around 1895—appear primarily in monotypes.[9] Some of the monotypes are based on studies in his sketchbooks, and some paintings appear to have been based on monotype compositions. *Telegraph Hill* (fig. 41), a scene of the old harbor in South Boston, is very similar in composition and palette to a painting with that title, despite small differences in some elements. To a large degree, the tonal variations in

Fig. 39

Maurice Brazil Prendergast, *Circus Band,* ca. 1895, color monotype with pencil additions, 31.4 × 23.9 cm (12⅜ × 9⅜ in.).

Collection of Rita and Daniel Fraad

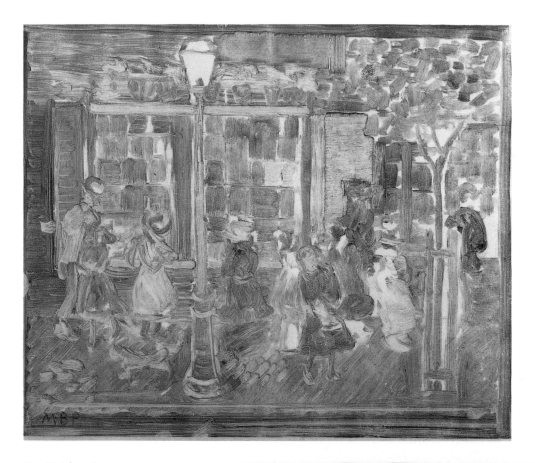

Fig. 40 (above)
Maurice Brazil Prendergast,
Afternoon, 1895–1900,
color monotype,
22.9 × 27 cm (9 × 10⅝ in.).

Collection of the Corcoran
Gallery of Art, Museum Purchase

Fig. 41 (right)
Maurice Brazil Prendergast,
Telegraph Hill, 1895–97,
color monotype,
35.6 × 36.2 cm
(14 × 14¼ in.).

Terra Foundation for the Arts,
Daniel J. Terra Collection,
1992.110. Photograph ©1996
Courtesy of Terra Museum of
American Art

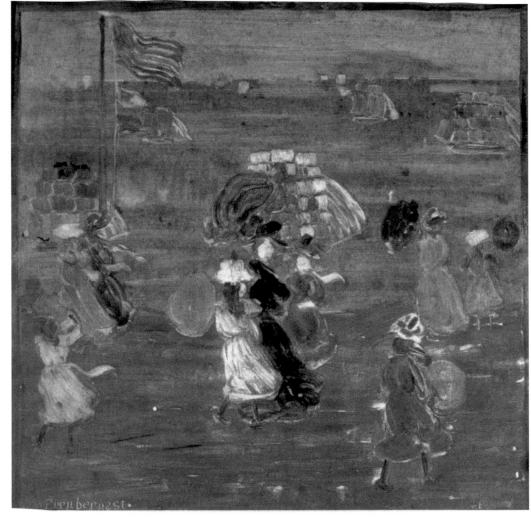

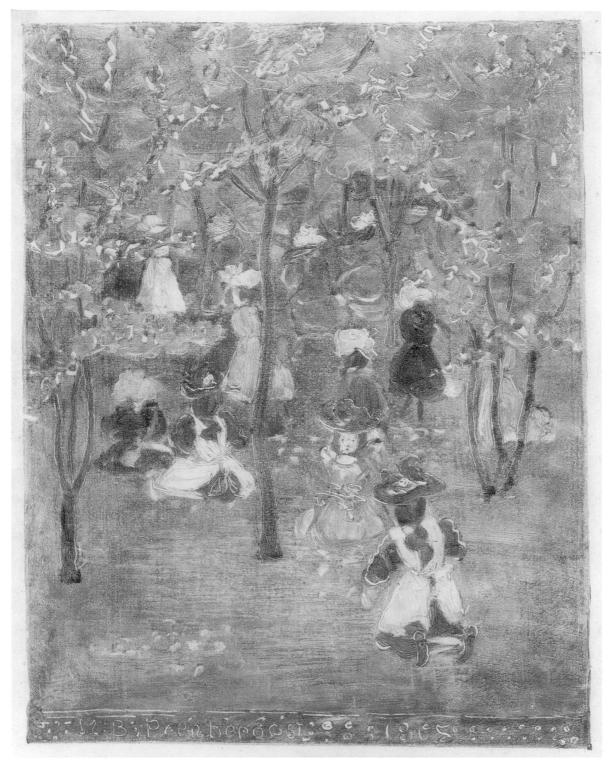

Fig. 42

Maurice Brazil Prendergast,
Spring in Franklin Park,
1895, color monotype, 25.6
× 20 cm (10 1/16 × 7 7/8 in.).

Terra Foundation for the Arts,
Daniel J. Terra Collection,
1992.106. Photograph ©1996
Courtesy of Terra Museum of
American Art

the three horizontal bands of color indicating land, sea, and sky are the result of variations in value and density of the ink on the plate. Careful examination of the surface, however, reveals slight differences of pressure that enhance the sense of movement and light in the outdoor setting. Because a printed image is reversed and the orientation of both compositions is the same, it is probable that this monotype preceded the painting. Conversely, some pairs of monotypes and paintings in which the compositions are reversed suggest that Prendergast sometimes based his monotypes on paintings. He showed them side by side when he began to exhibit in the late 1890s and early 1900s.

As an artist finding his way in the 1890s, Prendergast borrowed freely from the art around him to create a distinctive and highly sophisticated expression. During his early years in Paris, he was introduced by Morrice to *pochades*—quick oil paintings on small wooden panels or even the backs of cigar-box lids. Unlike the *ébauche*—the spontaneous, loosely painted, monochromatic sketch at the heart of the academic method of painting—the *pochade* was realized in color and considered a finished work. Like his watercolors and monotypes, the *pochade* was portable and well suited to an artist without a permanent studio. The colors of Prendergast's *pochades* and watercolors were relatively high key, but the monotypes were usually much more muted, at times almost monochrome, recalling the range of tonality he admired in the work of Whistler, Vuillard, and Cézanne.

In Paris in the early 1890s Prendergast had the opportunity to see the work of the Nabis and the Neo-Impressionists at the Barc de Boutteville Gallery, and he became aware of the importance of bright color in contemporary art. A van Gogh memorial exhibition was mounted in 1891, followed a year later by a large retrospective of Georges Seurat's work. Although the Impressionist group exhibitions had ceased by the 1890s, the works of Monet, Renoir, and Pissarro continued to be shown by Durand-Ruel and other dealers. He probably saw the exhibition of Degas's color landscape monotypes at Durand-Ruel in 1893.

By the time Prendergast returned to Boston in 1894, elements of Impressionism had become apparent in his work. Many American artists had been converted to Impressionism after contact with Monet at Giverny, and this style began to displace Boston's academic tradition. Light began to play a more important role in Prendergast's compositions, and the subject of figures in a park, popular among the Impressionists, gained prominence in his sketches, watercolors, and monotypes. In the latter, he took advantage of the transparency of the thinly printed color, using the white of the paper as a source of light across the entire surface, not just where he wiped away the paint or scratched into it with the stem of his paintbrush or another pointed instrument. As Prendergast indicated in his letter to Esther Williams, he sometimes considered the second or third pull, in which the paint was thinner and more transparent, to be the best.[10] For many monotypes he chose Japanese paper with bits of mica in it, which allowed light to flicker across the surface.

In *Spring in Franklin Park* (fig. 42), the white of the paper shows beneath the color throughout the composition, while the solid green background is enlivened by variations in wiping and pressure. As Charles Prendergast indicated in his reminiscence, his brother liked to pick up a portion of the paper to see how the printing was proceeding. Applying pressure with the back of a spoon, he could vary the pressure from one area to the next in order to print some areas darker than others. Hence, the solid green area of the background vibrates with subtle modulations of intensity and light while also unifying the composition. Quick shorthand strokes of color suggest blossoms in the trees, further enlivening the surface. In the

second pull of this composition, *Picnic in the Park* (Williams 1647), the overall flatness of the space in the first pull gives way to a greater sense of depth and perspective by means of more intense color in the central portion in contrast to the very thin color surrounding it. The variations in a composition from one proof to another intrigued Prendergast, and in several extant cognates he varied the printing significantly from one pull to the next.

During the summer of 1898, after exhibiting his work to great critical acclaim, Prendergast left for a sixteen-month tour of Italy. Impressed by the intense color in the paintings of Tintoretto and Carpaccio, the brilliant sunlight, splendid church facades and interiors, and colorful festivals and piazzas of Venice, he heightened the intensity of his color to an almost jewel-like brilliance. Even the monotypes, which until this time had been more muted in tonality, display the greater contrast and variety of color that characterize his paintings and watercolors. In *Roma: Flower Stall* (fig. 43), Prendergast further enlivened the surface of the composition by emphasizing the individual dabs of paint that create the forms, anticipating the Post-Impressionist brushwork and vivid color that are hallmarks of his mature painting style. In comparison with the monotypes made in Boston just before his trip to Italy, such as the several versions of *The Breezy Common* (Williams 1657–62), his Venetian compositions are much more luxuriant and complex, without a single focal point. When Prendergast returned to Boston, he continued to create complex, densely textured compositions with flowing, interwoven forms that strongly resemble his approach to painting. Executed in 1901, *Summer Day* (fig. 44) eschews the glowing translucency of his earlier monotypes for the more active broken surface of his contemporaneous paintings, such as *Salem Willows* (Terra Museum). Prendergast stopped making monotypes in 1902 at the time he was redirecting his activity from watercolor to oil painting.

Although Van Wyck Brooks suggested that Prendergast made monotypes merely as exercises "in order to see how a sketch would look in a painting," his exhibition history indicates that he regarded them as serious and fully independent works of art.[11] His first major exhibition in Boston, at Hart & Watson's Gallery in December 1897, consisted entirely of monotypes, and he showed more monotypes than watercolors in the Boston Water Color Club annual exhibition of 1898.[12] In his first museum exhibition, at the Art Institute of Chicago in January 1900, Prendergast included fifteen monotypes; his show at the Macbeth Galleries in New York later that year had twenty-six watercolors and forty-two monotypes.[13] Several of his monotypes were displayed in the Boston Water Color Club's annual exhibition in 1901, and later that year thirty-six monotypes and twenty-eight watercolors were included in a solo exhibition that traveled to the Detroit Institute of Arts and the Cincinnati Museum Association.

When Prendergast stopped making monotypes in 1902, he also stopped exhibiting them, but they were again included in later shows of his early works. In 1919 five of his monotypes were displayed at the Ehrich Print Gallery in New York in an "Exhibition of Unusual Monotypes by Contemporary Artists"; three of these were lent to the summer 1919 exhibition at the Memorial Art Gallery in Rochester, New York. A monotype purchased from the exhibition was donated to that institution, the first of his works to enter a museum collection. Prendergast's monotypes were well received by the public as well, and several were sold from each exhibition.

Although Prendergast exhibited his monotypes regularly until 1902, his innovative approach did not inspire many imitators. Few other artists made monotypes in color, and most of them printed their monotypes on presses rather than by hand. Stylistically, Prendergast's

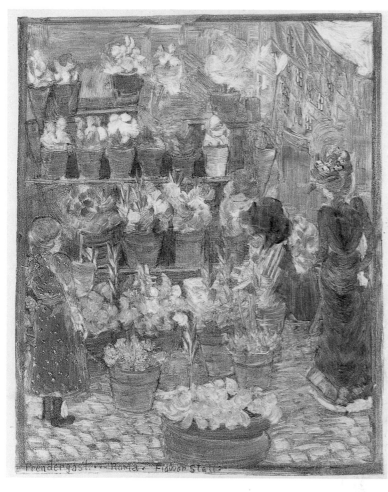

Fig. 43 (left)
Maurice Brazil Prendergast,
Roma: Flower Stall,
1898–99, color monotype
with pencil additions,
23.8 × 19 cm (9⅜ × 7½ in.).

McNay Art Museum,
San Antonio, Texas, Gift of the
Friends of the McNay

Fig. 44 (below)
Maurice Brazil Prendergast,
Summer Day, 1901, color
monotype with pencil
additions, 28.4 × 34.9 cm
(11³⁄₁₆ × 13¾ in.).

Terra Foundation for the Arts,
Daniel J. Terra Collection,
1992.109. Photograph ©1996
Courtesy of Terra Museum of
American Art

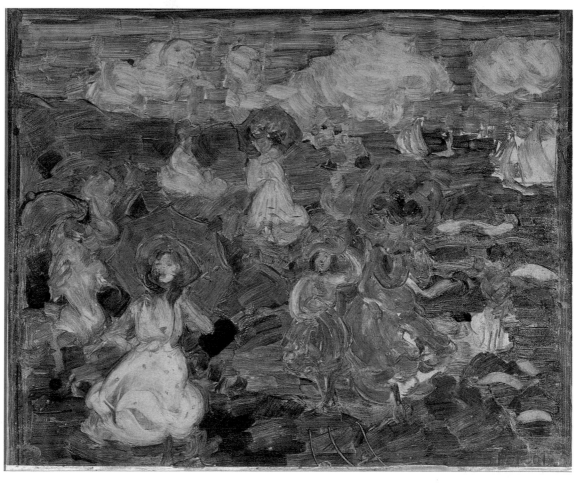

work had most in common with the American Impressionists and Post-Impressionists, few of whom made monotypes. He participated in the landmark exhibition of The Eight at the Macbeth Galleries in 1908, but this association was based less on stylistic affinity than on a previous relationship with the gallery and friendship with several of the artists.[14]

Albert Sterner and Eugene Higgins

The monotype particularly attracted artists involved in both painting and printmaking, many of whom supported themselves by working as illustrators. Like many artists of his generation, Albert Sterner began his career as an illustrator. In the mid-1880s he studied briefly at the Académie Julian and the Ecole des Beaux-Arts in Paris, returning there around 1890 and settling into a studio of his own. Having spent part of his childhood in Belgium, Sterner spoke French fluently and was able to socialize with both French and American artists. His first contribution to the Salon in 1891 brought the painting an honorable mention and considerable publicity. Having worked for a short time with the Chicago lithographers Shober and Carqueville in the early 1880s, Sterner began making a few lithographs in Paris at Lemercier's. Briefly returning to the United States, he won a competition to illustrate a new ediition of George William Curtis's book *Prue and I,* a critical success that allowed him to return to Paris with a handsome sum of money and the prospect of future royalties.

Sterner's first public exhibition was held at Keppel's New York gallery in 1894, and his entry for the Water Color Society's exhibition that year was hailed as "one of the gems of the exhibition." However, his critical reception was not entirely positive. In the foreword to the Keppel catalogue, W. Lewis Fraser remarked that "he still tries to do things which puzzle the critics and render them unhappy." In 1895 Sterner visited France, Germany, Italy, and England. One of his paintings won a gold medal at the International Ausstellung at the Glaspalast in Munich. Sterner, whose father was German, had spent part of his youth working as an apprentice in Germany and felt at ease with the language and culture. He took up lithography in Munich with the firm of Klein and Volbert, where he was introduced to color printing. His lithographs were purchased by the Alte Pinakothek in Munich and the Kupferstich Kabinet of the Royal Collection in Dresden. On a trip to London, he met the writer Israel Zangwill, one of the group with whom Sterner later made monotypes at the studio of Herbert Waldron Faulkner in Paris.

When Sterner returned to the United States at the turn of the century, he was one of the founders of the short-lived New York Monotype Club. By 1910 he had produced approximately fifty finished monotypes and numerous experimental studies in both monochrome and color. Although he continued to work as an illustrator, he exhibited widely, emphasizing portrait drawings. In 1911 Sterner showed his lithographs and monotypes at the Berlin Photographic Society in New York, whose director, Martin Birnbaum, championed some of the younger and more forward-looking artists of the day.[15] This show featured twenty lithographs, twenty-three monotypes, and ten drawings. Sterner received favorable attention for his lithographs and drawings, but the monotypes were taken somewhat less seriously. In response to an exhibition of Sterner's work at the Brooks Reed Gallery in Boston, F. W. Coburn of the *Boston Herald* characterized his "monkeying with monotypes" as a "process of vast interest to the curious and semi-curious soul."[16]

After these two exhibitions, Sterner began to do more work with pastel, leading to his first exhibition in this medium at Knoedler's Gallery in New York in 1915. Large-scale portraits pre-

dominated, many of them carried to a high degree of finish reminiscent of the eighteenth-century style in France. Sterner made his reputation as a painter of society portraits, but the scope of his subject matter in prints, drawings, and watercolors reveals a much more versatile artist. Central to all his work was the human figure, ranging from idealized nudes in a landscape to scenes with literary, symbolic, or biblical references.

Because Sterner dated very few of his monotypes, it is impossible to trace his stylistic or technical development in the medium. Two compositions of idyllic nudes in a landscape, which appear to have been done around the same time, were, in fact, made twenty years apart (figs. 45 and 46). Both reveal a very painterly approach to the medium, created primarily by the light-field method of painting the image on the plate. Sterner's monotypes are remarkable for their delicate equilibrium of spontaneity and control, evident in his application of color and modeling of form. Even in a work such as *Woman with Mask* (fig. 47), in which his free, expressive application and wiping of paint brought him as close to abstraction as he ever got, the sense of a master craftsman in total control of his medium is revealed.

Sterner worked on zinc because its whiteness allowed him to judge the quality of the color harmonies as they would appear on the paper. First he oiled his plate lightly, removing the superfluous oil with a rag. Then he covered the plate with a soft, underlying tone into which he painted the forms in color. Adding highlights and textures with finger, brush, stump, or rag, Sterner sometimes created his image in a matter of minutes, but at other times he worked on a single composition for several days. In order to extend the drying time of the paint, he immersed the plate in water each night.

Although he had won his earliest recognition as a painter, especially of portraits, Sterner made much of his art on paper, including watercolors, lithographs, pastels, monotypes, etchings, and drawings in red chalk (sanguines), charcoal, and pen and ink. On occasion he painted murals and designed for stained glass. He believed that mastery of technique left the artist free to create and to select the medium most appropriate for a particular work of art. Sterner did not subscribe to the traditional hierarchy of media that placed oil painting above the graphic arts. In 1915 he invited a group of artists to his studio to discuss the formation of a society of artists working in the graphic arts, which led to the founding of the Painter-Gravers of America. According to his biographer, Ralph Flint, Sterner was one of the earliest artists to recognize the potential of the film as a major art form. Although his work remained stylistically anchored in the conservative traditions of his time, Sterner's open-minded attitude reveals a more independent mind than his traditional imagery would suggest.

Eugene Higgins was another artist who probably had his first experience with etchings and monotypes as a student in Paris. He studied at the Académie Julian in 1897–98 and was admitted to the Ecole des Beaux-Arts in late 1899. He exhibited at the American Art Association and the Paris Salon in the early 1900s. Although Higgins made monotypes from the early twentieth century until at least the mid-1940s, few of them are dated, so it is impossible to trace stylistic or technical development with any certainty. The subjects of his monotypes closely parallel those of his paintings, but one medium was not used directly as the model for the other. Inspired by the work of Rembrandt and the Barbizon painters, especially Millet, Higgins depicted poor people, the downtrodden, the dispossessed, people at the margins of polite society, whom he portrayed with dignity and sympathy, often with moral or religious overtones. Higgins first gained recognition as a printmaker, and as early as 1907, his work was compared favorably to the literary accomplishments of Victor Hugo and Maxim Gorky.[17]

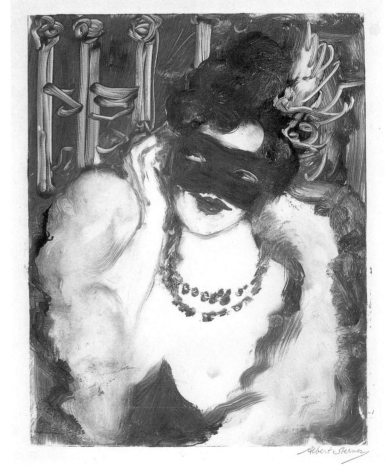

Fig. 45 (above)
Albert Sterner, *Nude in a Landscape,* 1911, color monotype, 50 × 29.8 cm (19¹¹⁄₁₆ × 11¾ in.).

The Metropolitan Museum of Art, Purchase, Anne Stern Gift, 1977. ©1979 The Metropolitan Museum of Art

Fig. 46 (above, right)
Albert Sterner, *The Bathers,* 1931, color monotype, 37.9 × 30.2 cm (14¹⁵⁄₁₆ × 11⅞ in.).

National Museum of American Art, Smithsonian Institution

Fig. 47 (right)
Albert Sterner, *Woman with Mask,* n.d., color monotype, 35.7 × 28 cm. (14¹⁄₁₆ × 11 in.).

Gift of Arthur Wiesenberger, Courtesy, Museum of Fine Arts, Boston

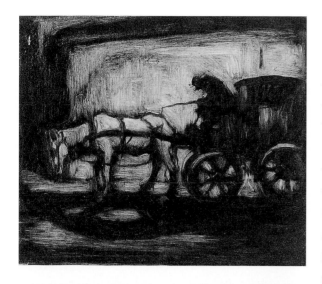

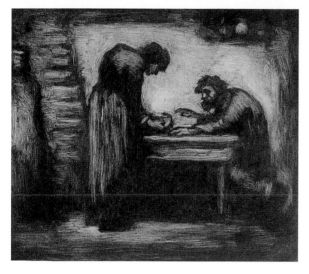

Fig. 48 (top)
Eugene Higgins, *Horse and Cab (The Tired Hack)* 1909, monotype, 12.5 × 15.1 cm (4¹⁵⁄₁₆ × 5¹⁵⁄₁₆ in.).

The Metropolitan Museum of Art, The Alfred Stieglitz Collection, 1949. All rights reserved, The Metropolitan Museum of Art

Fig. 49 (below)
Eugene Higgins, *Couple at Supper,* ca. 1910, monotype in green ink, 12.3 × 15.1 cm (4¹⁵⁄₁₆ × 5¹⁵⁄₁₆ in.).

Cooper-Hewitt, National Design Museum, Smithsonian Institution, Gift of Mrs. Alpheus Cole

In 1909 Higgins exhibited thirty monotypes and drawings at Alfred Stieglitz's Little Galleries of the Photo-Secession (known as "291"), making no distinction between the two media in the catalogue. Although he gave titles to his monotypes, it is often difficult to match a work with a specific title, further complicating efforts to date them. The only work that was surely in this exhibition is *Horse and Cab (The Tired Hack)* (fig. 48), a small monochrome image mounted on a sheet that served as the exhibition placard.[18] The stooped driver and his weary horse emerge from the shadows of a dark street as solid, monumental forms silhouetted against an artificially lit background created by deft and sensitive wiping of the plate. Because Stieglitz is best known for his championing of photography as an art form and his support of European modernism, this moody scene seems an incongruous choice for an exhibition in his gallery, let alone the placard announcing the show. The answer lies in the January 1910 issue of Stieglitz's magazine *Camera Work*: "His [Higgins's] interest lies mostly in the silhouettes of figures moving or resting in dim lighted streets or interiors, his composition being one of spotting, of the play of dark and light masses, and some of his monotypes have all the rich quality of a good platinum print."[19]

There is no indication that Higgins consciously sought this effect, but it does suggest that his earliest works were executed in monochrome black ink, and that small monochrome works such as *Couple at Supper* (fig. 49) may also date from the early 1900s. The massiveness of his forms recalls the solidity of sculpture, an inclination he attributed to the influence of his father, a stonecutter, as well as Michelangelo, his father's hero: "These men, Millet and Michelangelo," stated Higgins, "have influenced me more than all the years spent in the Paris ateliers; through them I learned poise and solidity and strength and sureness."[20]

In 1912 the Corcoran Gallery of Art in Washington, D.C., presented a special exhibition of Higgins's monotypes. In later exhibitions they were included alongside his paintings, watercolors, and etchings. By 1917 he had begun to make monotypes in color and in a larger format (fig. 50). He did not hesitate to reinforce the outlines of his bold, simplified forms with pen and ink or to add color to the surface of his monotype impressions to achieve the desired effect. In some monotypes the additions are minimal, but in others he appears to have used the printed composition almost as an initial sketch, which was then reworked with ink and watercolor additions. In *A Hold Up* (fig. 51), Higgins apparently first printed the image as a monotype, using black and brown ink or paint, then added to the impression areas of green, blue, red, red-brown, and yellow watercolor. Finally he reinforced the contours of the figures and other details with a brush and black and brown watercolor.[21]

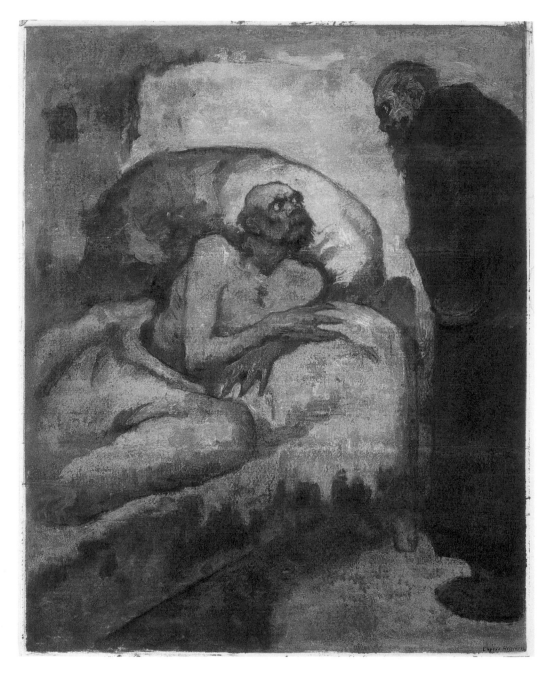

Fig. 50 (left)
Eugene Higgins, *The Pauper and the Quack*, 1917, color monotype, 45 × 36.3 cm (17¾ × 14¼ in.).
Courtesy of the Fogg Art Museum, Harvard University Art Museums, Gift of James N. Rosenberg

Fig. 51 (below)
Eugene Higgins, *A Hold Up*, n.d., color monotype with watercolor additions, 20.6 × 40.8 cm (8⅛ × 16 1/16 in.).
Courtesy of the Boston Public Library, Print Department

Because Higgins dated so few of his monotypes and, like Sterner's, very few of them can be identified with titles in exhibition catalogues, it is impossible to discern a definite stylistic or technical development during the more than forty years he was active in this medium. *A Hold Up* and numerous other monotypes depicting covered wagons and other subjects of the old West probably date from 1932–33, when he executed two murals representing the westward movement for post offices in Tennessee and Wisconsin. *Adrift—Washed Ashore* (fig. 52) refers to experiences during his childhood and youth in St. Louis, where he witnessed the destruction caused by floods along the Mississippi River—uprooted trees, dead livestock and people, barns afloat, survivors clinging helplessly to the wreckage of houses and furniture. He depicted such scenes in his first paintings and returned to the theme throughout his career; this monotype was probably done from memory decades after he witnessed a similar scene. Toward the end of his life many works had religious themes, including a commissioned series of monotypes based on the life of Christ. However, *The Juggler of Notre Dame* (fig. 53)—a subject based on a legend of the Virgin Mary, in which a tumbler or juggler was rewarded with a smile when he performed before the

Fig. 52 (above)

Eugene Higgins, *Adrift— Washed Ashore,* n.d., color monotype, 36.4 × 26.8 cm (14⁵⁄₁₆ × 10⁹⁄₁₆ in.).

Gift of L. Aaron Lebowich, Courtesy, Museum of Fine Arts, Boston

Fig. 53 (right)

Eugene Higgins, *The Juggler of Notre Dame,* ca. 1925, monotype, 40.4 × 30.6 cm (15⁷⁄₈ × 12 in.).

Cooper-Hewitt, National Design Museum, Smithsonian Institution, Gift of Mrs. Alpheus Cole

Virgin's statue—is not necessarily a late work, since the subject might also refer to Victor Hugo's *Les Miserables,* a novel that influenced Higgins so greatly in his career that he regarded himself as a personification of Jean Valjean.[22] Although Higgins often had specific incidents in mind, he rarely included details that tied a scene too closely to a specific source, preferring to transform a specific reference into a more generalized event that carried a more universal meaning. Well into the twentieth century, Eugene Higgins adhered to the Romantic ideals of such artists as Millet and Victor Hugo, using the monotype as one of the many techniques with which he expressed his visions and captured his memories.

The Eight

If the subjects of Albert Sterner and Eugene Higgins seem rooted in late-nineteenth-century Romanticism, a group of their contemporaries found their subject matter in scenes from everyday life. Referred to as The Eight after their landmark exhibition at the Macbeth Galleries in New York in 1908, most of these artists had started their careers in newspaper illustration or commercial art and were therefore used to making quick, spontaneous sketches.[23] All of them made monotypes at one time or another, although Maurice Prendergast's monotypes stand out as the most extensive and accomplished body of work in this medium by members of this group.

Stylistically and technically, Arthur B. Davies's monotypes most closely approximate those of Prendergast. He was perhaps introduced to the medium as early as 1883, when he studied at the School of the Art Institute of Chicago with Charles Abel Corwin, who had made monotypes with the Duveneck circle in Venice. However, the four monotypes by Davies that have been identified were all made in color and printed by hand, suggesting the influence of Prendergast.[24] Although additional monotypes by Davies may come to light, it is clear that his commitment to the medium was superficial compared with his interest in other printmaking techniques.

Similarly, Ernest Lawson produced a small body of color monotypes, but they are even further removed from Prendergast's approach. In *Landscape: Mountains* (fig. 54), the oil paint appears to have been applied to the plate with a palette knife, with forms created by scraping color from the plate. In some areas, such as the horizontal strokes of the water, scraping seems to have been used after printing as well. Unlike other members of The Eight, Lawson rarely worked on paper, and his method of applying paint to the plate is much like his approach to painting on canvas. Although he attended the Académie Julian in Paris in 1893 and possibly saw monotypes by his artist friends, his own monotypes appear to date from 1919–20, when he spent time in the mountains of New Hampshire and in Nova Scotia.[25] Only six of his monotypes have been located, most of them mountain landscapes, suggesting they were made around the same time.[26]

Everett Shinn, on the other hand, approached the monotype as an artist who had worked primarily in pastel. Only two of his monotypes have been located, and both were done in conjunction with pastel. Shinn referred to them as pastel monotypes, and one of them, *Circus* (Metropolitan Museum of Art), is a pastel over black monotype, a combination similar to Degas's work in this medium. The subject and composition of his other monotype, *Nude Getting into Bath* (fig. 55), are strongly reminiscent of Degas (fig. 5), but the technique is different and appears to be the result of Shinn's experimentation with pastel. Rather than adding pastel

Fig. 54 (opposite, above) Ernest Lawson, *Landscape: Mountains,* 1919–20, color monotype, 20.3 × 32.4 cm (8 × 12¾ in.).

Des Moines Art Center Permanent Collections, Truby Kelly Kirsch Memorial Fund, 1954.4

Fig. 55 (opposite, below) Everett Shinn, *Nude Getting into Bath,* ca. 1910, color monotype, 23.4 × 31.2 cm (9¼ × 12¼ in. sheet).

National Museum of American Art, Smithsonian Institution

to the surface of the printed image, he apparently transferred the pastel from another surface. Henri Pène du Bois's review describing the process does little to clarify the procedure he used: "Everett Shinn obtains in monotypes the most beautiful tones imaginable. He presses on pastels, which he has painted, tissue paper, and it takes their lines and colors with a refinement of values inaccessible at first. These are tints at which a painter of Degas's temperament would work in vain. The pastel has gained by its transfer delicacy and mystery."[27]

The reviewer is probably referring to Shinn's unusual method of working in pastel. After soaking a heavily mounted paper in water, he removed the water with his hand or a sponge. With the final composition in mind, he began applying patches of color with pastel, which immediately turned to a dark tone on the wet surface. Working quickly while the paper remained wet, the artist completed the composition. As the paper dried, the original color of the pastels returned, but unlike the usual, dustlike surface of a pastel, the evaporation of the water caused the pigment to dry hard, producing a more intense color with the hardness of tempera. Although Shinn learned to control this process, he warned others that "an awful lot that's unexpected can happen when you're puddling around on that wet ground with color that you can't see a few seconds after you've put it down."[28]

To make his monotypes, Shinn probably placed paper over the still-wet pastel composition and transferred the image through pressure. It is not known whether he used a press or printed by hand, but in either case there would be no plate mark, since Shinn was printing from a paper surface. This unusual method explains the peculiar texture of *Nude Getting into Bath*, which appears to have been printed from a granular surface. Shinn's pastel technique has much in common with making a monotype. In essence, he transformed the pastel from a dry to a wet medium that needed to be worked quickly, introducing an element of chance into the process. It is possible that he invented this unusual method of working with pastel after seeing monotypes being made.

The subject and composition of *Nude Getting into Bath,* as well as the technique of pastel over monotype in *Circus,* are strongly reminiscent of Degas's monotypes, suggesting that Shinn was familiar with these works.[29] However, it is not clear where he might have seen Degas's monotypes, since he rarely exhibited them. If Shinn had access to Degas's monotypes, it was most likely at the Goupil Gallery in Paris, where he exhibited some of his own pastels in July 1900 during his first trip abroad. In February of that year Shinn had shown more than forty pastels at the Boussod, Valadon Gallery in New York. With the American taste for pastels at its height, the exhibition was reviewed in thirteen newspapers in New York, Philadelphia, and Pittsburgh, and most reviews were favorable. The cover of Shinn's exhibition catalogue at Boussod, Valadon indicates that the gallery was associated with Goupil and Company of Paris, a relationship that explains how Shinn was able to show at Goupil's so soon after his arrival. There is no record that Shinn ever met Degas, but it is clear in his works of the early 1900s that Degas's monotypes and pastels had a major impact on the young artist and were probably the direct inspiration for his own brief experimentation with monotype.

William Glackens, George Luks, and Robert Henri apparently had limited interest in the monotype, although each tried the medium at least once in his career. Only one monotype by Glackens has been located, *Three Figures at a Table* (fig. 56), and judging by the ages of his two children depicted in the family group, it was probably done in 1916–18.[30] Employing a full range of color, Glackens seems to have regarded the monotype as a form of painting rather than printmaking.

Fig. 56 (opposite) William Glackens, *Three Figures at a Table,* 1916–18, color monotype, 26 × 20.3 cm (10¼ × 8 in.). Belmont, The Gari Melchers Estate and Memorial Gallery, Mary Washington College, Fredericksburg, Va.

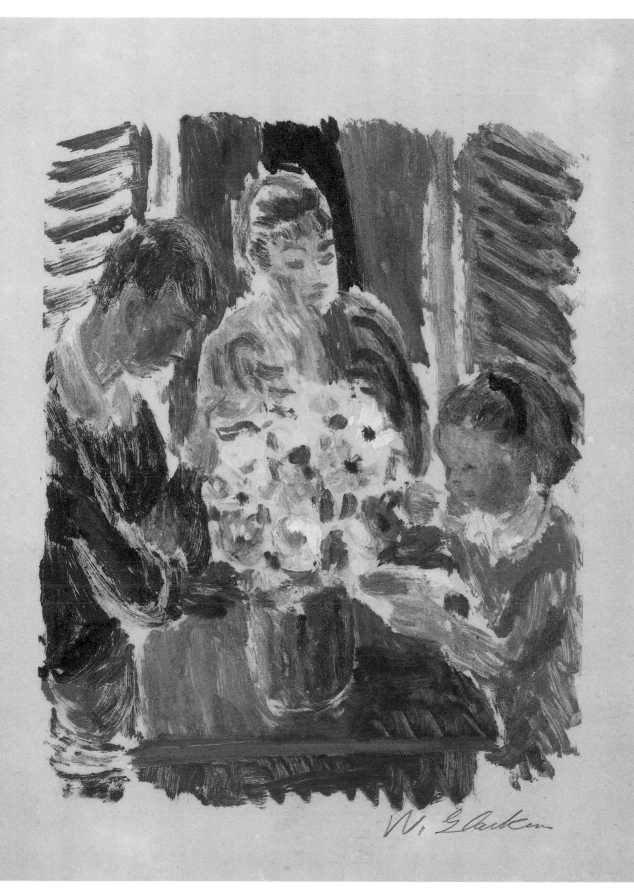

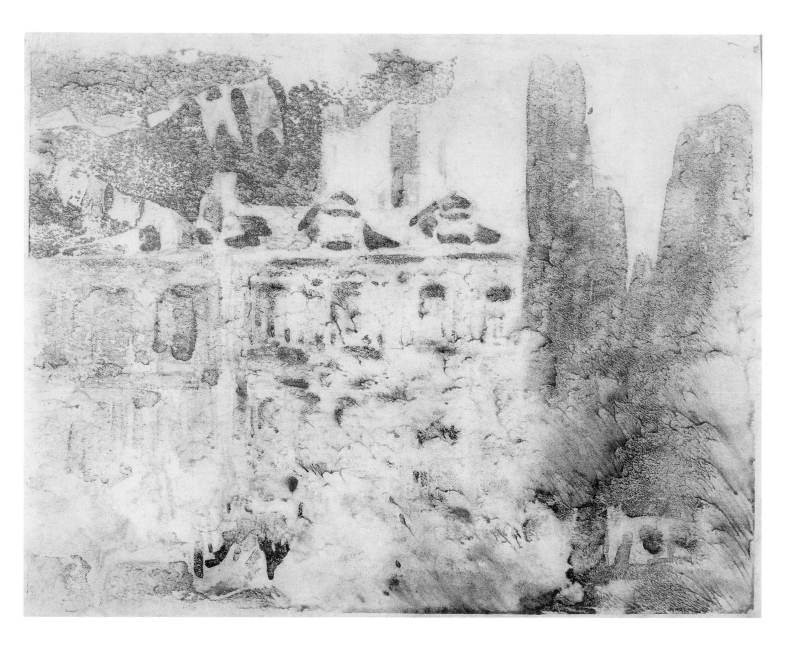

Fig. 57 (above)
George Luks, *City Scene,*
n.d., color monotype,
21.5 × 28 cm
(8½ × 11¹⁄₁₆ in. sheet).
National Museum of American
Art, Smithsonian Institution, Gift
of Mr. and Mrs. Jacob Kainen

Fig. 58 (opposite, left)
George Luks, *Cake Walk,*
ca. 1907, monotype,
12.7 × 17.8 cm (5 × 7 in.).
Delaware Art Museum, Gift of
Helen Farr Sloan

Fig. 59 (opposite, right)
Robert Henri, *Street Scene,*
1898, monotype, 15.6
× 17.8 cm (6³⁄₁₆ × 7 in.).
Lee M. Friedman Fund, Courtesy,
Museum of Fine Arts, Boston

Luks presumably experimented with monotype somewhat more extensively, judging by the very different approaches he took in two monotypes. His *City Scene* (fig. 57) takes advantage of the unusual textures and softened edges of paint transferred from one surface to another to create an atmospheric scene of translucent blues and purples. Combining specific details, such as laundry hanging on a line and dormer windows on a rooftop, with large areas of abstracted forms and textures, Luks appears to be exploring the possibilities of the medium. The delicate, impressionistic cityscape gives no indication of Luks's background as an illustrator, while another of his monotypes, *Cake Walk* (fig. 58), reveals the sure draftsmanship and expressive line of an experienced illustrator. Carefully placing the figures asymmetrically on the sheet as if they were about to strut off the edge, Luks reinforced their dynamism through his free and spontaneous handling of the medium. Using a dry, black ink, he wiped and scratched it away from the surface of the plate to create an image in line and tone at once boldly graphic and subtly atmospheric.

Inspired by the monotypes of his friend Augustus Koopman, Henri made his first monotypes in Paris in 1898, including a promenade along the Seine and a street scene at night (fig. 59). The latter monotype is very similar in size to that of many of his oil on wood panel paintings (*pochades*) of Paris street scenes done at the same time. Although the scene recalls several in Prendergast's monotypes, Henri's choice of brown ink and his reliance on the tip of the brush to incise white lines in the ink surface to create forms, reflections, and shadows are very different from Prendergast's colors and his selective use of white line for highlights and outlines. Although the two artists became friends after Henri returned from Paris in 1900, they were not acquainted in 1898, and Henri almost certainly had not yet seen Prendergast's monotypes.

Henri appears to have taken up the monotype again in 1907 in the company of John Sloan, who recorded in his diary on 7 April 1907 that Henri had come to dinner and they "had a little monotype fun with the etching press."[31] One of Henri's monotypes, *Nude in*

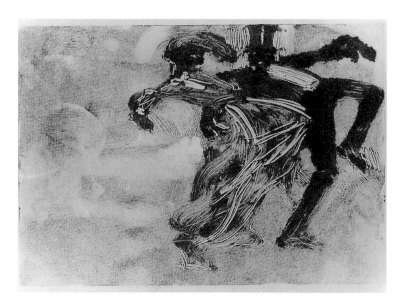

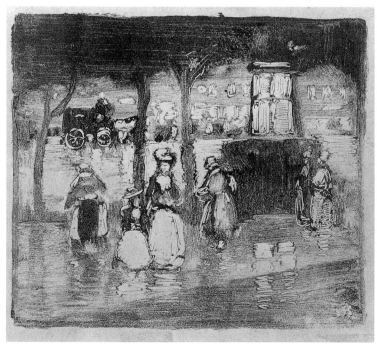

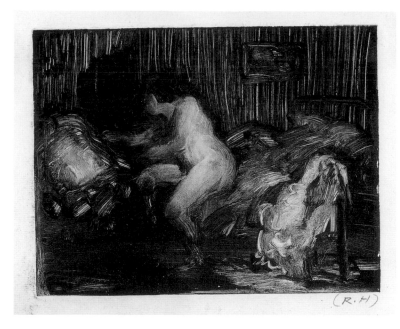

Fig. 60 (left)
Robert Henri, *Nude in Interior,* 1907, monotype, 13.3 × 17.8 cm (5¼ × 7 in.).
Los Angeles County Museum of Art, Graphic Arts Council, M.76.105

Fig. 61 (middle)
Robert Henri, *Satyr and Nymph,* 1907, monotype, 13.3 × 17.6 cm (5¼ × 6¹⁵⁄₁₆ in.).
Delaware Art Museum, Gift of Helen Farr Sloan

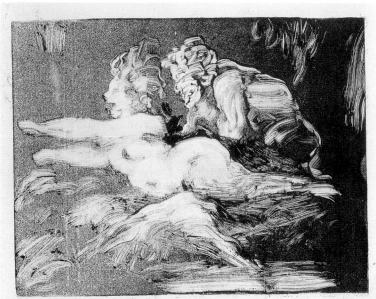

Fig. 62 (below)
John Sloan, *A Band in the Backyard,* 1907, monotype, 13.7 × 17.5 cm (5⅜ × 6⅞ in.).
Terra Foundation for the Arts, Daniel J. Terra Collection, 1987.30. Photograph ©1996 Courtesy Terra Museum of American Art

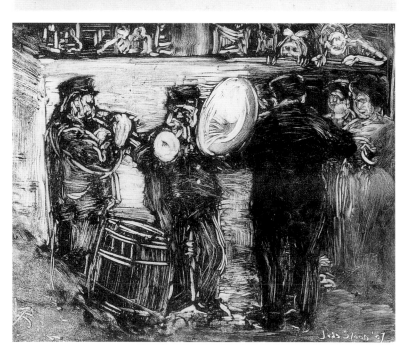

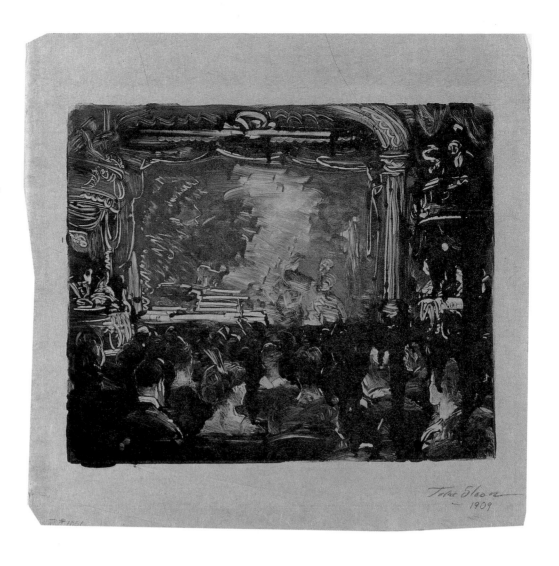

Fig. 63

John Sloan, *The Theater*, 1909, monotype in black and green ink, 19.1 × 22.8 cm. (7½ × 9 in.).

©1996 The Cleveland Museum of Art, Gift of Mr. and Mrs. Ralph L. Wilson, in memory of Anna Elizabeth Wilson, 1961.162

Interior (fig. 60), is dated 18 March 1907, suggesting that the two artists made monotypes in Sloan's studio on numerous occasions, at times with other artist friends present.[32] Henri's *Satyr and Nymph* (fig. 61) reveals a playful attitude rarely seen in his paintings, reflecting the leisurely atmosphere in which the monotypes were made.

Other than Prendergast, Sloan was the only member of The Eight to make a significant body of monotypes over a period of several years. Although he began making monotypes for fun, he experimented with the medium's possibilities for creative expression over a period of at least nine years, executing some of his most intriguing and sensitive images in monotypes.[33] Most of them are not dated, but the few that are suggest a gradual change in his approach to the medium. The earliest, dated 1907, *A Band in the Backyard* (fig. 62), shows Sloan creating the image almost entirely by line, almost as if he were drawing into the ground on the surface of a copper plate. In *The Theater* (fig. 63), he continued to work primarily with line but began to wipe away broader areas of ink with a cloth and his fingers. Recognizing the potential for working in color, he depicted the brightly lit stage with green ink that contrasts dramatically with the darkened theater. He experimented with inks of different colors, but none of his monotypes, among the twenty-four that have been located, use more than two colors in a single image. His use of hatched lines, as well as wiping, to create middle tones in several monotypes probably made between 1910 and 1914 offers evidence of Sloan's experience as an etcher.

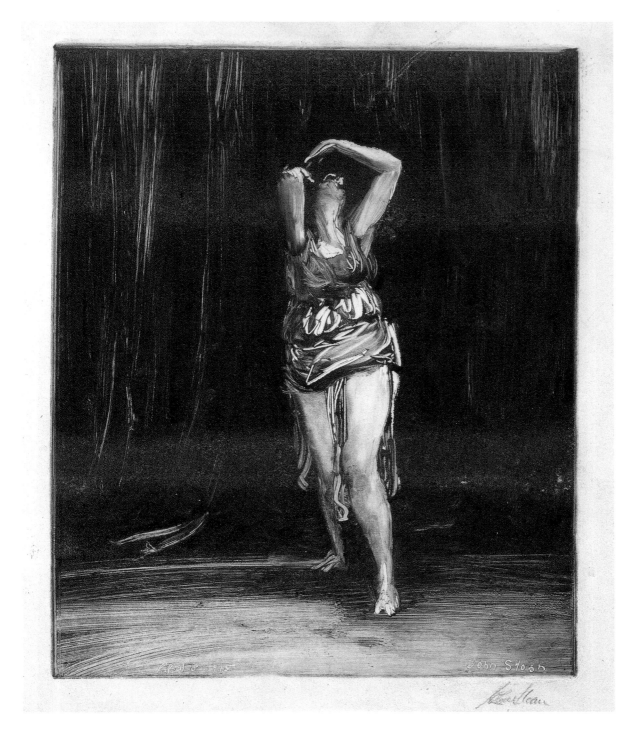

Fig. 64 (left)
John Sloan, *Isadora Duncan*, 1915, monotype, 22.2 × 18.4 cm (8¾ × 7¼ in.).

Des Moines Art Center Permanent Collections, Gift of Dwight Kirsch to the Truby Kelly Kirsch Memorial Collection, 1954.36

Fig. 65 (opposite)
John Sloan, *Nude and Cat,* possibly 1907, monotype, 13.7 × 17.8 cm (5⅜ × 7 in.).

Delaware Art Museum, Gift of Helen Farr Sloan

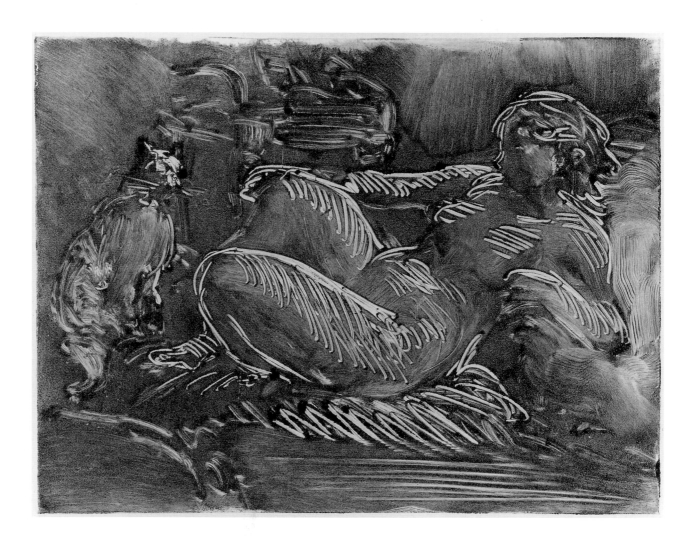

By 1915 Sloan fully realized the painterly possibilities of manipulating the wet ink to suggest mood and expressive gesture without relying on line at all. He painted and etched Isadora Duncan on several occasions, but his three monotypes of the famous dancer made in 1915 are surely his most expressive depictions of the freedom and spontaneity that characterized her uninhibited style of dance, as well as the possibilities of the monotype process (fig. 64). In the monotype Sloan found the perfect medium to express the earthiness and vitality of the dancer's bold movements and defiance of conventional taste.

Sloan's *Nude and Cat* (fig. 65) was printed from a plate the same size as Henri's *Nude in Interior* and perhaps was made at the same informal evening gathering. The very simple linear image drawn in the ink indicates that this was one of Sloan's earliest monotypes, executed before he recognized the medium's possibilities for tonal variation and modeling. This quick sketch is possibly a reference to Manet's *Olympia,* a notorious painting admired by realists such as Henri and Sloan. Just as Manet's painting of a prostitute looking directly at the viewer had been castigated for being too frank and confrontational, two of Sloan's etchings from his *New York City Life* series had just been rejected by the American Watercolor Society for its 1906 exhibition on the grounds that they were "vulgar" and "indecent," although they were well received by the press. When nudes later reappeared in his paintings and etchings, they were more formal and decorous, but in his monotypes, which were more personal and intimate, Sloan continued to explore nude subjects with greater freedom. He created several

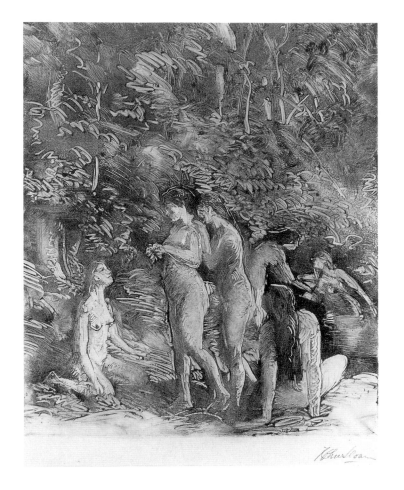

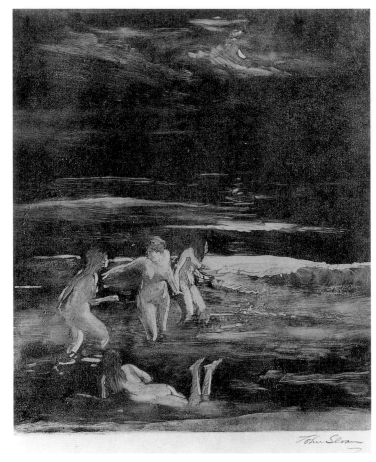

Fig. 66 (above)
John Sloan, *Bathers,* ca.
1910, monotype in purple-
brown ink, 22.7 × 18.7 cm
(8¹⁵⁄₁₆ × 7⅜ in.).

National Museum of American
Art, Smithsonian Institution,
Museum purchase in memory of
Allen Tucker

Fig. 67 (above, right)
John Sloan, *Bathers
(Bathers at Seashore),*
ca. 1915, monotype,
25.1 × 18.7 cm
(9⅞ × 7⅜ in.).

Delaware Art Museum, Gift of
Helen Farr Sloan

scenes of bathers, ranging from a formal Cézannesque composition (fig. 66) to a lyrical scene of nymphs at play in the moonlight (fig. 67) to a nude man and voluptuous woman frolicking in the waves (fig. 68).[34] Henri had always emphasized the importance of executing an image quickly, and when Sloan reminisced about his friend and mentor, he recalled how liberating this attitude was "from the stuffy studio concoctions of the academic limitation of the eye-sight painters."[35]

Several of Sloan's compositions with female subjects recall the intimacy of Degas's mono-types, both in his choice of pose and more subtle manipulation of the ink. In *Bath* (fig. 69), for example, the diagonal of the tub and the view from above suggest Degas's portrayals of women bathing, while Sloan's modeling of the flesh with wiping, hatched lines, and finger-prints reveals a much more sophisticated understanding of the monotype's possibilities. Of special interest in this image is the care with which he distinguished those parts of the figure submerged in water, incising lines to suggest water behind the figure and blurring the ex-tended right leg with fingerprints to contrast with the foot protruding from the water. He included just enough details to make the scene concrete and specific: a pattern of tiles on the wall, wainscoting above the tiles, a faucet, and a claw-foot tub. Similarly, in another image of a woman grooming herself (fig. 70), Sloan composed the scene with just enough details— a basin and faucet, a mirror, a gaslight, and the suggestion of lace on the model's strap—to convey a sense of concrete reality while at the same time retaining the sense of spontaneity he found so appealing. Although Sloan began to exhibit some of his monotypes in 1916 at the Whitney Studio Club and the Hudson Guild, he did not show a nude subject until 1919, when *Bath* was included in an exhibition at the Ehrich Print Gallery in New York.

The subjects of many of Sloan's monotypes are directly related to those of his paintings and etchings, but in no instance are they copies of other compositions. *A Band in the Back-yard* (fig. 62), *McSorley's* (fig. 71), *On the Roof* (fig. 72), and *Woman Drying Her Hair* (fig. 73) depict scenes of everyday life in Sloan's own neighborhood. The view of Greenwich

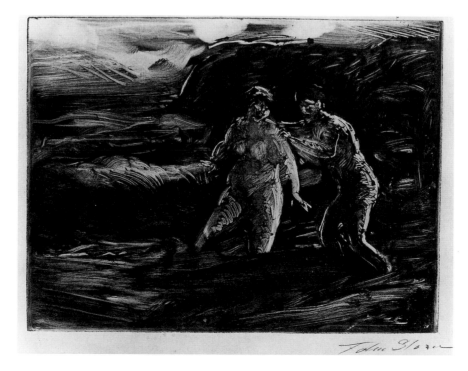

Fig. 68

John Sloan, *Adam and Eve,*
ca. 1907, monotype,
13.3 × 17.8 cm (5 ¼ × 7 in.).
Kraushaar Galleries, New York

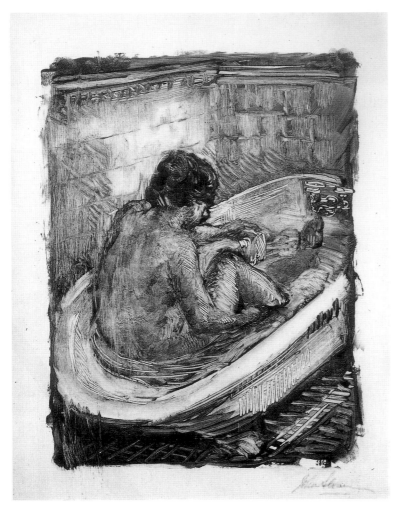

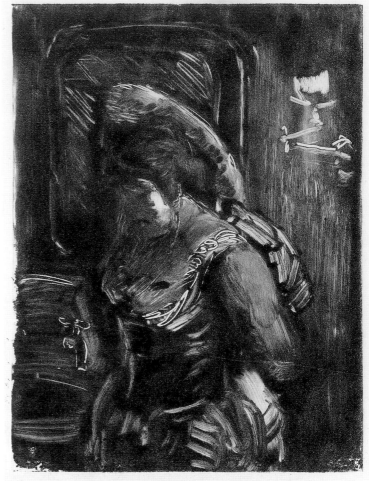

Fig. 69 (above, left)
John Sloan, *Bath,* ca. 1915,
monotype, 28.9 × 21.6 cm
(11⅜ × 8½ in.).

Ailsa Mellon Bruce Fund, ©1996
Board of Trustees, National
Gallery of Art, Washington

Fig. 70 (above, right)
John Sloan, *Dressing by
Gaslight,* ca. 1907,
monotype, 17.8 × 13.3 cm
(7 × 5¼ in.).

Private collection

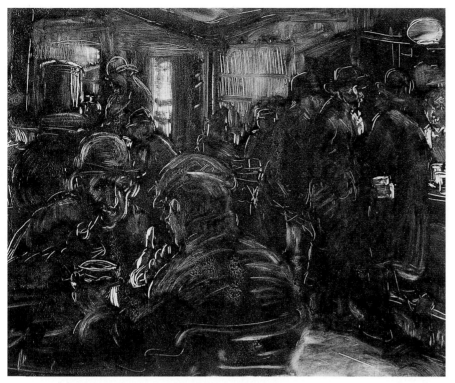

Fig. 71 (left)
John Sloan, *McSorley's*,
ca. 1915, monotype,
20.2 × 25.1 cm (8 × 9 ⅞ in.).
Gift of Frank and Jeannette Eyerly,
©1996 Board of Trustees, National
Gallery of Art, Washington

Fig. 72 (below, left)
John Sloan, *On the Roof*,
1910–15, monotype,
22 × 14.6 cm (8 ⅝ × 5 ¾
in.).
Amon Carter Museum, Fort
Worth, 1982.48

Fig. 73 (below, right)
John Sloan, *Woman Drying
Her Hair,* ca. 1915,
monotype, 22.2 × 16.8 cm
(8 ¾ × 6 ⅝ in.).
Gary and Brenda Ruttenberg

Fig. 74
George Overbury "Pop"
Hart, *The Brook,* 1926,
color monoprint with
etching and softground,
30 × 22.7 cm
($11^{13}/_{16}$ × $8^{15}/_{16}$ in.).
The Brooklyn Museum, Museum
Collection Fund

Village in *Woman Drying Her Hair* is what Sloan saw from his studio window on Washington Place at Sixth Avenue, where he moved in 1914.

The Modernists and Their Contemporaries

Aware of the hybrid nature of the monotype, few artists saw it as a totally independent medium, and many of them used it in conjunction with other printmaking or drawing techniques. George O. "Pop" Hart turned to monotype as a method of adding color and tone to his prints. He began making prints in 1924, drawing directly on a metal plate with a sharp instrument to create a drypoint image. A simple, direct method of making an image, the drypoint does not require knowledge of special ground or acids. The soft, velvety line made by the sharp instrument dragging through the metal surface appealed to Hart, who gradually began to explore other methods of adding tone to his images. At first he tried dense hatching and light wiping to leave an overall tone on the plate, but he soon was using finely grained sandpaper to create a subtle range of tones. He then expanded his technical repertoire to include lines made with a roulette, a revolving wheel with sharp points that leaves a track of dots on the plate resembling the texture of a pastel or chalk drawing.

Eager to learn other intaglio printmaking techniques, Hart studied prints at the New York Public Library under the tutelage of Frank Weitenkampf, curator of the print collection and a noted specialist in the field. Hart experimented with soft-ground etching, a technique that produces a lighter and grainier line than traditional etching. He often combined the drypoint and soft-ground techniques and printed images in pastel tinted inks. In order to obtain a broader range of tonalities, he experimented with aquatint, which allowed him to print broad areas of tone. He varied their texture by using both coarse and fine rosin dust to create the aquatint surface. By varying the amount of time the plate was left in the acid, he could control the tone of the aquatint areas from dense black to delicate grays that could suggest watercolor washes. He combined all these intaglio techniques freely on a single plate in order to achieve a more painterly quality in his prints. In *The Brook* (fig. 74) he exploited the sensuous qualities of etching, soft-ground etching, aquatint, and monotype to create an image with a distinctive character that could not have been achieved with a single printmaking technique.

Hart's painterly approach to printmaking indicates that he considered it to be an extension of his work in watercolor, drawing, and painting rather than a separate endeavor. By using monotype inking on an intaglio plate, he was able to vary his colors in every impression, allowing him the freedom to explore the possibilities of a composition without having to redraw the basic composition. Each proof is unique because of the monotype inking but is also part of a varied edition.

Hart's approach to printmaking is essentially a bold extension of the preference for variable inking that characterized so much American etching during the last two decades of the nineteenth century. This tendency continued into the early twentieth century, but many second-generation disciples of the etching revival regarded the fresh conceptions and experimental methods of Whistler and his contemporaries as being overly refined and formulaic. Many of the younger generation of artists, including "Pop" Hart, Max Weber, John Sloan, Edward Hopper, Arthur B. Davies, Abraham Walkowitz, and John Marin, rejected the regressive practices of the etching revival, as well as traditional attitudes toward subject matter, style, and technique. Rather than seeking intricate technical effects such as *retroussage,* these artists took a much bolder and more individualistic approach to printmaking, sometimes employing

unusual combinations of techniques. Many of them tried the monotype or a monoprint variation, but few of them made a significant body of work in the medium.

Many artists who studied with William Merritt Chase tried monotypes, including Edward Hopper, Gifford Beal, and Joseph Stella. Using the monotype as a teaching device to illustrate the principles of composition and to encourage spontaneity, Chase approached the monotype as a type of sketch rather than an experience with printmaking or a final work of art. Hopper's first prints were monotypes, printed on scraps of paper and envelopes post-

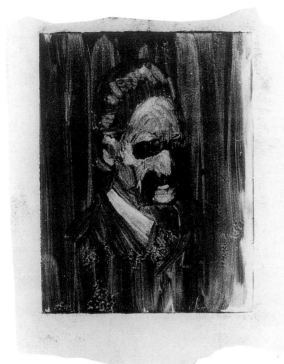

marked 1902 (fig. 75). At that time he was studying at the New York School of Art with Chase and Henri. The five monotypes he kept were all monochrome portraits, suggesting that he learned the technique from Chase, who made numerous quick portrait sketches in the medium. Stella made a few early portrait heads (fig. 76) and returned to the medium several times later in his career, once to create a series of monotype illustrations for *Survey Magazine* and on other occasions to make monotype images of figures or flowers.[36] Georgia O'Keeffe made several small monotypes early in her career, possibly under Chase's influence in 1907–8, when she studied with him at the Art Students League.[37] However, this brief flirtation with the monotype appears to be an anomaly in her career. Many of their contemporaries had their first experience with monotype in Paris, just as American artists of the older generation had. Although John Marin experimented with *retroussage* and variable inking of his etching plates as early as 1906, he does not seem to have abandoned the etched image entirely to make a true monotype.[38] Alfred Maurer made at least two monotypes in Paris, which he gave to his friend and fellow artist Jack Stark, who was also in Paris during the early years of the twentieth century (fig. 77). The abstraction of the head and the spontaneity of wiping suggest his move from a more descriptive to a more freely rendered image seen in some of Maurer's paintings of 1906. Max Weber also made a few small monotypes in Paris in 1906–7, but other than a later group of color woodblock prints, each individually colored by hand on the block, which could be considered monoprints, he apparently did not return to this activity.

Alone among the early American modernists in creating a large and varied body of work in the medium was Abraham Walkowitz, who began making monotypes in Paris and continued after returning to the United States. From approximately 1906 to 1910, he executed hundreds of monotypes, both in sepia monochrome and in brilliant color.[39] Cézanne's paintings in the 1906 Salon d'Automne, draped in black after the artist's death, had a great impact on the young American, and a series of monochrome figure compositions in monotype appear to embody his powerful response to Cézanne's monumental bathers (fig. 78). Taking a structural approach, he eschewed the lyrical and symbolic associations that usually characterized this subject at the turn of the century.

In 1906–7, after studying at the Académie Julian, Walkowitz traveled to Holland and Italy, where he lived for a time in the hill town of Anticoli Corrado outside of Rome. He

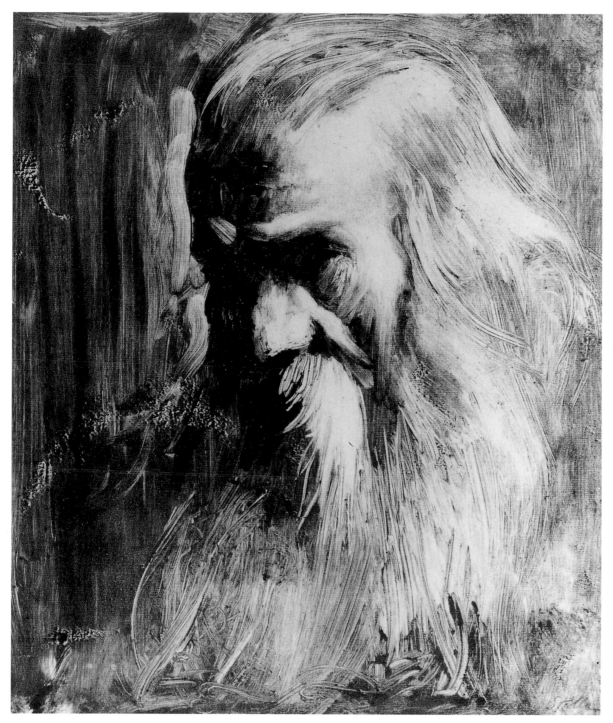

Fig. 75 (opposite)
Edward Hopper, *Man's Head*, ca. 1902, monotype, 10.8 × 8.3 cm (4¼ × 3¼ in.).
Collection of Whitney Museum of American Art, Josephine N. Hopper Bequest. Photograph ©1996 Whitney Museum of American Art

Fig. 76 (left)
Joseph Stella, *Untitled (Bearded Old Man)*, ca. 1900, monotype, 33 × 29.2 cm (13 × 11½ in.).
Private collection

Fig. 77 (left)

Alfred Henry Maurer, *La Vilette*, ca. 1902–6, monotype, 25.6 × 16.5 cm (10 1/16 × 6 1/2 in.).

Santa Barbara Museum of Art, Gift of Jack Stark

Fig. 78 (opposite, above)

Abraham Walkowitz, *Untitled (Four Female Nudes)*, 1909, monotype, 22.2 × 30 cm (8 3/4 × 11 3/4 in.).

The Fine Arts Museums of San Francisco, Achenbach Foundation for Graphic Arts purchase

Fig. 79 (opposite, below)

Abraham Walkowitz, *Town in Italy*, ca. 1907, monotype, 23.8 × 32.4 cm (9 3/8 × 12 3/4 in.).

The Metropolitan Museum of Art, Gift of Abraham Walkowitz, 1940. All rights reserved, The Metropolitan Museum of Art

filled numerous small sketchbooks during his travels and made a large series of monochromatic umber monotypes of scenes in Maarken, Holland, and Anticoli Corrado. The scenes of Maarken convey a sense of low, flat land at water's edge, peopled with lonely figures moving silently through the streets. The views of Anticoli Corrado emphasize the scenic hills, buildings, and tile roofs of this picturesque town, also peopled by small, dark figures reduced to simplified forms, who seem less isolated and stark than those in Maarken (fig. 79). Limiting himself to varying shades of brown and sepia ink, Walkowitz created powerful and complex compositions with a rapid, direct notation that focuses on structural essentials rather than picturesque details.

There is no indication that these monotypes were studies for paintings; many of his European oils, which are related in execution and appearance to the monotypes, were painted on heavy, slick-surfaced paper rather than on canvas. Although Walkowitz made oil paintings throughout his career, he seemed to prefer watercolors and drawings, which allowed him to express his immediate feelings and visual impressions rapidly and directly. The spontaneity of the monotype process, as well as its possibilities for experimentation, undoubtedly intrigued him and facilitated a break from his academic training. As fully independent compositions, the monotypes reveal Walkowitz's early movement toward modernist abstraction, as well as his experimental approach to works on paper.

At the 1906 Salon d'Automne he also saw a large representation of Fauvist painting, possibly inspiring the introduction of bright colors in many of his monotypes. In *Figures in Doorway* (fig. 80), the scene might be a market in Italy or the Lower East Side of New York, with the robed figures and the suggestion of a tent in the background lending an air of exoticism to the scene. However, in other works, such as *Picnic* (fig. 81) and *Beach Scene* (fig. 82), contemporary surroundings are clearly depicted, as Prendergast and other members of The Eight chose to do. *Picnic*, in particular, recalls the friezelike arrangement of figures in a landscape that characterizes many of Prendergast's monotypes, suggesting that Walkowitz may have been familiar with these works. Even though the composition of *Beach Scene* creates an impression of deep space, the printed image has a strong sense of unity and overall flatness as a result of the pressure used to transfer the paint and the muting of intense color variations by transferring the pigment from one surface to another.

Walkowitz explored some of the technical possibilities of the medium by experimenting with different densities and viscosities of paint, in some instances using a relatively dry mixture of pigment and oil and in others preferring a more oily combination. The reticulated texture of the figures in *Beach Scene* results from the process of pulling the paper from the heavily painted surface of the plate and is typical of many monotypes by Walkowitz and others. Oil spreading beyond the pigmented area from a very oily mixture of paint produced creamy halos around some of the forms. In *Picnic* the paint is so thick and viscous that it began to pull away some of the fibers of the soft paper on which it is printed as the paper was removed from the plate. Some of Walkowitz's monotypes may have been printed on a press, but others have barely visible plate marks, indicating that they were printed by hand and that Walkowitz may have been familiar with Prendergast's monotypes before going to Paris. Although Walkowitz's large body of monotypes appears to have been executed during a period of five to ten years at the beginning of his career, he exhibited these works regularly throughout his career.

Fig. 80

Abraham Walkowitz,

Figures in Doorway, ca.

1908, color monotype,

22.8 × 30.3 cm

(9 × 11¹⁵⁄₁₆ in.).

National Museum of American
Art, Smithsonian Institution

Fig. 81

Abraham Walkowitz,

Picnic, 1909, color

monotype, 22.2 × 34 cm

(8¾ × 13⅜ in.).

Philadelphia Museum of Art, Gift
of the artist

With the American modernists and their contemporaries, the monotype moved further from the Romantic ideals of variable inking, inspired by the etching revival, and toward a more independent identity for the medium. The increasing importance of color and the practice of transferring the image without a press strengthened the perception of the monotype as a printed drawing rather than a uniquely wiped print. Artists began to execute more ambitious compositions, but no artist adopted the monotype as his or her primary medium of expression. Even those artists who made monotypes throughout their careers, such as Eugene Higgins and Albert Sterner, used it as one of many techniques to create images on paper. Although members of the Henri circle made monotypes for their own amusement, John Sloan recognized its expressive potential and executed some of his most successful images in this medium. Artists continued to learn the process from one another in an informal fashion, and as they moved around the country, they introduced the monotype to artists outside the main art centers of Boston, New York, and Philadelphia.

Fig. 82

Abraham Walkowitz,

Beach Scene, 1908, color

monotype, 15.2 × 22.9 cm

(6 × 9 in.).

Amon Carter Museum, Fort
Worth, 1989.3

3

Not a little fuss is being made about the monotype process, as it is called, for producing pictures which have something of the combined effects of a wash drawing and an etching. —Montezuma (pseud.), 1882[1]

The Emergence of the Monotype

During the 1930s the editioned print gained renewed respect as a democratic medium at a time when the ideal of "art for the people" encouraged the production of high-quality multiple originals available at low cost to those who could not afford unique works of art. Beginning in the 1940s, however, a subtle but distinct change in attitude toward printmaking occurred that anticipated the emergence of the monotype as a much more prominent medium in the postwar period. The emphasis shifted from the production of a completed edition to the act of creating the print, whether or not an edition was ever printed. Jackson Pollock, for example, made several intaglio plates in 1944 at Stanley William Hayter's New York workshop, but he never editioned any of them. The process of making a print came to be viewed as an integral part of the creative act rather than simply a means to an end.

The Cincinnati Connection

In 1890 Frank Duveneck returned to his native city of Cincinnati from Boston, where, beginning in the mid-1870s, his work had found great favor. Widely known as an artist and teacher, both in Europe and the United States, he was invited to teach the first serious class in oil painting offered by the Cincinnati Art Academy. A large studio was constructed in the Cincinnati Art Museum, where he conducted the class from the fall of 1890 through the spring of 1892. Although Duveneck did not formally teach the monotype technique, several of the students in his class later made monotypes, suggesting that this activity became an informal amusement outside of class for the artists who gathered around him. In 1890 the Cincinnati Art Club was established, whose members formed the nucleus of the city's art community. Several of its charter members were Duveneck's students, and it is possible that monotypes were made in this informal setting.

Among the students in Duveneck's painting class was Lewis Henry Meakin, who recalled that Duveneck's "vigorous and dominating personality, combined with his great knowledge of the subject, gave him

E. Martin Hennings,
Through the Aspen Grove
(detail, fig. 93), ca.
1921–25, color monotype

Fig. 83

Lewis Henry Meakin,

Landscape, monotype,

ca. 1895, 20.2 × 40.3 cm

(7 15/16 × 15 13/16 in.).

Cincinnati Art Museum, Gift of

L. H. Meakin

strong influence over those who came under his direction."[2] Meakin's monotype *Landscape* (fig. 83) is strongly reminiscent of Duveneck's views of the Tuscany landscape. The ambitious size of the composition, as well as the skill with which the ink has been applied and wiped away to suggest sky, foliage, and different types of vegetation, indicates that this monotype was made after considerable practice with the medium. About 1882 Meakin had become a charter member of the Etching Club organized by the Cincinnati artist and architect James McLoughlin, who designed the buildings of the Cincinnati Art Museum and Art Academy, so it is possible that Meakin printed monotypes on his own press.[3] In addition to participating in Duveneck's class at the Cincinnati Art Museum, Meakin spent the spring of 1895 at Chioggia, near Venice, where Duveneck was painting; this landscape possibly depicts a view he saw in Italy. Meakin exhibited five monotypes in a solo exhibition of his paintings, watercolors, etchings, and pastels at the Cincinnati Art Museum in 1898. The titles suggest that his monotypes were based on sketches made during his travels.

A charter member of the Cincinnati Art Club and another of Duveneck's students, Matt A. Daly began to work at one of the local potteries about 1892. By 1893 he was asked to join the artistic staff at the Rookwood Pottery, which was later regarded as one of the most distinguished art potteries in the United States. Although Daly became one of Rookwood's prize-winning artists, he continued to paint and to experiment in printmaking. His greatest social interest was the Cincinnati Art Club, where he possibly made monotypes at gatherings of members. Of the five monotypes by Daly that have been located, all are signed and dated 1899, suggesting a surge of interest in the medium that year. However, the images are so skillfully executed that it is likely he had previously made monotypes. Among this group were *Cavalier* (Cincinnati Art Museum) and *High Bear, Sioux* (fig. 84). *Cavalier,* after Frans Hals,

calls to mind the fact that Duveneck and other members of the Munich School esteemed the Dutch artist's virtuoso painting skills.[4] There is no indication that Daly traveled west in 1899, so the subject of *High Bear, Sioux* is probably a portrait of Ogala Fire, a Sioux Indian who was temporarily stranded in Cincinnati on his way home from a visit with President Benjamin Harrison in Washington. Daly's friend and fellow Art Club founder Joseph Henry Sharp persuaded the Indian to pose.[5] The untitled landscape monotype appears to be a more typical subject for Daly (fig. 85). His subtle creation of textures and atmospheric effects to suggest a dramatic change in weather reveals the Romantic sensibility out of which his monotypes developed.

Similarly, Edward T. Hurley's *Storm Tossed Ship* of 1897 (fig. 86) depicts another quintessential Romantic subject, conveyed by the spontaneity and drama of vigorously brushed and wiped ink, manipulated to create a scene of man at the mercy of uncontrollable nature. Best known as a decorator at the Rookwood Pottery, where he worked for fifty-two years, Hurley was encouraged to learn etching by Duveneck after he saw some of the young artist's drawings. Unlike most

Fig. 84 (above)
Matt A. Daly, *High Bear, Sioux*, 1899, monotype, 35.4 × 25.1 cm (13¹⁵⁄₁₆ × 9⅞ in.).
Cincinnati Art Museum, Gift of Mr. and Mrs. John M. Anderson in memory of John W. Fischer

Fig. 85 (right)
Matt A. Daly, *Untitled*, 1899, monotype, 22.3 × 29.2 cm (8¹³⁄₁₆ × 11¾ in.).
Cincinnati Art Museum, Gift of Allen W. Bernard

Fig. 86

Edward Timothy Hurley,

Storm Tossed Ship, 1897,

monotype, 35.2 × 25.1 cm

(13 ⅞ × 9 ⅞ in.).

Cincinnati Art Museum,
Centennial Gift of Mr. and Mrs.
Robert J. O'Brien

students, Hurley admired Duveneck's etchings as much as his paintings. Acquiring his own
etching press, he printed between two and three thousand scenes of Cincinnati.[6] An experi-
menter by nature, Hurley combined etching with glazing techniques at the pottery; he in-
vented Hurley Crayons and Hurley Etching Ground, which he sold by mail order from his
home. An accomplished photographer, he took pictures of landscapes that he later painted.
Hurley learned soft-ground etching and aquatint, often varying his etchings by printing them
in inks of different colors or changing his manner of wiping the plate. The spontaneity and

Fig. 87

R. Bruce Horsfall,

Moonlight and Surf, 1897,

monotype, 40 × 71 cm

(15¾ × 28 in.).

Jane Voorhees Zimmerli Art
Museum, Rutgers, The State
University of New Jersey, Gift of
Helgi Johnson

experimental nature of the monotype had great appeal for him. Hurley's daughter recalls Sunday-afternoon monotype parties at their home, where artists and would-be artists gathered around the etching press on the third floor.[7]

Like Hurley, Robert Bruce Horsfall worked as a designer and painter for the Rookwood Pottery from 1893 to 1897 and experimented with the monotype as a departure from his traditional academic training in Munich and Paris as well as the requirements of his craft at Rookwood. A former student of Duveneck, Horsfall appears to have made most of his monotypes in the summer of 1897 while he was vacationing in Mackinac, Michigan. Although he later became known as a distinguished natural science illustrator, Horsfall's early renderings of nature evoked the drama or poetry of nature (fig. 87), which he later repeated in the background of some of his animal illustrations. For his Romantic landscapes of 1897, he chose a very heavy, absorbent paper that softened the forms and enhanced the poetic mood of the scene. Despite the freedom offered by the monotype, Horsfall never rejected the lessons of his academic training, as noted in an article on his monotypes in the August 1898 issue of *Pen and Pencil*:

Only absolute knowledge, the result of repeated experiments, can be the means of assuring such perfectly satisfactory prints. There is nothing in any of these to suggest chance or happy accident. . . . All is serious and honest, composed and executed with the same care as the most important exhibition

Fig. 88
Mary Louise McLaughlin,
*Landscape with Sunset and
Stream,* 1919, color
monotype with watercolor,
20.4 × 28.1 cm
(8 1/16 × 11 1/16 in.).
Cincinnati Art Museum, Gift of
Theodore A. Langstroth

Fig. 89
Zulma Steele, *Bee Hives of
a Coffee Plantation,*
ca.1910–15, color
monotype, 12.7 × 20.6 cm
(5 × 8 1/8 in.).
Jean Young and Jim Young

picture, yet full of spontaneity. Drawing is never in a single instance sacrificed because it might inter-fere with a "broad effect" nor is charm of detail overlooked to preserve some accidentally clever brush stroke.[8]

Mary Louise McLaughlin began making studio porcelain called Losanti ware in 1898 in the backyard of her home. Famed in craft circles for having originated plastic slip underglaze painting and one-fire porcelain artware, she was an inventor in the field of pottery decoration, whose technique was adopted by the Rookwood Pottery. McLaughlin had studied art at the McMicken School of Design in the 1870s. She probably learned to etch in 1877 as a student of Henry Farney, and in 1880 she published an etching manual.[9] A student in Duveneck's painting class, she later stated that, despite her varied training, Duveneck was the only teacher who had any influence on her artistic development.[10] McLaughlin's earliest dated monotype is from 1905; most of her extant work in this medium is dated 1930–31, although other examples are dated 1919 or 1921.[11] In contrast to the monotypes by other Cincinnati artists, all of McLaughlin's monotypes were made in color (fig. 88). The famous actor and amateur artist Joseph Jefferson spent several days at Rookwood, and it is possible that his example as a monotypist inspired McLaughlin to make color monotypes.[12]

Because the Rookwood Pottery provided a livelihood for many artists who had been trained as painters and etchers, it is not surprising that they made paintings, watercolors, etchings, and monotypes in their spare time. The Arts and Crafts movement had generated interest in handcrafted pottery around the turn of the century, placing great value on the artist's individual touch in contrast to more impersonal means of production. Nonetheless, designers at the pottery had to work within certain limits, using motifs and colors that had proved popular among buyers. Although a certain latitude with technical experimentation was permitted, they worked under numerous practical and aesthetic restraints in their decora-tion. Outside the pottery, however, they could express themselves as they pleased. The monotype, with its experimental nature and strong reliance on the artist's personal touch, had great appeal. Almost a century later a potter described the monotype, with its spontaneity and unpredictability, as "the raku of printmaking."[13]

Artists of the Arts and Crafts Movement

Artists involved with the Arts and Crafts movement in other areas also found the monotype an appealing medium for their fine-art work. It appears that female artists who were part of this movement were among the first women to make monotypes. In the 1890s Alabama artist Clara Weaver Parrish was employed as a designer of stained glass with Louis Comfort Tiffany. Having studied art with William Merritt Chase, Kenyon Cox, H. Siddons Mowbray, and J. Alden Weir, she continued to paint and work in pastel, even as she achieved recogni-tion for her stained glass in the early 1900s. News clippings of 1901 mention her monotypes, which were perhaps precursors to her later work in color etching.

Zulma Steele was one of the first artists invited to join Byrdcliffe, an artists' colony in Woodstock, New York, founded in 1902 as a utopian Arts and Crafts community emulating the principles of John Ruskin and William Morris. Steele, with her friend and fellow Pratt Insti-tute student Edna Walker, created designs inspired by local flora for most of the decorative panels of Byrdcliffe furniture, which was sold in New York City. At the colony, Steele studied

with landscape painter Birge Harrison, and from approximately 1910 to 1915, she painted and made monotypes of the Catskill Mountains, the Ashokan Reservoir, and scenes based on her travels to the Caribbean (fig. 89). Most of her monotypes were in color, using very dry, thinly applied paint that allows the white of the paper to unify the composition and creates an airy, impressionistic sense of light throughout the scene.

Although both Mary Cassatt and Georgia O'Keeffe were introduced to the monotype, each made only a few examples and abandoned the technique early in their careers. The more extensive bodies of monotypes by McLaughlin, Parrish, and Steele suggest that the hands-on, intimate quality of the monotype had an appeal similar to that of wood carving, stained glass, and pottery. At the turn of the century, the decision to pursue a craft was often a practical one for a woman, who could earn a living more readily in this field than in the fine arts. However, opportunities for personal expression were somewhat limited by the technical demands of the craft, which often led those with traditional art training to continue to paint, draw, or make prints when time permitted.

Unlike male artists, many of whom were introduced to the medium at informal gatherings or clubs, women were not permitted to join organizations such as the American Art Association in Paris or the Salmagundi Club in New York. There is no indication that monotypes were made at the American Women's Club in Paris, which primarily provided housing for art students, or at the Women's Art Club in New York, which was organized expressly to afford members more opportunities to exhibit their work. Clara Weaver Parrish was possibly introduced to the monotype as a student of William Merritt Chase, and Mary Louise McLaughlin may have participated in the Sunday monotype sessions at Edward Hurley's home, but in general women had fewer opportunities to experiment with new painting or printmaking techniques at the turn of the century. Those inclined toward technical experimentation often satisfied this proclivity by working in one of the craft media.

The close association between the decorative arts and the monotype for some artists may explain why the monotype was not taken more seriously by painters. "Decorative experimentation, such as the tying of bows on backs of chairs, painting on tea cups, making monotypes aided by a clothes-wringer for a press, was the chief joy and occupation of amateurs."[14] Although the Arts and Crafts movement attracted many American artists during the late nineteenth and early twentieth centuries, they maintained a strong distinction between fine art and craft. For example, the members of the Tile Club, including William Merritt Chase and other leading painters of the 1870s and 1880s, participated in the decorative craze of the time by painting tiles at their meetings. Once the tiles were finished, however, they often threw them at one another, kept them in storage, and never mentioned them to their students of fine art.[15] Their ambivalence toward these painted tiles may indicate a similar ambivalence toward their monotypes.

The Monotype Moves West

As artists traveled to various parts of the country, the monotype began to take root in new locales. Joseph Henry Sharp met Frank Duveneck in Munich in 1886, and they traveled together in Italy and Spain. After both artists returned to Cincinnati, Sharp probably began making monotypes under Duveneck's influence in the early 1890s. Sharp's early monotypes, such as *Head of an Indian* (fig. 90), are characterized by dense ink worked entirely in the dark manner to create a carefully composed and finished image. In contrast to Duveneck's freer

Fig. 90

Joseph Henry Sharp, *Head of an Indian,* ca. 1897, monotype, 27.8 × 17.8 cm (10 $^{15}/_{16}$ × 7 in.).

Cincinnati Art Museum, The Israel and Caroline Wilson Fund

and more bravura wiping of ink, Sharp's tighter, more calculated use of the medium probably reflects his Paris training, where academic standards emphasized finish rather than the more spontaneous painting techniques of the Munich school. Intrigued by the monotype, Sharp purchased his own press and explained his interest to a newspaper interviewer:

One never knows what he is going to get until that big wheel revolves and your impression comes out the other end. You may find a print that will give pleasure or a "botch." No matter what the cause or the result you are anxious to try it again and again. . . . There are many little things that will spoil a

The Emergence of the Monotype

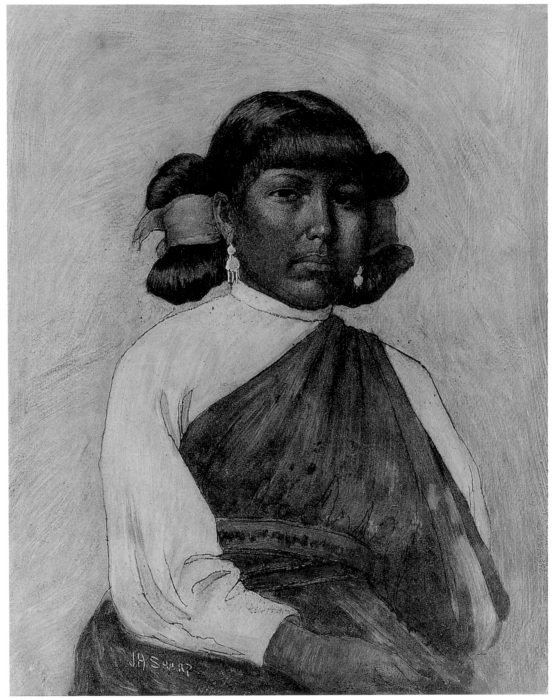

Fig. 91

Joseph Henry Sharp, *Hopi Girl,* ca. 1900, color monoprint with etching, 35.3 × 27.5 cm (14 × 10¾ in.).

Private collection, Akron, Ohio. Courtesy Eric G. Carlson

print and hours of work. I have seen good results printed with a clothes wringer. One can get an immense variety of technical effects by using dry brushes, the fingers, palm of the hand, rags, etc. Accidentals, too play an important part, and one should be on the outlook to take advantage of them.[16]

After two earlier trips to the Southwest in 1883 and 1893, Sharp returned to the West in 1897, and two years later he visited the Crow agency on the Montana plains. He continued to divide his time between Cincinnati, Taos, and the Crow reservation in Montana, making trips to the Pine Ridge Sioux reservation in South Dakota and the Blackfoot reservation near Browning, Montana. As his press was in Cincinnati, he probably created his monotypes there, based on drawings or photographs made during his travels.

Sharp's portraits of Indians and their way of life received a great deal of attention, and with it came the realization that he could combine color monotype printing with etched portraits to create images that could be sold as unique works of art. On large steel plates he etched six portraits of Indians based on his paintings, copying only the general outline of the face and other prominent physical features. Once the image was printed from the deeply etched lines, the plate was cleaned of ink, and paints of different colors were applied to unworked areas of the plate, using the etched outlines as a guide (fig. 91). The etched impression was carefully placed face down on the painted plate and run through the press one more time. After lifting the paper from the plate, he used a blunt instrument to scratch his signature into the wet paint of the impression. He always used different colors for each impression and was careful to show no more than one of each in the same city.[17]

In 1898 Sharp's monotypes drew the attention of a New York firm. Taking time off from his teaching position at the Cincinnati Art Academy, he traveled east to discuss business arrangements, leaving several monotypes with the New York firm and others with the Copley Print Company in Boston. In December 1898 his monotypes were exhibited at the Denver Artists' Club at the suggestion of his friend Mrs. W. H. Cole. Because of her wealth and influence, the show was well reviewed and approximately twenty monotypes were sold. His work also sold well in New York and Boston, but it attracted few buyers when he sent some monotypes to Europe at the suggestion of his friend Henry O. Tanner, the African American artist who had achieved success in Europe. When Sharp returned to the Crow reservation in the summer of 1900, he visited Sheridan, Wyoming, and contacted Herbert Coffeen, a local bookseller who mounted an exhibition of his monotypes.[18] The mixed reception of his monotypes over etching appears to have led to a burst of activity in this medium, followed by a waning of interest.

Sharp was one of the founding members of the Taos Society of Artists in 1915. The nucleus of artists working in New Mexico attracted others, many of whom were painters, but, like Sharp, several devoted some of their energy to prints. In 1921 E. Martin Hennings moved to Taos from Chicago, where he had painted a number of murals and taught at the Academy of Fine Arts. In 1917 he had made his first trip to the area, commissioned by a group of Chicago businessmen to paint eight to ten canvases. Two friends from his student days in Munich, Walter Ufer and Victor Higgins, had previously made similar arrangements, and he was greeted in Taos by an established colony of artists. Hennings's move to Taos had great importance for his career, enabling him to abandon commercial work in favor of painting. Inspired by the intense New Mexico sunlight, he lightened his palette considerably, turning away from the dark tonalities he had learned in Munich.

The move also allowed Hennings the time to experiment with media other than mural and easel painting. One of the first Taos artists to experiment with etching and lithography, he began making etchings as early as 1921 but never editioned the plates, possibly because an etching press was not available.[19] In 1924–25 he drew eight lithographs on zinc plates and sent the plates to be printed at the Jahn and Ollier Lithographic Company in Chicago, where his brother-in-law was art director. His monotypes probably date from 1921–25, as his wife did not recall his making prints after their marriage in 1926. Two of his monotypes relate directly to two etched compositions, but it is impossible to determine which were completed first.[20] One of the monotypes, *Watching the Dance* (fig. 92), is strongly related to a painting titled *Announcements* that includes two of his favorite models, Frank and Cruzita Samora, which won

Fig. 92

E. Martin Hennings,

Watching the Dance,

1924–25, color monotype,

20.3 × 30.5 cm (8 × 12 in.).

Gerald Peters Gallery, Santa Fe,

N.M.

the Walter Lippincott Prize at the Pennsylvania Academy of the Fine Arts in 1925. There is no evidence of etched lines in the monotype, and the image is slightly larger than the etching.

Although Hennings was trained primarily as a figure painter, after moving to Taos he placed his subjects in the spectacular landscape. In *Through the Aspen Grove* (fig. 93), the figures are secondary to the splendid groves of trees that characterize the area. Late in his life Hennings recalled: "Nothing thrills me more, when in the fall, the aspen and cottonwoods are in color and with the sunlight playing across them—all the poetry and drama, all the moods and changes of nature are there to inspire one to greater accomplishments from year to year."[21] Hennings's small but impressive body of monotypes was apparently inspired by his brief interest in prints and the practical possibility the monotype offered to print an image in color without a press. The white paper beneath the intense yet translucent colors in *Red Chiles* (fig. 94) creates a sense of atmospheric light that permeates the entire composition. Hennings could express his newly developed interest in bright sunlight and its effect on color more emphatically in the monotype than in the more opaque medium of oil painting. In contrast to Sharp, who attempted to exploit the commercial possibilities of the monotype over etching, Hennings kept many of his monotypes, not selling them until later, during the Depression, when he needed money.[22]

In 1899 Oscar Berninghaus made his first trip from his native St. Louis to the Southwest, commissioned by the Denver and Rio Grande Railroad to paint a series of watercolor sketches

"Through the Aspen Grove" E.Martin Hennings

Fig. 93 (left)
E. Martin Hennings,
Through the Aspen Grove,
ca. 1921–25, color
monotype, 22.9 × 25.4 cm
(9 × 10 in.).
Mrs. Ronald C. Bracken

Fig. 94 (below)
E. Martin Hennings, *Red
Chiles,* ca. 1925, color
monotype, 24.8 × 27.3 cm
(9 ¾ × 10 ¾ in.).
Gerald Peters Gallery, Santa Fe,
N.M.

E.Martin Hennings

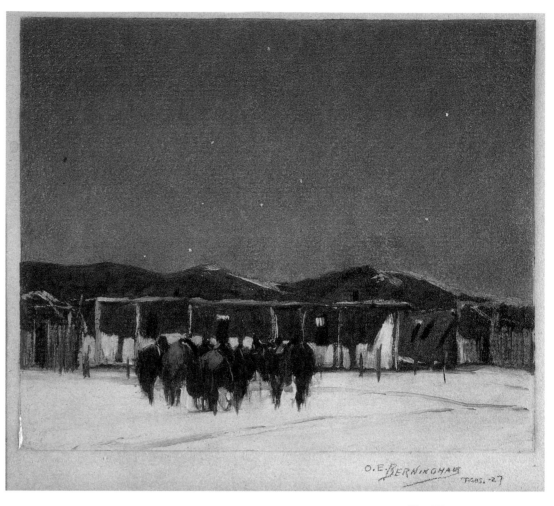

Fig. 95

Oscar Edmund

Berninghaus, *Moonlight,*

Taos, 1927, color

monotype with watercolor

additions, 12.7 × 15.2 cm

(5 × 6 in.).

Mr. and Mrs. John M. Brenner

illustrating the scenery and economic potential of the region. This trip marked the beginning of his success as an artist and infected him with what he called the "Taos germ." Returning to his job in a commercial lithography plant in St. Louis, he took night classes until he became an accomplished designer, draftsman, and printmaker. Although he did not move permanently to Taos until 1925, he went there most summers to paint and began exhibiting in the Taos Society of Artists' traveling shows.

As an experienced printmaker, Berninghaus owned a press and used it to print his monotypes.[23] In *Moonlight, Taos* (fig. 95), one of his earliest monotypes, the dramatic effects of light are given as much attention as the building. Highlights are painted on the surface of this impression, whose composition appears to be the model for a painting titled *Winter Night*. Horses were among the artist's favorite subjects, often featured in both his paintings and monotypes. About 1932 Berninghaus made a group of monotypes based on a trip to Mexico, and his daughter recalled further monotype activity about 1940, indicating that the medium continued to interest him.[24] Most of his subjects are based on his surroundings in Taos (fig. 96), but others are apparently related to a more generalized history of the West, such as *Apache Tepee* (fig. 97), possibly inspired by his having shared a studio for a brief time in St. Louis with the famous cowboy artist Charles M. Russell. Most of the Taos artists had studied at academies in Munich, Paris, Cincinnati, or Chicago, but Berninghaus had little formal training, although he was a conscientious, meticulous craftsman. Like many artists who had worked as illustrators, he appreciated the freedom and speed of making a monotype in

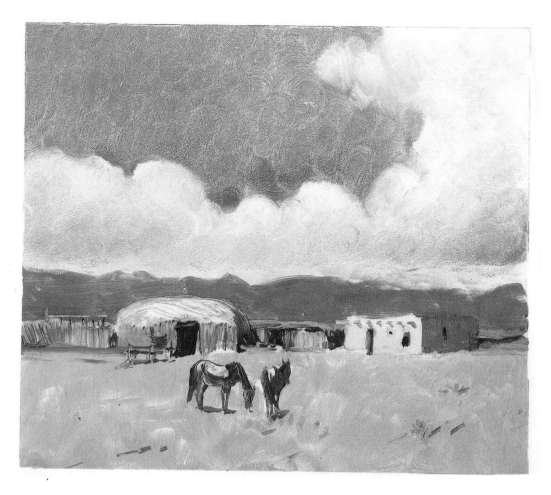

Fig. 96 (above)
Oscar Edmund
Berninghaus, *Native Farm,*
ca. 1940, color monotype,
17.8 × 20.3 cm (7 × 8 in.).
Stark Museum of Art, Orange, Tex.

Fig. 97 (right)
Oscar Edmund
Berninghaus, *Apache
Tepee,* ca. 1930, color
monotype, 17.8 × 20.3 cm
(7 × 8 in.).
Marilyn Pink Fine Art,
Los Angeles

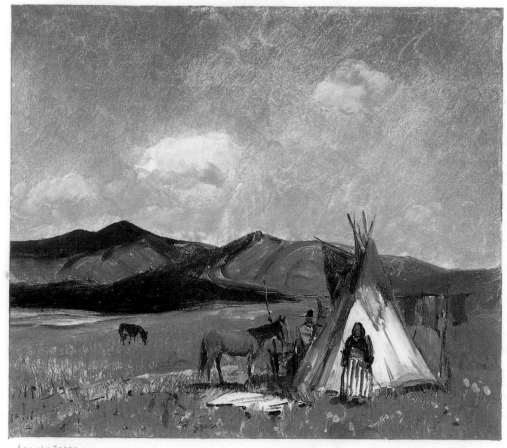

contrast to the more laborious work of completing a painting or the rigid requirements of printing a lithograph. In his monotypes Berninghaus worked in a looser, more spontaneous fashion than he did in his paintings, without forfeiting the ability to capture the distinctive colors and dramatic effects of light. Several other Taos artists, such as William Penhallow Henderson and Nicolai Fechin, made a small number of monotypes, but on the whole this group of artists concentrated on painting.

The Monotype Movement in California

In contrast to the Taos artists' relatively limited interest in the monotype, artists in the San Francisco Bay Area were more open to its possibilities, probably reflecting their greater interest in etching and color printmaking, especially color etching, in the early twentieth century. By 1912 the California Society of Etchers had been founded. Whereas traditional color etching required making a separate plate for each color ink to be printed, or careful application and wiping of ink on the plate with a rag and a tarlatan (à la poupée), the monotype allowed the artist to create an image freely in color, unfettered by the boundaries of the etched lines.[25] The close relationship of the two media was noted by a critic for the San Francisco Examiner in 1915: "For those to whom the monotype is something of a mystery, it may be well to remind them that it is, in a way, an etching in color except that you don't etch your line on your plate, which plate may be copper or hard wood, and that you can take but the one impression of your work. You paint swiftly and fluently upon this plate." The critic, reviewing the work of Xavier Martinez at the Helgesen Galleries, praised him as "a master of the method . . . who has seriously studied its many possibilities—[for whom] less and less is left to chance, and more and more depends upon innate artistry. The poet that is ever evident in this most genuine of Western artists has a splendid chance for lyrical utterance in the monotype."[26]

Born in Guadalajara, Mexico, of Spanish-Indian parentage, Martinez went to San Francisco in 1893 to study at the California School of Design. After graduating in 1897 and winning the Avery Golden Medal for the excellence of his work in all media, Martinez went to Paris and enrolled in the atelier of Jean-Léon Gérôme at the Ecole des Beaux-Arts. In 1900 he studied with Eugène Carrière and was influenced by the work of Whistler, Manet, and the Nabis as well. Adopting a restricted palette of ochers, greens, grays, and browns, highlighted with a dab of bright color, Martinez abstracted and flattened his figures, often creating a decorative composition of rhythmic forms and patterns against an atmospheric background. It is not known whether he spent time at the American Art Association in Paris or began making monotypes while there, but by 1912 he seems to have completed a fairly significant body of work in the medium. His monotypes were done on a variety of surfaces, including copper, zinc, silver, wood, lithographic stone, and porcelain. Martinez and Perham Nahl exhibited their monotypes in 1912 at the Elder Gallery in San Francisco, where a reviewer noted that "an effect frequently produced in the monotype is a subtle heightening of whatever quality of mystery or romance may reside in subject or treatment."[27]

Martinez exhibited several monotypes at the Panama-Pacific Exposition in San Francisco in 1915 and received an honorable mention for his evocative image titled Valkyrie of the Sea (fig. 98).[28] In each of the three versions of this subject, a nude female (portrayed by his wife, Elsie Martinez), with hair streaming, sits astride a large fish swimming in gray-green water. Although Martinez was one of the founders of the California Society of Artists, an organization formed in 1902 to protest conservative views of the San Francisco Art Association, it is clear

Fig. 98

Xavier Tizoc Martinez,

Valkyrie of the Sea, ca.

1915, color monotype,

19.8 × 19.8 cm

(7¹³⁄₁₆ × 7¹³⁄₁₆ in.).

National Museum of American
Art, Smithsonian Institution

that elements of nineteenth-century Romanticism and Symbolism survived in his work despite the influence of the more advanced art he had seen in Paris.

A colorful bohemian, according to fellow artist Arnold Genthe, "with a shock of black hair, and eyes like great beads of jet, he [Martinez] dressed like the painters in the Latin Quarter—in corduroys, and always wore a bright crimson flowing tie, no matter what the time of day."[29] As one the region's foremost artists, Martinez valued individuality and the ability to express human feeling. He studied with Arthur F. Mathews, a leader of the California Arts and Crafts movement, whose values were shared by many of the artists and writers in Martinez's circle of friends.[30] Members of his group sought to attain a state of direct, intuitive knowledge through emotion, placing special value on their identity as creative individuals.[31] Perhaps Martinez's engagement with the monotype—a medium with few rules or traditions—was an effort to temper his formal academic training through spontaneous expression and technical experimentation. Intimate and personal, the monotype represented a process of creating art directly opposed to industrialization and its attendant dehumanization, which this group of artists deplored.

In 1909 the Helgesen Galleries in San Francisco presented the first exhibition in California

devoted almost exclusively to monotypes, featuring the work of Gottardo Piazzoni. Like Martinez, he had studied with Mathews before going to Paris, where he studied at the Académie Julian with Henri Laurens and Benjamin Constant and at the Ecole des Beaux-Arts with Gérôme. A reviewer of Piazzoni's exhibition noted "the element of uncertainty which enters largely into their production making it a delight when an unusually fine proof appears."[32] Clearly, the aesthetic of the *belle épreuve* was an important factor in the growing popularity of the monotype in California.

Like Martinez, Perham Nahl experimented with printing monotypes from a variety of surfaces, especially canvas. In *Ophelia* (fig. 99), the texture of the canvas remains apparent across the surface, making the monotype a virtual printed painting. Many of Nahl's monotype images were significantly larger than those of his contemporaries, even when he printed from a smooth surface. As early as 1910, in *A Forest Pool* (fig. 100), his very subtle use of color and skillful manipulation of paint density reveal a special sensitivity to the possibilities of the medium. Among the monotypes he showed at the Elder Gallery in 1912 were "monotone monotypes," which, according to the reviewer, had "the quality of mezzotint etchings."[33] Working in both monochrome and color, Nahl created a substantial body of monotypes that probably served as models for others artists in his circle—Armin Hansen, Frank Hammarstrom, Mary DeNeale Morgan, and Worth Ryder—who made monotypes only occasionally.

Of all the early-twentieth-century California artists who made monotypes, Clark Hobart came closest to specializing in this medium. He received his earliest training at the San Francisco Institute of Art and then spent three years in the late 1890s at the Art Students League in New York. After three years of study in Paris, he returned to New York and worked as art editor of *Burr-McIntosh Magazine* from 1903 to 1911. Some of Hobart's later monotypes, such as *Gossips* (fig. 101), suggest that he saw exhibitions of Maurice Prendergast's monotypes in New York. Like Prendergast, he came to the medium as a painter rather than a printmaker and also concentrated on depicting fashionable figures in a landscape setting.

Fig. 99 (above)
Perham Nahl, *Ophelia*,
1910–15, monotype,
42.7 × 35.2 cm
(16 13/16 × 13 7/8 in.).
Collection of The Oakland Museum of California, Gift of Miss Maryles Nahl

Fig. 100 (opposite, above)
Perham Nahl, *A Forest Pool*, 1910, color monotype, 49.5 × 38.1 cm
(19 1/2 × 15 in.).
Collection of The Oakland Museum of California, Gift of Miss Maryles Nahl

Fig. 101 (opposite, below)
Clark Hobart, *Gossips*,
ca. 1915, color monotype,
27.9 × 37.5 cm
(11 × 14 3/4 in.).
Marsha Gleeman

At the Panama-Pacific Exposition in 1915, Hobart's monotypes were displayed in the print section near those of Martinez and were awarded a silver medal—the highest honor conferred upon monotypes by the international jury. That same year his color monotypes were exhibited at the Helgesen Galleries in San Francisco and at the Museum of the History of Science and Art in Los Angeles. Also in 1915, the Pennsylvania Academy of the Fine Arts invited Hobart to submit four color monotypes to its annual print exhibition, and the following year forty-nine of his monotypes were shown at the Kennedy & Company gallery in New York. When the Oakland Civic Art Museum opened in 1916, Hobart's monotypes were given an entire room. Throughout his active career, which lasted through the 1920s, he continued making and showing monotypes along with his paintings. In a review of the Bohemian Club annual exhibition of 1929, Hobart's three monotypes were singled out as "among the happiest contributions to the exhibition."[34]

From the beginning, Hobart's monotypes were acclaimed by critics who admired his color and skillful technique. J. E. D. Trask, chief of the department of fine arts of the Panama-Pacific Exposition, declared: "His color is charming, his composition both graceful and learned and his control of his process remarkable." Another critic ventured that "there is probably no other artist in the country who sows a more fertile imagination, a more varied range of subject, or a more adequate technical equipment in the field of the monotype; nor . . . do they display anything like Hobart's wide range of color effects." His use of color inspired poetic similes—"And such exuberance of color, with rose-pinks strewn everywhere like tender lambent flames!"—as well as comparisons to the "jewel-like quality of Monticelli" and the "oriental virtuosity of Besnard."[35]

Hobart's serious involvement with monotypes is indicated by the fact that he signed all of them and gave most impressions an individual title, inscribed in pencil beneath the image. Ranging from exuberant, impressionistic compositions such as *Edge*

of the Woods (fig. 102), printed from a smooth surface, to softer, more atmospheric idylls such as *Indian Summer* (fig. 103), printed from a canvas surface, Hobart's monotypes reveal an artist who explored diverse color effects to create a decorative and charming body of work. As a commercial gallery, Helgesen recognized the sales potential in Hobart's work; its catalogue for Hobart's exhibition concluded with a practical appeal:

If there is one form of the fine arts that is peculiarly suited to the embellishment of modern homes with their many panels and consequently limited wall spaces, it is the monotype. Moderately small in size . . . glowing in color . . . it forms a decorative spot that must liven up and otherwise greatly enhance the appearance of the space within which it is hung, while at the same time it bears its message to lovers of the beautiful, as an individual object of art.

Despite such promotion and the popularity of Hobart's colorful monotypes, few other California artists adopted the monotype as their primary medium, although many of them experimented with it and made smaller bodies of work.

The visibility of monotypes and the prizes awarded to them at the art exhibition of the Panama-Pacific Exposition encouraged many artists to explore this unusual new technique. Eric Spencer Macky, who received widespread recognition for his murals and paintings in the exposition, made an accomplished color monotype of a sculptural fountain at the site, based on a very complete drawing of the subject (fig. 104). Karl Eugen Neuhaus made monotypes, as did William Henry Clapp, who also served as curator of the Oakland Civic Art Museum from 1918 to 1949, where he exhibited and collected works in this medium. Monotypes were of special interest to some of the California Impressionists, who appreciated the medium's potential for translucent colors and glowing light. Although John Aloysius Stanton began making monotypes late in his career as an aid for painting, he became intrigued by the medium and experimented with printing images on the back of absorbent wallpaper, probably to achieve an even softer, more diffuse sense of light (fig. 105). Alfred J. Casella and Lee Randolph (figs. 106 and 107) also took advantage of the inherent

Fig. 102 (above)
Clark Hobart, *Edge of the Woods,* ca. 1915, color monotype, 34.3 × 44.5 cm (13½ × 17½ in.).

Roger Genser, The Prints & the Pauper, Santa Monica, Calif.

Fig. 103 (below)
Clark Hobart, *Indian Summer,* n.d., color monotype, 29.9 × 39.4 cm (10¾ × 14⅝ in.).

The Annex Galleries, Santa Rosa, Calif.

Fig. 104 (above)
Eric Spencer Macky,
Fountain of the Panama Pacific International Exposition, 1915, color monotype printed on wallpaper, 32.4 × 25.1 cm (12¾ × 9⅞ in.).
The Annex Galleries, Santa Rosa, Calif.

Fig. 105 (above, right)
John Aloysius Stanton,
California Desert Landscape, ca. 1910, color monotype, 15.2 × 31.4 cm (6 × 12⅜ in.).
The Annex Galleries, Santa Rosa, Calif.

Fig. 106 (right)
Alfred J. Casella, *Hillside,* ca. 1920, color monotype, 25.4 × 30.5 cm (10 × 12 in.).
Peter Hastings Falk

Fig. 107 (right)
Lee Randolph, *In a Garden,*
ca. 1915, color monotype,
26.7 × 33.7 cm
(10½ × 13¼ in.).
Terry and Paula Trotter

Fig. 108 (right, below)
Benjamin Chambers Brown,
Grand Canyon, Arizona,
n.d., color monotype,
12.5 × 17.5 cm
(5 × 6¾ in.).
The Fine Arts Museums of San
Francisco, Achenbach Foundation
for Graphic Arts, California State
Library Long Loan

luminosity of the monotype, creating fully realized compositions that indicated they viewed the monotype as a form of painting rather than a mere sketch.

Although most monotype activity in early-twentieth-century California occurred in the northern part of the state, especially the San Francisco Bay Area as far south as Monterey, the monotype was not unknown in southern California. Benjamin Chambers Brown settled in Pasadena in 1896 after studying at the St. Louis School of Fine Arts and the Académie Julian. He began as a portrait painter but switched to landscape and worked outdoors whenever possible. A founder of the California Art Club and, with his brother Howell C. Brown, of the Print Makers Society of California in 1914, he served as president of the latter organization until 1929. Brown experimented with color etchings, using soft-ground and aquatint for tone, and won a bronze medal for a color etching at the Panama-Pacific Exposition. His monotypes appear to be closely related to his color etchings, in which the translucency of the colored inks produced brilliant colors bathed in diffuse light free of etched lines (fig. 108).

Karl Yens worked primarily in watercolor but also experimented with unusual media, including hand-colored *clichés-verres*. During the years he lived in Pasadena, before 1919, he may have begun making monotypes at the suggestion of fellow resident Benjamin Chambers Brown (fig. 109). Carlton T. Chapman made color monotypes in the Los Angeles area, and Cora Smith, a resident of Ocean Beach, near San Diego, made black-and-white monotypes in the 1920s and 1930s. Not much is known about her career, but in 1935 she exhibited monotypes at the California-Pacific International Exposition in San Diego, where she was listed as a painter and etcher; it is clear that her monotypes and etchings are closely related (fig. 110). Her tight, linear, detailed landscape compositions reveal exceptional control at the expense of spontaneity. William A. Sharp, who also worked in southern California, favored a monochrome palette as well, but his landscape monotypes are freer and more painterly (fig. 111).

Most California artists, however, preferred to work in color. Daniel Sayre Groesbeck, a Los Angeles illustrator, muralist, painter, printmaker, and motion-picture art director, made color monotypes in the 1920s and 1930s based on his memories of travels to Russia,

Fig. 109 (above)
Karl Julius Heinrich Yens,
Out of My Garden, 1919,
color monotype,
45.1 × 30.2 cm
(17¾ × 11⅞ in.).
Roger Genser, The Prints & the Pauper, Santa Monica, Calif.

Fig. 110 (right, above)
Cora A. Smith, *San Diego Back Country,* 1927,
monotype, 17.8 × 30.5 cm
(7 × 12 in.).
Daniel C. Lienau, The Annex Galleries, Santa Rosa, Calif.

Fig. 111 (right, below)
William A. Sharp,
Landscape with Stream,
1892–1907, monotype,
14.6 × 24.1 cm
(5¾ × 9½ in.).
Peter Hastings Falk

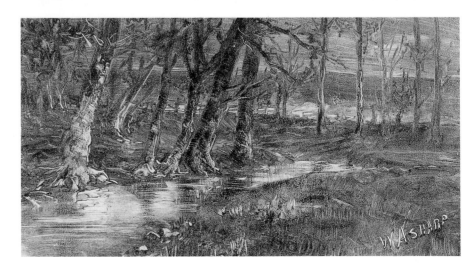

Fig. 112 (left)
Dan Sayre Groesbeck,
Outdoor Market, Russia,
ca. 1925, color monotype,
29.8 × 34.3 cm
(11¾ × 13½ in.).
The Annex Galleries,
Santa Rosa, Calif.

Fig. 113 (below)
Peter Krasnow, *Variation I,*
ca. 1930, color monotype,
39.4 × 44.1 cm
(15½ × 17⅜ in.).
Peter & Rose Krasnow Art
Foundation, Courtesy of Tobey C.
Moss Gallery, Los Angeles

Fig. 115 (below)

George Demont Otis,

Trees Against Red, Yellow,

Orange Sky, ca. 1915, color

monotype, 12.5 × 14.5 cm

(4¾ × 5½ in.).

The Annex Galleries,

Santa Rosa, Calif.

Fig. 114 (left)

Paul Dougherty, *California*

Coastline, ca. 1932, color

monotype, 41.9 × 35.6 cm

(16½ × 14 in.).

Sandra Sofris Dolmatch,

L'Estampe Originale

Germany, Korea, and Japan (fig. 112). His rich colors evoke exotic locales, recalling the Orientalist tradition of Romanticism. Modernist Los Angeles artists such as Peter Krasnow, David Phillip Levine, and Dorr Bothwell also made monotypes in conjunction with their work in other media from the late 1920s to the 1940s (fig. 113).

The monotype remained much more popular with artists in northern California throughout the next several decades. The San Francisco Bay–Monterey area continued to attract artists from other parts of the country, several of whom had made monotypes before going to California. Paul Dougherty had achieved a significant reputation as a marine painter depicting the surf crashing against the rocky coast of Maine. His monotypes dating from the late teens include figure compositions as well as seascapes, done primarily in monochrome inks. In 1931 Dougherty settled on the Monterey Peninsula. Although views of the sea continued to fascinate him, his depictions of the brilliant colors of the Pacific coast and its lush vegetation distinguish his monotypes of the 1930s from his earlier work (fig. 114).

George Demont Otis went to San Francisco in 1930 after studying with Robert Henri in New York and spending ten years in southern California. It was Otis, a visitor to California several times before moving there, who had persuaded William Merritt Chase to teach a summer course in Carmel in 1914.[36] An etcher as well as a painter, Otis made monotypes that show the vigor and spontaneity of Henri's work, but Otis's numerous color landscape monotypes reveal a much more extensive involvement with the medium (fig. 115). One of his private students, George Roberts, recalled how strongly Otis emphasized the value of spontaneity, of preserving a sense of one's first impression: "The most poetic landscape is the one

Fig. 116

Edward Hagedorn, *The Crowd, Two Figures/Blue and Red Eyes*, ca. 1925, color monotype, 38.1 × 28.2 cm (15 × 11⅛ in.).

National Museum of American Art, Smithsonian Institution, ©1978 Denenberg Fine Arts, San Francisco, Calif.

which to a layman carries a certain freedom, a pleasure in doing. . . . A work that seems unlabored will usually be more pleasing."[37]

The appeal of the medium reached beyond the California Impressionists. In comparison with the East Coast, modernism was slow to take hold in California, where the Fauve-like Post-Impressionist landscapes of the Society of Six were the most progressive art to emerge before the mid-1920s. William Henry Clapp, the most conservative member of the Society of Six and curator of the Oakland Civic Art Museum, refused to hang a modernist nude in the museum's fourth annual exhibition in 1926, but the following year he accepted the paintings selected by the modernist jury members. The artist whose nude had been rejected by Clapp the previous year was the young Edward Hagedorn. He had briefly attended the San Francisco School of Fine Arts in the early 1920s, but the greatest influence on his work was the 1926 exhibition at the Oakland Civic Art Museum of the work of the European artists known as the "Blue Four" (Paul Klee, Lyonel Feininger, Alexei Jawlensky, and Wassily Kandinsky), curated by Galka Scheyer. An artist of independent means, Hagedorn could afford to work as he wished. According to a fellow artist, "Ed was an outsider, a 'loner,' a tall thin man with a hooked nose who walked down the street looking like a question-mark; he had no use for success."[38]

Adapting the bold, expressionistic color and form of Jawlensky and Kandinsky to a distinctive personal idiom, Hagedorn created paintings, gouaches, drawings, etchings, relief prints, and lithographs, and during the late 1920s he also completed a powerful body of boldly conceived and executed expressionistic monotypes, quite unlike anything done in the medium until that time. Painting with thick, saturated colors, Hagedorn created dynamic abstract compositions suggesting crowds, distorted heads, shouting mouths, and glaring eyes, frequently bounded by thick, black outlines (fig. 116). He printed them on thin, translucent paper relatively large in scale—some measure 11 by 15 inches—and exhibited his work in group shows in the late 1920s and 1930s. In spite of the strong differences in the work of Hagedorn and Clapp, their monotypes were often shown together because they were considered modernist in comparison to the more conservative work of most California artists of the time.

Despite Galka Scheyer's promotion of the "Blue Four," Expressionism had few adherents in California. James Blanding Sloan studied at the Chicago Academy of Fine Arts, where he rebelled against the dogmatic, academic approach of his professors. One of the more progressive among them, B. J. O. Nordfeldt, encouraged him to paint as he pleased. Sloan became enamored of the color etchings of George Senseney, an East Coast artist who had exhibited at the Panama-Pacific Exposition. In addition to painting and carving wooden puppets, Sloan explored a variety of printmaking techniques. A catalogue of his etchings and block prints published in 1926, shortly after he moved to San Francisco, reveals his experimental approach to printmaking, which led him to try such unusual techniques as painting with asphaltum on the etching plate or letting the etching ground bubble on the surface. Several monotypes were also included in the catalogue.[39] When his work was shown several years later in southern California, a reviewer described its impact: "In the midst of quiet, wealthy Pasadena, a human volcano suddenly erupts ideas onto copper plates and wood-blocks. . . . Technical master of print making in all its known forms and some never seen before, this artist is too full of ideas to care about that precious bloom called by print-dealers, 'quality.'"[40] Instead, Sloan was an impulsive artist who valued spontaneity and created images ranging from poetic landscapes to visionary heads and humorous caricatures, such as *Grouch* (fig. 117).

Frank Van Sloun was also attracted by the experimental nature of the monotype. After

Fig. 117 (left)
James Blanding Sloan,
Grouch, 1930s, color
monotype, 31.3 × 24.8 cm
(12 5/16 × 9 3/4 in.).

Conrad R. Graeber

Fig. 118 (below)
Frank Van Sloun, *Artist and
Model,* monotype,
17.8 × 22.9 cm (7 × 9 in.).

Collection of The Oakland
Museum of California, Gift of
Alice and John Desgrey

Fig. 119 (opposite)
George Stillman, *Untitled
(#4),* 1949, color
monotype, 25.7 × 8.7 cm
(10 1/8 × 3 7/16 in.).

George Stillman, courtesy
The Annex Galleries,
Santa Rosa, Calif.

studying with Robert Henri and William Merritt Chase in New York, he settled in California in 1911. He learned the basic techniques of etching and monotype as well as painting and became especially interested in Rembrandt's etchings, seeking in his own etchings and monotypes the Dutch master's soft burr and chiaroscuro effects. Van Sloun drew directly on the plate and developed a method of applying full-strength acid to the etching plate without the use of a ground. Although he was intrigued by the soft-focus effect of the monotype, he was disturbed by the accidental nature of the medium and experimented with methods to obtain a more controllable and predictable outcome. Van Sloun developed a special combination of inks and oil paints that would retain the images and also special processes for printing them. In *Artist and Model* (fig. 118), he helped define the image with lines drawn on its surface, but in later years he developed a technique that he called a "pen monotype," in which the image was created by line alone.[41]

William Seltzer Rice worked primarily in watercolor before 1915, but he was so strongly impressed by the Japanese prints he saw at the Panama-Pacific Exposition that he turned to linoleum and woodblock prints for most of his work. The monotypes he saw at the fair probably inspired him to work in this medium later in his career. Like several other California artists, Rice experimented with making monotypes from a variety of surfaces. He published articles on printing from a sandpaper surface, as well as from a sheet of transparent celluloid upon which the image was drawn with lithographic crayons.[42]

In the mid-1940s George Stillman began making monotypes after experimenting with the *cliché-verre*. In 1946 he began to paint on glass and manually transfer the image to paper. As a student at the California School of Fine Art at this time, he was also painting, etching, and making lithographs, but he was not aware of anyone else making monotypes. His style changed rapidly in the following years, moving toward abstraction. As Stillman recalls: "The monotype was clearly the way to make explorations. Many of my paintings during that period directly reflected the images I discovered using monotypes. After all, time and money were always at a premium. Making a small monotype was less risky than investing a lot of paint in a large painting."[43] He then began making images on copper plates, using an etching press to print them on rice or mulberry paper (fig. 119).

Although Stillman's work of the late 1940s is now considered Abstract Expressionist, it is different from the work of

artists who were dripping, brushing, or throwing paint on a canvas, as he was investigating forms and methods suggested by printmaking. Looking back at the period immediately following World War II, Stillman recalls that "the intellectual climate during those years in the San Francisco Bay area . . . did not really encourage anything as frivolous as monotypes, the reasoning being that if one were going to make a unique work, why not just paint one? In the past twenty-five years of teaching and encouraging others to make monotypes, I have found it difficult to characterize the process through intellectual argument. . . . One needs to do it and use it to find its benefits."

From Coast to Coast

Although monotype activity tended to be focused in certain geographic areas during the first half of the twentieth century, artists experimented with the medium well beyond these regions. Artists who were printmakers, with ready access to presses, continued to be the likeliest practitioners. H. Nelson Poole, an illustrator for Honolulu's *Pacific Commercial Advertiser* during the 1920s, made monotypes during this period. A prolific printmaker, he apparently abandoned the monotype after moving to San Francisco, where he spent the better part of his career. Poole's intimate, monochrome landscape (fig. 120), with skillful manipulation of fingerprints to suggest form and create texture, indicates that he may have been inspired by the artfully wiped etchings and monotypes in the Claghorn Collection, which he would have seen during his student years at the Pennsylvania Academy of the Fine Arts. Among the other printmakers who experimented with the monotype in Hawaii during the early twentieth century were John Kelly, Nils P. Larsen, John Kjargaard, and Juliette May Fraser.

At the tip of Cape Cod, in Provincetown, Massachusetts, the color monotype developed among artists who had joined the growing art colony after studying in Paris. With the outbreak of World War I, many of them returned to the United States and sought a genial setting that reminded them of Europe. With its scenic beaches, simple lifestyle, and population of Portuguese fishermen, as well as a lively art community, Provincetown became a mecca for artists. By the summer of 1916, the town had five summer art schools, in addition to the schools established earlier by Charles Webster Hawthorne and E. Ambrose Webster. Upon returning from Paris, George Elmer Browne settled in New York but became a regular visitor to Provincetown, where he taught at the West End Art School. His monotype *Mule Train* (fig. 121) indicates more than a passing familiarity with the medium, but where it was made— Provincetown, the Salmagundi Club in New York, or elsewhere—is uncertain. The American Impressionist painter Richard E. Miller settled in Provincetown soon after returning from Paris and printed several colorful Impressionist monotypes over which he painted heavily, using the composition as a study.

Both Browne and Miller came to the monotype as painters, but for many other artists the medium was a logical development of their experimentation with the color woodblock print. Among the many artists interested in woodcuts who came to Provincetown during the summer of 1915 were Blanche Lazzell, Ada Gilmore Chaffee, Mildred McMillen, Ethel Mars, Juliette Nichols, Maud Hunt Squire, B. J. O. Nordfeldt, and Agnes Weinrich. Most of them preferred to work in color—a complicated process that involved cutting a key block and additional blocks for each color, which had to register perfectly with the key block. According to Ada Gilmore Chaffee, Nordfeldt grew impatient with the mechanical labor of cutting so

Fig. 120 (left)

H. Nelson Poole, *Nocturne,*
ca. 1916, monotype,
15.2 × 12.5 cm (6 × 4 $^{15}/_{16}$ in.).

Honolulu Academy of Arts, Gift of
Eliza Lefferts and Charles
Montague Cooke, Jr., 1927

Fig. 121 (below)

George Elmer Browne, *Mule
Train,* ca. 1914, monotype,
28.6 × 38.7 cm
(11¼ × 15¼ in.).

Baker/Pisano Collection

many blocks of wood before he could express his idea, so he invented a method of printing all the colors on a single block. Cutting a groove in the wood around each color area, he proceeded to ink each area separately; in printing, this left a white line separating the colors.[44] This method allowed the artist to print a uniform edition by inking the block identically each time. However, most of the artists were not interested in repeating their work, preferring to ink each impression differently and create a group of monoprints that would be called, in contemporary parlance, a varied edition.[45]

As few of the works are dated, it is uncertain when some of these Provincetown printmakers began to print from a smooth, uncut surface. Lazzell's earliest dated monotype is from 1922, and other dated monotypes reveal that she worked in the medium at least through the early 1940s (fig. 122). Although she had studied with William Merritt Chase at the Art Students League in 1908, her brightly colored monotypes of flower arrangements, based on her garden in Provincetown, had little relation to Chase's monochrome, tonal compositions. Her vigorous brushwork and boldly abstracted forms suggest the influence of Cubists Albert Gleizes, Fernand Léger, and André Lhote, with whom she studied in Paris. Upon returning to the United States in 1924, she began to explore a variety of media, including china painting, batik, rug design, and monotype, often transposing an idea from one medium to another.

Although making color monotypes was just a small step from making a white-line woodblock, only a few of the Provincetown printmakers took it. Ellen Ravenscroft made several skillful compositions of Provincetown landscapes (fig. 123), and Agnes Weinrich created several figure compositions and still lifes in monotype (fig. 124). However, the medium proved to be no competition for the color woodblock print.[46] The greatest monotype activity in Provincetown took place among painters such as Ross Moffett, Edwin Dickinson, and Karl Knaths. Dickinson and Moffett had been close friends since their studies with Hawthorne before World War I; Knaths and Moffett had been fellow students in Chicago. Dickinson represented a more traditional approach to painting, based on his studies with Hawthorne, whereas Knaths was attracted to the modernist ideas of artists such as Agnes Weinrich and Blanche Lazzell, both of whom had studied with Gleizes in Paris. Moffett was sympathetic to both approaches and often served as a mediator between the conservative and modernist factions in Provincetown.

Despite their artistic differences, Moffett, Dickinson, and Knaths became close friends and sometimes worked together. Moffett and Dickinson had adjacent studios at the Days lumberyard from 1915 through 1917, during which time Moffett began making monotypes. He had experimented with etchings around 1914 but made very few. As a follower of Hawthorne's principle of using direct color as a statement of form, Moffett perhaps found the black-and-white etching too limiting a means of expression. Although he was not part of the group of Provincetown color woodblock printers, he was surely aware of the technique they used, which may have inspired him to make monotypes. Painting in the light-field method with oils on a smooth surface allowed Moffett to follow the precepts he had learned from Hawthorne while working more spontaneously than was possible on canvas. Intense colors and painterly surfaces distinguish Moffett's monotypes from the more decorative images of the color woodblock printers. A work such as *Woman with Red Hair* (fig. 125) conveys a sense of emotional energy reminiscent of the art of Edvard Munch, which Moffett had seen as a student at the

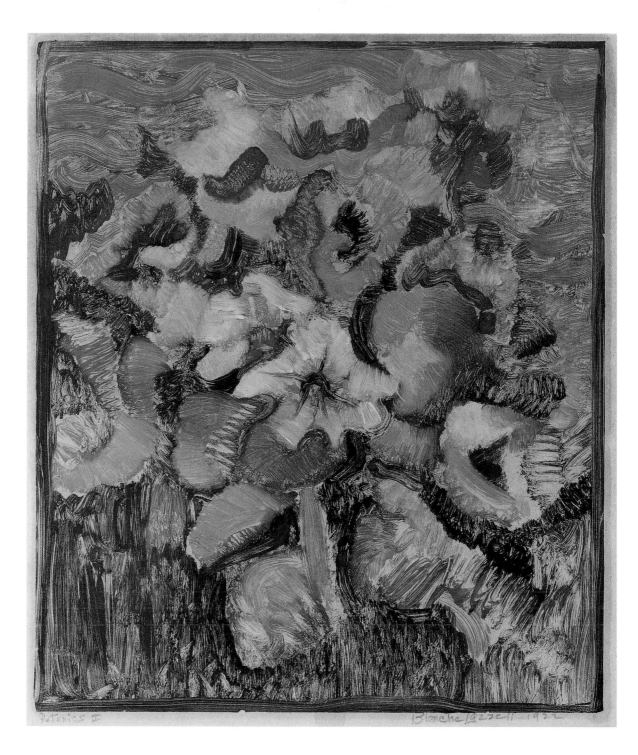

Fig. 122

Blanche Lazzell, *Petunias II*,

1922, color monotype,

35.5 × 30.5 cm (14 × 12 in.).

National Museum of American

Art, Smithsonian Institution

Fig. 123 (above)
Ellen Ravenscroft, *Untitled
(Provincetown Street),* ca.
1920–25, color monotype,
19.7 × 24.8 cm
(7 ¾ × 9 ¾ in.).
Georgia Mattison Coxe

Fig. 124 (right)
Agnes Weinrich, *Two
Women in Garden,*
ca. 1920, color monotype,
23.5 × 19.2 cm
(9 ¼ × 7 9/16 in.).
Maurice and Margery Katz

Fig. 125

Ross Moffett, *Woman with Red Hair,* 1922–25, color monotype, 36.8 × 30.2 cm (14½ × 11⅞ in.).

National Museum of American Art, Smithsonian Institution, Gift of Josephine and Salvatore Del Deo

School of the Art Institute of Chicago. Toning down the bright colors and expressionistic brushstrokes when he returned to Provincetown in 1920 after army service during World War I, he continued making monotypes through the 1940s. In four monotypes from 1931 that recall his Iowa boyhood, including *The Mink Trapper* (fig. 126), Moffett's monotype style became more linear, with forms defined by dark outlines and tones created by patterns of short, bold brushstrokes. Turning away from depicting the people and landscape of Provincetown, he focused on minerals and other geologic forms abstracted into Cubistic compositions.

Edwin Dickinson's notebooks reveal a very active period of making monotypes in August and early September 1916, at a time when he was in closest contact with Moffett.[47] Only one of his monotypes is dated, so it is impossible to determine whether he continued to work in the medium. *Imaginary Paris Studio* (fig. 127), which was probably made during this period of concentrated monotype activity, displays the vigorous, expressive brushwork that relates strongly to Moffett's approach to the medium at that time. However, in other monotypes, such as *Backyard, Provincetown* (fig. 128), Dickinson created images more akin to his broadly painted landcapes that emphasize nuances of the gray and chalky tones of a cloudy day on Cape Cod, in which lines and forms are softened by the enveloping mist. Applying paint much more judiciously, and working in both the light and dark manner of creating form, he used the white of the paper as a compositional element to unify the scene, wiping away paint and exploiting its luminosity through thinly brushed paint. Accented by discreet touches of color, the muted tones and abstracted imagery suggest an almost Whistlerian delicacy, but the broad, painterly brushstrokes and flattened sense of space reveal an artist seeking to adapt his conservative training to modern ideas of composition and form.

As a student at the School of the Art Institute of Chicago, Karl Knaths had met Ross

Fig. 126

Ross Moffett, *The Mink Trapper*, 1931, color monotype, 26.7 × 40.6 cm (10½ x 16 in.).

National Museum of American Art, Smithsonian Institution, Gift of Josephine and Salvatore Del Deo

Fig. 127

Edwin Dickinson, *Imaginary Paris Studio,* 1916, color monotype, 38.3 × 30.8 cm (15 ⅛ × 12 ⅛ in.).

The Brooklyn Museum, Dick S. Ramsay Fund

Fig. 128

Edwin Dickinson, *Backyard, Provincetown,* ca. 1916, color monotype, 54 × 52 cm (21 ¼ × 20 ½ in.).

Morris Collection

Fig. 129 (opposite)
(Otto) Karl Knaths, *Untitled*
(Figure in Landscape), ca.
1920, color montype, 38.1
× 30.5 cm (15 × 12 in.).
Collection of Mary and David
Green, courtesy Robert Henry
Adams Fine Art

Moffett, who was already talking about Provincetown. Knaths did not go there until 1919. He must have begun making monotypes with Moffett shortly thereafter, as the two artists exhibited monotypes in the annual watercolor and miniature exhibition at the Pennsylvania Academy of the Fine Arts in 1920. Following his first exposure to modern art when the Armory Show traveled to Chicago, Knaths had begun to compose his subjects as simplified planes and to experiment with color. His monotypes of 1919–20 reveal his interest in merging the bold, nondescriptive colors of Fauve painting with the geometric abstraction of Cubism (fig. 129).[48] His exploration of modernist abstraction attracted the attention of Agnes Weinrich, which led to his association with the other Provincetown printmakers. Although Knaths considered himself primarily a painter, monotypes such as *Mountain Landscape (Sunset)* (fig. 130) represent his most successful assimilation of modernist color and form into a distinctive personal expression.

Moffett and Knaths appear to have been the most prolific monotype artists in Provincetown from the 1920s through the 1940s, but numerous other artists also experimented with the medium, including Dorothy Loeb, Jerry Farnsworth, Oliver Chaffee, Julius Katzieff, Bruce McKain, and Fritz Pfeiffer. The medium was not associated with any particular style or faction, although it tended to attract artists who favored abstraction and experimentation rather than those of a more academic bent. Interest continued in succeeding generations of artists who lived year round or spent summers in Provincetown, such as Boris Margo, Nanno de Groot, Wolf Kahn, Mervin Jules, and Tony Vevers.

Boris Margo took his plates and inks across the dunes to a beach hut, where he worked in solitude. Surrounded by nature and little else, he applied ink to the plate with broad strokes suggesting the dunes, sea, and sky around him. Pressing a piece of paper over the wet ink surface, he created patterns and textures that suggested forms, which he defined with ink outlines and developed into compositions. An extension of his earlier experiments with decalcomania, the monotype served as a window into his imagination, a process that tapped his unconscious thoughts, inviting chance effects that helped the artist develop his abstract, surreal imagery (fig. 131).[49] During the summer of 1940, Margo created more than fifty monotypes, many of which became the basis for later paintings.

The Monotype in the Midwest

The year-round community of artists in Provincetown inevitably became aware of one another's work and shared ideas. Those who came during the summer brought new ideas and also took away what they had learned. For example, Jesse Beard Rickly, who had studied with Robert Henri, Charles Hawthorne, and Henry Hensche at the Cape Cod Art School, returned to the Midwest, where she co-founded the Ste. Genevieve artists' colony in the picturesque town of Ste. Genevieve, Missouri, in 1932. One of her goals was to bring to the region some of the more advanced ideas on contemporary art that she had been exposed to in Provincetown. In 1934 she and another former student of Hawthorne's, Aimee Schweig, established the Ste. Genevieve Summer School of Art, based on Hawthorne's conservative principles but encouraging modernist ideas and experimentation. Rickly's monotypes of the 1930s, such as *Uncle Tom Rozier* (fig. 132), recall the outlined compositions of Moffett and Knaths, while the solid, angular forms of the figure and trees suggest a Cézannesque style of abstraction applied to a regionalist subject.

Exerting influence from the West Coast was the Panama-Pacific Exposition of 1915, whose

Fig. 130 (left)
(Otto) Karl Knaths,
*Mountain Landscape
(Sunset),* ca. 1920, color
monotype, 37.5 × 30.5 cm
(14¾ × 12 in.)

Gabriel Zepecki and Frederick Jules

Fig. 131 (below)
Boris Margo, *Untitled,*
1940, monotype with ink
additions, 22.8 × 29.5 cm
(9 × 11⅝ in.).

National Museum of American
Art, Smithsonian Institution,
Museum purchase made possible
by the Richard Florsheim Art
Fund, ©1978 Boris Margo

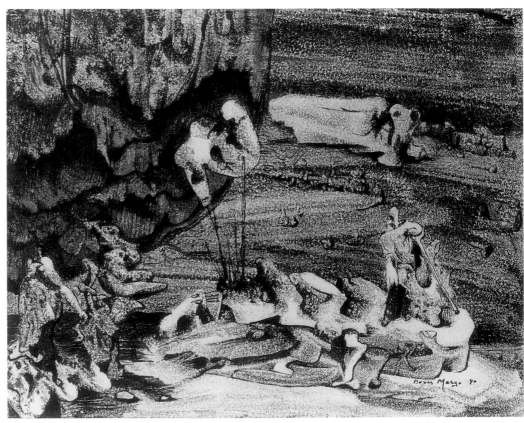

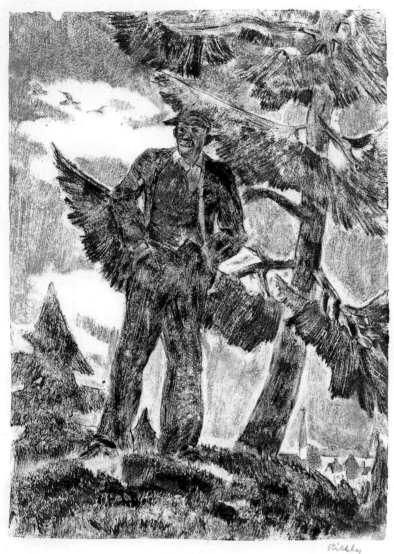

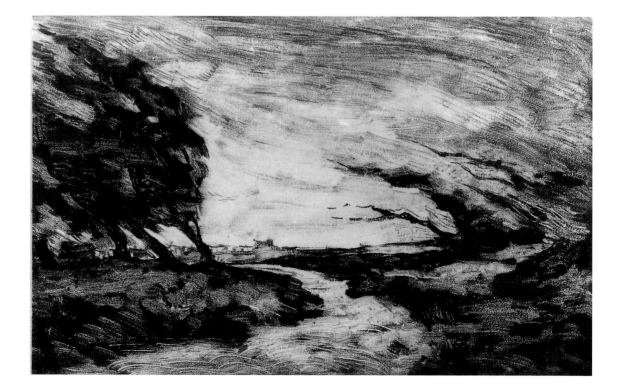

Fig. 132 (left)
Jessie Beard Rickly, *Uncle Tom Rozier,* 1930s, color monotype, 22.9 × 16.5 cm (9 × 6 ½ in.).
Aaron Galleries, Chicago

Fig. 133 (below)
Francis F. Brown, *Stormy Landscape,* 1917, monotype, 17.2 × 24.8 cm (6 ⅜ × 9 ¾ in.).
Denenberg Fine Arts, San Francisco

impact was felt far beyond the San Francisco Bay Area. Many artists from around the country exhibited and visited the exposition. Indiana artist Louis Oscar Griffith was awarded a bronze medal for his entry and returned home after seeing the color monotypes on display at the exposition. Francis Focer Brown of Muncie, Indiana, made monotype landscapes strongly reminiscent of the moody, Romantic scenes inspired by the variable wiping of plates during the etching revival of the 1880s and 1890s (fig. 133). As early as 1880, etchings were made in Indianapolis by members of the Bohemian Club, including William Forsyth, Fred A. Hetherington, and Thomas E. Hibben. In 1905 Forsyth began teaching at the newly opened John Herron Art Institute, where Brown may have been introduced to the medium as a student.

The Brown County (Indiana) Etchers Club was founded during World War I, and by 1918 Chicago artist Charles Dahlgreen was a seasonal visitor to the Brown County art colony. An experienced etcher who had won an honorable mention for his work at the Panama-Pacific Exposition, he showed a large group of monotypes at the Roullier Gallery in Chicago in 1914 and exhibited forty-five etchings and fifty-five monotypes at the Art Institute of Chicago in 1916. Presenting a Romantic, brooding view of nature, often with trees silhouetted against turbulent skies, the monotypes elicited greater attention than his etchings in the many positive reviews of the exhibitions (fig. 134). Dahlgreen's stature as an etcher, as well as his extensive work in monotype, probably inspired several artists he met in Brown County, such as Brown, to work in this medium. The Brown County Etchers Club disappeared from the record in 1920, but by 1930 enough etchers were there to justify a catalogue of their work, published for an exhibition and sale.

Despite vigorous activity in etching and a burst of interest in the monotype between 1915 and 1920, few artists in Indiana appear to have devoted much time to the monotype. When Paul Warren Ashby of Wolcottville, Indiana, established the American Monotype Society in 1940 and organized a traveling exhibition for the society in 1941, he was the only Indiana artist included.[50] One of the medium's most ardent advocates, he probably learned the process from Francis Focer Brown, with whom he had studied at the John Herron Art Institute. Ashby explained his reasons for making monotypes in a pamphlet, *The How and the Why of a Monotype,* published privately in 1941.[51]

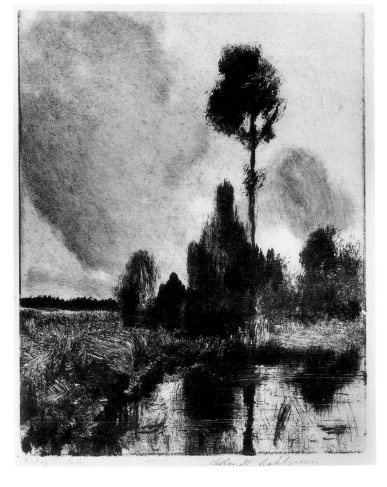

Fig. 134

Charles Dahlgreen, *End of the Lake,* ca. 1914–16, monotype, 17.7 × 13.8 cm (6 15/16 × 5 7/16 in.).

Graphic Arts Collection, National Museum of American History, Smithsonian Institution

I bother [making monotypes] because the restraints and handicaps of the medium tax my ingenuity and are intriguing. I bother because it does require sureness of touch, color and good drawing. To me it is not as uncertain as the uncertainties of color variation in drying water colors, or the uncertainties of the long drying period of oils. . . . It is genuinely exhilarating to take a fluid medium and bring from it while still in a fluid state, definiteness, sureness and good drawing. It takes skill to put just the right amount of the medium on the plate . . . to escape the blurry condition of too much ink, the spotty condition obtained by uneven application of ink. The temperature of the room, the temperature of the medium all enter into this, for variations bring widely different results. I must

judge these conditions and learn to control them. I must be sensitive to the tonal values in black and white with all the intermediate values. I must be alert to every changing condition far more so than in any other medium. . . . It gives me a greater feeling of satisfaction and more pure creative joy than any other medium.

Ashby also responded to critics who questioned the financial wisdom of taking a single proof from a plate:

From a time element, it takes no longer for me to make fifty monotypes than it does for me to design, cut a block and make fifty prints in monochrome. On an edition of fifty prints from a set of five or more color blocks, I spend a great deal more time than I do on fifty full color monotypes. The expense of paper, inks, etc., is about the same for both groups . . . hence I can make a monotype for no more than I do a block print.

Nor was he daunted by using fifty subjects instead of one, for he had a fertile imagination and saw subjects all around him. The American Monotype Society was short-lived, and Ashby's influence was negligible.

Other artists in the Midwest had begun to make monotypes in the 1930s and 1940s, but there is no evidence of a cohesive group interested in the medium. In Chicago Julio de Diego and Walter Ellison made monotypes during the 1930s independently of each other. The subject of de Diego's *Le Duet Intime* (fig. 135) reveals his European background, while Ellison's autobiographical narrative, *The Sunny South* (fig. 136), is full of specific details characteristic of American regionalist art.

In Lincoln, Nebraska, Dwight Kirsch made monotypes and introduced others to the process during the 1940s while teaching at the University of Nebraska, and later in Des Moines, Iowa, where he became director of the Des Moines Art Center. Roger Crossgrove, who studied with Kirsch in Nebraska and introduced later generations of artists to the monotype as a teacher at the University of Connecticut, recalled monotype parties at Kirsch's home. Kirsch had concocted his own medium so that watercolor paints and homemade gouache would spread evenly and remain moist long enough to create an image on glass and transfer it to paper.[52]

On the Eastern Seaboard

In the mid-Atlantic region, artists making monotypes in the early twentieth century included James Henry Moser, Will H. Chandlee, August H. O. Rolle, and Ruel Pardee Tolman, as well as Gwyneth King Brown and Herbert Pullinger in

Fig. 135

Julio de Diego, *Le Duet Intime,* 1933, color monotype, 28 × 22 cm (11 × 8½ in.).

Robert Henry Adams Fine Art

Fig. 136

Walter W. Ellison, *The Sunny South,* 1939, color monotype, 53.5 × 40.6 cm (21⅛ × 16 in.).

The Art Institute of Chicago, H. Karl and Nancy von Maltitz Endowment, 1990.158. Photograph ©1996 The Art Institute of Chicago. All rights reserved

Fig. 137

William Fowler Hopson,

Sunset by the Coast,

ca. 1900, monotype and

ink, 12.1 × 24.8 cm (4¾

× 9¾ in.).

National Museum of American

Art, Smithsonian Institution

Philadelphia. Artists in Connecticut and other parts of New England had been familiar with the monotype since shortly after the turn of the century. Many had studied in Paris, and most of them regularly visited the major art centers of New York and Boston to exhibit their work, visit galleries, and participate in social activities at such places as the Salmagundi Club. Charles De Wolf Brownell, who lived in Bristol, Rhode Island, and Jay Hall Connaway made color monotypes in Vermont in the mid-1920s. William Fowler Hopson, a professional engraver and bookplate designer who lived in New Haven, Connecticut, appears to have turned to the monotype (fig. 137) because of the medium's personal, expressive qualities of line and tone: "The personality of an engraver consists not in rendering accurately the drawing and tones of the picture before him, but in the character of the lines which he weaves into his plate of block. As individuality of technique goes beyond mere production, however skillful, so does sweetness of line and atmospheric feeling far transcend individuality."[53] In his monotypes Hopson gave free reign to his romantic longing for individuality and atmosphere.

In the area around Darien, Connecticut, monotypes were made by artists associated with the Silvermine art colony, including Addison T. Millar and David Humphrey. Humphrey, in particular, won local renown for his color monotypes, which he made over several decades from approximately 1912 through the 1930s. A published description of his monotypes in 1931 applies to his earliest monotypes as well: "misty, gray-green trees; graceful figures in diaphanous robes, drifting languidly through exquisite flower-spangled meadows of shadow-haunted forests; fascinating satyrs, leering behind gray lichen-draped rocks—a world poetic in its conception,—a visualization of Debussy's 'A l'après midi d'un faune'[54] (fig. 138).

Elsewhere in the region, other artists took up the monotype for briefer periods of time. Rudolf Scheffler, who earned a comfortable living designing mosaics, murals, and stained-glass windows, took up summer residence in the artists' colony of Old Lyme, Connecticut, in the late 1920s, where he pursued a second career as a painter and craftsman. As Eugene Higgins lived nearby, it is possible that his work inspired Scheffler's interest in the monotype. Marion Huse, a painter associated with Springfield, Massachusetts, Pownal, Vermont, and Albany, New York, made monotypes while living in Europe in 1947–49. An exhibition of silkscreen prints at the Springfield Art Museum and a demonstration of the process by Harry Gottlieb led to her interest in serigraphy in 1940. Relishing the opportunity to make prints in color, she experimented with serigraphy to achieve more impressionistic and painterly effects through a more complex manipulation of the medium. During her eighteen months in Europe, she worked primarily in oil on paper, thickly applying intense colors in bold outlines and

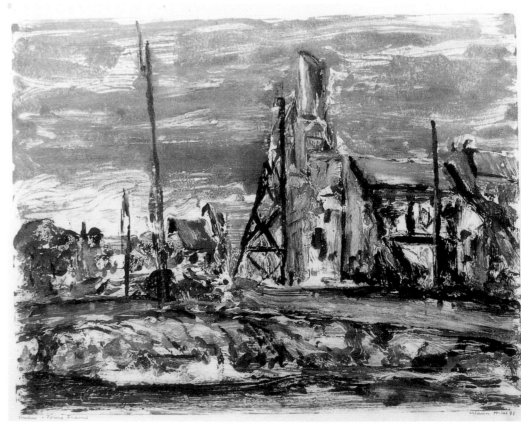

Fig. 138 (left)
David W. Humphrey,
The Rivals, n.d., color
monotype, 26.4 × 30.8 cm
(10⅜ × 12⅛ in.).

National Museum of American
Art, Smithsonian Institution

Fig. 139 (below)
Marion Huse, *Ruins—
Tours, France,* 1948, color
monotype, 35.6 × 45.8 cm
(14 × 18 in.).

Fuller Museum of Art, Brockton,
Mass. Marion Huse Collection,
Gift of Dr. Robert A. Barstow

Sunset over Hudson - Peekskill - N.Y. Seth Hoffman '37

Fig. 140

Seth Hoffman, *Sunset Over Hudson—Peekskill, New York,* 1937, monotype, 17 × 24.6 cm (6⅝ × 9⅝ in.)

Cornelia Cotton Gallery, Croton-on-Hudson, N.Y.

vigorous brushstrokes. As she lacked silkscreen equipment while abroad, Huse experimented with monotypes beginning in the summer of 1947, relishing the spontaneity and simplicity of the process. Painting her designs on a glass plate and printing them on paper with hand pressure, she worked in a more expressionistic style than the silkscreen permitted (fig. 139).

As painters began to appreciate the monotype as a method requiring little training or special equipment, access to a press became less important. Seth Hoffman, both a painter and a sculptor, worked with printer's ink on a glass plate, modeling three-dimensional forms primarily with his thumb and printing the image on dry paper by rubbing the joints of his fingers across the back of the paper (fig. 140). For Hoffman, the challenge of the monotype was to achieve the perfect balance of control and spontaneity in his imagery and technique:

In the six years which I have devoted to learning to control the ink, I have become steadily more enamoured of the Monotype. It repays so rapidly and so strongly what you give to it. It is such a personal art and such an exciting one. When I make a Monotype, I concentrate all my energies with a heightened sharpness. It is as if the nerve-ends in the fingers and eyes are sand-papered, and all the controls tightened. The results of such focussing of efforts seem to me to have a certain heat, a spontaneity.[55]

Hoffman's monotypes represent the extreme control that was possible with the subtractive method of working. Leaving nothing to chance, he even had a special ink made. Other artists invented other means to print their images. Georgia O'Keeffe's sister, Ida Ten Eyck O'Keeffe, printed her monotypes with an electric iron and wrote about the artist William J. Scott, who printed his monotypes with a hot spoon.[56]

New York remained one of the centers of monotype activity through the 1950s. The Salmagundi Club continued to provide the opportunity to experiment with the process on a casual basis, but several members were sufficiently interested to create significant bodies of work in monotype. Salvatore Antonio Guarino exhibited sixty color monotypes at the Newark Public Library and the Kraushaar Galleries in New York in 1917, and two years later at this gallery he showed monotypes along with his paintings. According to one critic, Guarino's monotypes united "the virility of oils with the soft allure of Japanese silk-painting."[57] Although he had been strongly influenced by Whistler's compositions and choice of subjects, Guarino took advantage of the rich, intense colors of oil paint to create a distinctive body of monotypes that renounced the muted tones of Whistler's paintings while maintaining a delicacy of surface that recalled the subtleties of Whistler's hand-wiped etchings (fig. 141). A. Henry Nordhausen, president of the Salmagundi Club from 1959 to 1963, made a substantial number of monotypes in the 1930s and 1940s. When Will Barnet began teaching printmaking at the Art Students League in the mid-1930s, he introduced the monotype to his students.[58]

A variety of reasons led both conservative and modernist artists to the monotype process. William Gropper made monotypes from 1921 to 1924 because he lacked adequate funds to buy canvas for paintings. An artist who did his own printing, he explored the monotype as a

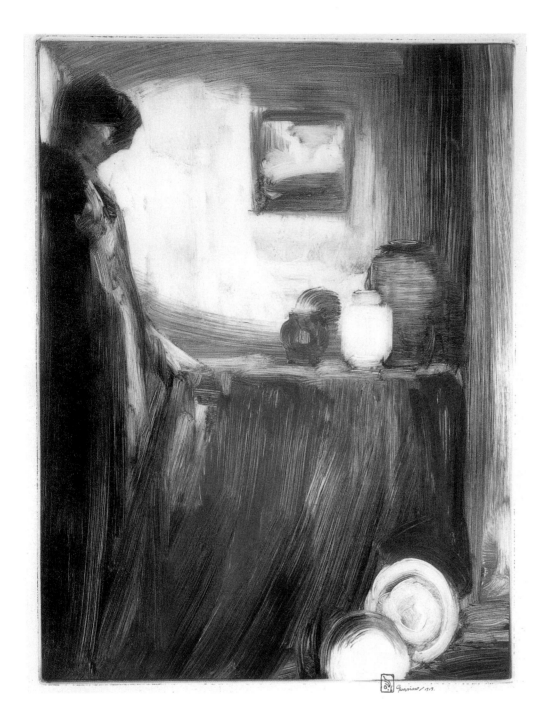

Fig. 141

Salvatore Antonio Guarino,

Porcelains, 1917, color

monotype, 40.6 × 30.5 cm

(16 × 12 in.).

Kraushaar Galleries, New York

means of moving toward a more painterly form of printmaking that would allow him to work easily with color. Similarly, during the 1920s and 1930s Theresa Bernstein chose the process because it permitted free application of expressionistic brushstrokes in her depictions of New York scenes (fig. 142). Her husband, William Meyerowitz, focused much of his attention on color etching; the monotype appears to have been Bernstein's painterly contribution to his experimentation, especially those impressions that she printed as monotypes over etching. On the other hand, Blendon Reed Campbell made monochrome monotypes so detailed and linear in conception that, at first glance, they appear to be lithographs or etchings. Upon closer inspection, however, it is apparent that their linear quality is the result of ink applied with a stiff brush in a very precise and controlled manner (fig. 143), as if Campbell wished to achieve the look of a print without engaging in the actual process of making an etching or lithograph.

The relative simplicity of creating a monotype remained an important aspect of its appeal

Fig. 142 (left)
Theresa Bernstein, *New York Street,* 1924, color monotype, 43.2 × 28.2 cm (17 × 11⅛ in.).

Graphic Arts Collection, National Museum of American History, Smithsonian Institution

Fig. 143 (below)
Blendon Reed Campbell, *Paris (Courtyard),* 1927, monotype, 32.2 × 23.5 cm (12¹¹⁄₁₆ × 9¼ in.).

Whitney Museum of American Art, Gift of Juliana Force. Photograph ©1996 Whitney Museum of American Art

for many artists. In 1949, at the height of his creative powers, Milton Avery suffered a serious heart attack and spent the winter seasons of 1949–50 and 1950–51 at studios established for artists in Maitland, Florida, near Orlando. Unable to endure the physical exertion of painting, he was encouraged to make monotypes by his friend Boris Margo, who occupied a neighboring studio. Avery painted the images on glass and printed them by hand, usually on watercolor or rice paper. The whimsical nature of many of his monotype subjects reveals the delight he took in the technique, whose spontaneity gave free reign to his imagination. Although Avery had made some monotypes in 1930, they were smaller and more detailed, without the sweeping line and sure touch that came from an additional twenty years of experience.

Fig. 144 (above)
Milton Avery, *Fish in Dappled Sea,* 1950, color monotype with mixed-media additions, 43.8 × 55.9 cm (17 ¼ × 22 in.).
Milton Avery Trust

Fig. 145 (right)
Milton Avery, *Nude Recumbent* (*Nude Asleep),* 1950, color monotype, 55.3 × 42.6 cm (21¾ × 16¾ in.).
Mr. and Mrs. Herman Binder

During the early 1950s Avery made almost two hundred fifty monotypes, using a wide variety of techniques: painting, wiping, scratching, saturation with turpentine or oil, stick and brush work, overpainting, stencils, and numerous variations of each (fig. 144). The monotype process complemented the formal direction of his painting, which was moving toward a more reductive expression, a flattening of form, and a more calligraphic gesture. Avery's years of experience as a painter are evident in his assured application and manipulation of paint. Yet he relished the element of chance introduced by the transfer process, as well as the great varieties of texture and line that resulted from the process of pulling the printed impression from the still-wet plate (fig. 145).

Avery's discouraging experience with exhibiting his monotypes may indicate why he stopped making them after a few years, and why this has often been the case for other artists. His exhibition of monotypes at the Laurel Gallery in New York in 1950 received attention and favorable reviews, but not a single work was sold. There was no market for monotypes. Print collectors were uncomfortable with the hybrid nature of the process and the lack of an edition, while those who collected paintings viewed monotypes as prints and therefore not in their realm of interest. Monotypes were often specifically excluded from juried print exhibitions. Although Avery was much less financially dependent on the sale of his work than many other artists, the lack of appreciation may have discouraged him, just as it surely would have discouraged artists who needed to make sales in order to support themselves.

Fig. 146
Adolph Gottlieb, *Untitled*, 1973, color monotype, 61 × 45.7 cm (24 × 18 in.).
©1979 Adolph & Esther Gottlieb Foundation, Inc., New York

Avery was not the only artist to take advantage of the monotype's directness and ease of execution at a time of illness or declining physical stamina. In 1970 Adolph Gottlieb suffered a major stroke that left him paralyzed in one arm and confined to a wheelchair. No longer able to develop a painting on canvas, even one of moderate size, he needed assistants to prepare the canvas, mix colors, and position the surface so he could reach the areas he wanted to paint. It became necessary to preconceive the painting in order to instruct his assistants. During the spring of 1973 art dealer Brooke Alexander encouraged Gottlieb to begin a new series of prints and sent a press, paper, and a printer to the artist's studio in East Hampton, New York. In preparation for a series of etchings and aquatints, he began making monotypes, a technique he had not used since the 1930s and 1940s. When he realized he could make monotypes by himself and print them with the assistance of his wife, he sent the printer away. The smaller scale of the paper and the smaller quantities of paint needed for a monotype allowed him to return to a hands-on process of creation and regain control over his work despite physical limitations. Gottlieb's wife recalled that he approached the monotype with

Fig. 147

Mervin Jules, *Cove*, ca.

1980–85, color monotype,

60.1 × 48.3 cm

(24 × 19 in. sheet).

National Museum of American
Art, Smithsonian Institution,
Gift of Gabriel Zepecki and
Frederick Jules

renewed joy and energy to produce an impressive body of more than thirty monotypes during the last year of his life (fig. 146).[59]

Mervin Jules produced some of the strongest works of his career when he began to make monotypes during the 1970s after a serious illness that confined him to a wheelchair. Moving from the more detailed, figurative style of his earlier work, he sought inspiration in the sea and land surrounding his Provincetown retreat and created strong abstract compositions that reveal his ability as a colorist (fig. 147). Sculptor Reuben Kadish also turned to the monotype in the 1970s when he could no longer make his monumental metal and terra-cotta forms. His powerful black-and-white images of snakelike forms and anatomical parts suggest aggression and carnality while also evoking the mythic imagery and drama that characterize his work throughout his career (fig. 148).

New Approaches to the Monotype

Artists associated with the colony around Woodstock, New York, such as Paul Rohland, Alfred Hutty, Andree Ruellen, Konrad Cramer, Werner Drewes, and Rolph Scarlett, made monotypes, but there is no indication of organized monotype activity in the colony itself. Most of these artists spent their winters elsewhere. Alfred Hutty spent much of the year in Charleston, South Carolina; Paul Rohland spent time in the south of France and the American South; and Werner Drewes was teaching at Washington University in St. Louis at the time he made his monotypes.

The monotypes made by Rohland and Hutty represent the now-standard approach of transferring a wet image from a single surface to a sheet of paper, but some of the other artists began to develop a more experimental approach. For example, Cramer made a series of monotypes in 1923 depicting a woman seated in a chair (fig. 149). Beginning with an

Fig. 148

Reuben Kadish, *Duo,* 1985, monotype, 55.8 × 75.7 cm (22 × 29 13/16 in.).

National Museum of American Art, Smithsonian Institution, ©1985 Reuben Kadish

Fig. 149 (left)
Konrad Cramer, *Untitled
(Woman in Chair with Arm
Raised),* ca. 1923, color
monotype, 35.9 × 27.3 cm
(14⅛ × 10¾ in. sheet).
National Museum of American
Art, Smithsonian Institution

Fig. 150 (opposite)
Werner Drewes, *Nausikaa
(no. 149),* 1951, color
monotype, 50.5 × 37.8 cm
(19⅞ × 14⅞ in.).
National Museum of American
Art, Smithsonian Institution, Gift
of the artist

image painted loosely in bright colors against a blank background, with suggestions of a cur-
tain and a floor, he created three unique prints based on the first image. Using the paint left
on the plate as a guide, he modified the pose in each impression to create a small variant edi-
tion. Drewes also explored the possibility of creating a variant edition from a monotype im-
age. Painting on a slick celluloid surface, he created as many as ten related impressions, re-
taining the basic composition but varying the colors in each proof (fig. 150).[60]

Scarlett combined monotype with woodblock and pochoir to create unique images in
which some of the elements recurred but did not form an exactly repeatable matrix (fig. 151).
Rolling color on a flat surface, he generated a background pattern or texture that could not
be repeated and then printed woodblock or pochoir forms over the brayer marks. The entire
image was printed as a monotype, with additional lines often drawn on the surface of the
impression to complete the image. Although the pochoir and woodblock elements could be

3/X Dvm̌k 51

Fig. 151 (left)
Rolph Scarlett, *Nature's Catalyst,* 1940s, color monotype with watercolor additions, 62.2 × 45.7 cm (24½ × 18 in.).
Collection of Harriet and Albert Tannin

Fig. 152 (below)
Charles William Smith, *Red Accents,* 1930s, color monotype printed from movable blocks, 42 × 52.8 cm (16½ × 20¾ in.).
Courtesy of the Fogg Art Museum, Harvard University Art Museums, Louise E. Bettens Fund

La Mesa negra; Monotype 1949

Fig. 153

Adja Yunkers, *La Mesa,*

ca. 1948, color monotype,

47.5 × 66 cm (18¹¹⁄₁₆

× 26 in. sheet).

Rosenwald Collection, ©1996
Board of Trustees, National
Gallery of Art, Washington

repeated from one image to the next, they never reappeared in the same configuration, resulting in unique compositions that did not constitute a variant edition.

Some artists explored the possibilities of using repeatable elements inked differently or placed in changing relationships to one another for each impression. In the 1930s Charles Smith worked with movable woodblocks to create unique compositions with repeatable parts (fig. 152). Recognizing that his images were not monotypes in the strictest sense of the word, Smith called his impressions "block paintings."[61] In the 1950s Naum Gabo created a series of wood engravings that he varied from print to print by changing the inks, colors, pressure, and papers. Gabo printed his engraved woodblocks by hand with pressure from a spoon or other implement, eschewing the possibility of making a consistent edition.

The freedom and spontaneity of the monotype appealed to many forward-looking contemporary artists who were exploring new technical possibilities for creating images. Adja Yunkers, a woodcut artist with an international reputation, came to the United States in 1947 to teach at the New School for Social Research in New York. He began making monotypes in 1948 during a summer spent teaching at the University of New Mexico and continued experimenting with the medium into the mid-1950s.[62] In *La Mesa* (fig. 153), he printed the texture of crumpled paper to suggest clouds, much as artists at Stanley William Hayter's workshop in New York were experimenting with imprinting unusual textures in soft-ground etchings. An experienced printmaker as well as a painter, Yunkers often conceived his monotypes in several stages, using superimposed pieces of paper and several layers of printing to create various effects of density and transparency.

Fig. 154

Harry Bertoia, *#1260*,

ca. 1940, color trace

monotype, 60 × 85.1 cm

(23 ⅝ × 33½ in.).

National Museum of American

Art, Smithsonian Institution, Gift

of B. Valentiner Bertoia

The experimental approach developed by artists during the postwar decades anticipated the proliferation of monotype processes that would be explored in the 1980s. Robert Broner created "texture imprints" by printing from ink or oil color painted on the surface of fabric collages. In Chicago, Don Baum printed monotypes in printer's ink over watercolor backgrounds.[63] During the late 1940s Hedda Sterne transformed some of her drawings into trace monotypes in order to introduce a softness to her line and an atmospheric quality surrounding the forms, as well as an element of chance that expressed her ambivalent reaction to the sense of mechanized power she experienced in New York after emigrating from Bucharest. In 1953 Cy Twombly experimented with making monotypes from pieces of cardboard scored crudely with a nail and inked in black—the most primitive method of image-making combined with the simplest and most direct method of printing.

Perhaps the most fully resolved and sustained bodies of work in monotype dating from the postwar period were those made by Harry Bertoia and Mark Tobey. For Bertoia, working in the 1940s and 1950s, the monotype process was primarily a method of drawing that introduced an element of chance into an otherwise controlled process, an adaptation of the accidental images derived from automatism. Beginning with a film of printer's ink rolled onto a smooth surface, he laid a sheet of rice paper over it and drew on the back of the paper with a pencil, a stick, a block of wood, the heel of his hand—anything that would imprint a line or texture onto the paper (fig. 154). Sometimes he inserted a hand-cut stencil between the inked surface and the paper to create white forms set off by the grainy texture of the ink. In

Fig. 155 (above, left)
Mark Tobey, *Brown
Composition*, 1960,
tempera monotype on
crumpled and torn paper,
45.5 × 28.5 cm
(17 × 11 in.).
Paolo Baldacci Gallery, New York

Fig. 156 (above, right)
Mark Tobey, *Trees in
Autumn*, 1962, tempera
monotype on chamois
paper, 40.6 × 30.5 cm
(16 × 12 in.).
Paolo Baldacci Gallery, New York

1943 Bertoia showed nineteen monotypes at the Solomon R. Guggenheim Foundation and continued to exhibit monotypes until he ended his relationship with the Nierendorf Gallery in 1947. Thereafter he used his work in this medium as a private notebook of ideas, referring to them regularly during his subsequent career as a furniture designer and sculptor.

Bertoia made monotypes early in his career before developing the sculptural imagery for which he is best known, whereas Tobey came to the monotype toward the end of his career, in the 1960s, after attaining international acclaim for his mature paintings. Working on slabs of lightweight plastic that was porous and often heavily textured, he applied tempera paint—more fluid than oil paint or printer's ink and a more quick-drying substance than oil-based pigments. Sometimes working with a kitchen sponge, sometimes creating lines with wax or string, Tobey appreciated the role of accident in determining the final image. His fascination with the monotype has been described as a "desire to distance himself from process, to turn picture making into a voyage of discovery, rather than an imposition of intellect."[64] Tobey valued the residues left from one printing to the next and often printed ghost images from the plate or counterproofs from the wet impressions. The absorption of the paper, as well as the thinning and bleeding of the paint as it was transferred from one surface to another, gave his

Fig. 157
Theodore Stamos, *Divining Rod III*, 1950, color monotype, 33.6 × 24.3 cm (13¼ × 9⅝ in.).

The Baltimore Museum of Art: Gift of the Artist, BMA 1958.147.3

monotypes an overall luminosity that serves as a metaphor for universality and wholeness. In *Brown Composition* and *Trees in Autumn* (figs. 155 and 156), he used crumpled paper to introduce another element of chance to the transfer process, adding a web of line and texture to the printed image that was not on the painted plate.

During the 1940s and 1950s the traditional boundaries of printmaking were challenged. Artists began to seek new methods of making color prints. The silkscreen was converted from a commercial medium for making banners to an artistic medium capable of producing complex and even painterly color prints. Engraving was transformed from a reproductive medium to a technique for original expression. Soft-ground etching became a process for creating texture and tone on an intaglio plate. Artists began to mix relief, intaglio, and planographic methods of printmaking to create a single image. The types of matrices from which artists made prints and three-dimensional multiples increased dramatically. Photographic images and offset presses, which had traditionally belonged to the world of reproductive printmaking, were gradually accepted into the realm of fine-art printmaking. At the same time that technology made it possible to create large editions of virtually identical impressions, the unique print gained acceptance and popularity.

Just as technical experimentation began to flourish among artists who printed their own work, professional printers hired by Tatyana Grosman and June Wayne were encouraged to invent new lithographic techniques to meet the needs of the painters invited to their workshops.[65] As more painters and sculptors were encouraged to try printmaking, new techniques were developed to allow them greater flexibility in creating their images. Simultaneously, several painters recognized the painterly possibilities of the monotype. Theodore Stamos's monotype *Divining Rod III* (fig. 157) focuses on the painterly gesture as an act of discovery. Created at a transitional point in his career, when Stamos was moving from organic abstraction toward a more gestural expression, based on an Oriental sensibility of calligraphic line, to structure his paintings, this monotype anticipates the direction his work would take in the next few years. Stamos appears to have recognized in the monotype a means to adopt a more spontaneous expression without sacrificing the distance and reflection that characterize his earlier work. Even the title of the series of three monotypes suggests their role as a touchstone for the artist's future development.

Although the creation of editions remained central to post–World War II American printmaking, the shift in emphasis to experimentation, color printing, and the painterly possibilities of graphic art laid the groundwork for the heightened interest in the monotype throughout the country during the 1970s and 1980s. As Richard Field has observed, "Only recently have we grown accustomed to looking at prints from a distance. No longer do we require them to consist of intimate details, but happily embrace the large images that hang on our walls and derive their meaning from the bold, gestural language of Abstract Expressionism or from the photographic illusions of mass media. For the most part, the monotype conforms to this recent preference. . . . To be sure, its textural complexities invite close inspection, but in the last analysis, the monotype appeals because it is a print become painting."[66]

4

The Contemporary Monotype Phenomenon

In 1972 critic Lawrence Campbell, commenting on the monotype, observed that "the medium seems beginning to move."[2] In New York a group of Milton Avery's monotypes at the Grace Borgenicht Gallery and a large selection of monotypes by various artists at the Pratt Graphics Art Center in New York were on display in concurrent exhibitions. In May of that year *An Edition of One,* an exhibition of monotypes selected by artist Matt Phillips, opened in Washington, D.C., and toured under the auspices of the Smithsonian Institution Traveling Exhibition Service (SITES). Also in 1972, an exhibition of Paul Gauguin's monotypes was presented at the Philadelphia Museum of Art, and the Philadelphia Print Club hosted an exhibition of contemporary monotypes. "The monotype seems headed for the stars," wrote Campbell, "like those which Avery made by wiping spots out of the paint on his glass."[3]

By 1978 independent curator Jane Farmer observed that "the monotype is currently enjoying unprecedented popularity. Artists who have never printed monotypes are trying them, and artists who have been working in the medium are now exhibiting their work for the first time."[4] During the 1980s the number of artists attracted to the monotype climbed even higher. Printmaking workshops began to offer assistance, and experimentation with the monotype became a widespread phenomenon, if not an actual movement. The emergence of the monotype as a popular medium of expression after almost a century of waxing and waning interest suggests that a changed set of circumstances, ideas, and values contributed to the discovery of its expressive potential by a new generation of artists.

A Persistent Attraction

At the same time, some artists continued to make monotypes for many of the reasons that had attracted their late-nineteenth-century predecessors. Washington, D.C., artist Jacob Kainen, reflecting upon his own involvement with the medium, expressed the attitude of

Sam Francis, *Slant* (detail, fig. 195), 1979, color monotype

147

Fig. 158 (left)
Jacob Kainen, *El Presidente*,
1978, color monotype,
45.7 × 60.9 cm
(18 × 24 in.).

National Museum of American
Art, Smithsonian Institution,
©1978 Jacob Kainen

Fig. 159 (below)
Robert Gordy, *Wanderer*,
1986, color monotype,
90.2 × 76.2 cm
(35¼ × 30 in.).

Roger Houston Ogden
Collection, New Orleans, La.

many painters who have found the mono-
type an invigorating complement to their
work in other media (fig. 158):

I have been doing monotypes for some years
now as a change of pace from the rigors of
painting on canvas. I like to begin without
much preconception but as the pictorial idea
develops I usually make numerous drastic
modifications, putting pigment on the plate
and taking it off as I choose, swiftly, through
various means, before transferring the image
to paper through pressure. Because of this
magic flexibility, the monotype permits both
spontaneity and its afterthoughts. And the
monotype has a physical presence uniquely
and strikingly its own—it can yield beauties of
color and facture unlike those of any other
medium.[5]

New Orleans artist Robert Gordy turned
to the monotype as a means of freeing
himself from a repetitive, formal manner
of applying paint to canvas, which led him
to feel constrained despite the acclaim his
work had received. "I had the feeling that
if I worked almost like knitting an Ivory
Tower . . . that in an almost mindless sort

Fig. 160

Beauford Delaney,

Untitled (Istanbul, Turkey),

1966, color monotype,

57.2 × 76.2 cm

(22½ × 30 in.).

Private collection, courtesy
Michael Rosenfeld Gallery,
New York

of way I would wind up with a sweater or something."[6] Introduced to the monotype during a trip to New Mexico in 1981, Gordy broke free from this rigidity to work in a looser, more painterly manner that nonetheless retained many of the hallmarks of his distinctive imagery. His turn to monotypes during the last five years of his life also coincided with the progressive deterioration of his health from the effects of AIDS. Being able to complete an entire work in a single day with less physical exertion than a painting demanded became an important aspect of the medium's appeal. *Wanderer* (fig. 159) was Gordy's last work and his most personal one. The figure looking back over his shoulder reflects on his past while moving inexorably toward his fate, suggested by the sun descending from high noon but not yet set. At once monumental and intimate, the image proclaims the artist's spiritual strength in the face of his illness.

Many African American artists have recognized in the monotype a visual counterpart to the improvisational nature of jazz, a musical form that has strongly influenced their work. In traditional subjects, such as Beauford Delaney's landscape view of Istanbul (fig. 160), as well as in more specifically jazz-related subjects, such as Romare Bearden's *Vampin' (Piney Brown Blues)* (fig. 161), the monotypes of these two artists represent a significant departure from their tighter, more controlled work in other media. *Vampin' (Piney Brown Blues),* one of Bearden's many monotypes from the 1970s that refer directly to jazz or the blues, shows a jazz pianist "vampin'," or performing an improvisation at the Sunset, the Kansas City nightclub managed in the 1930s by Piney Brown—himself the subject of a 1940 song by Joe Turner. The smoky atmosphere of the club, evoked by Bearden's choice of colors, as well as the softening effect of transferring paint and the absorption of thinned paint into paper, also suggests a recalled memory rather than an immediate experience. Recognition of the correlation between monotypes and jazz was not limited to African American artists. Matt Phillips described the plate from which a monotype was printed "as an arena of quicksilver activity,

Fig. 161 (above)
Romare Bearden, *Vampin'*
(Piney Brown Blues),
ca. 1976, monotype with
watercolor additions,
74.9 × 104.8 cm
(29½ × 41¼ in.).

National Museum of American
Art, Smithsonian Institution,
©1979 Estate of Romare Bearden

Fig. 162 (right)
Karl Schrag, *Flowering*
Tree—Bright Night, 1987,
color monotype,
52.7 × 61 cm (20¾ × 24 in.).

National Museum of American
Art, Smithsonian Institution, Gift
of the artist, ©1993 Karl Schrag

Fig. 163 (top)

Wendy Mark, *Cry To Me I*,

1995, color monotype,

7 × 7.6 cm (2 ¾ × 3 in.).

Theodore and Elizabeth Rogers,
New York

Fig. 164 (below)

Wendy Mark, *Cry To Me II*,

1995, color monotype,

7 × 7.6 cm (2 ¾ × 3 in.).

Theodore and Elizabeth Rogers,
New York

change and risk taking, like playing jazz, the image being built or canceled out by a cloth wipe or turpentine."[7]

Karl Schrag, a painter as well as a skilled printmaker in both lithographic and intaglio techniques, regarded the monotype as the perfect marriage of the two mediums, uniting the immediacy of painting with the distinctive surface effects of printmaking (fig. 162). Commenting on the variety of media in which he worked throughout his career, Schrag explained:

I have always had the feeling, that many, and very different forms of expression had to be found to correspond to the great wealth which I saw in the world around me. Nature in its ever-changing variety seems to be fantasy itself. The years as they pass have made greater and greater demands upon my own creative gifts to reach forms of expression which would correspond to the great variety of sensations I had, looking at the world. The works themselves must therefore at times have the lightness of a breeze, and at others the power of the storm.[8]

The Romantic landscape—a favorite subject of monotypes from the 1880s and 1890s—continues to be perceived as an especially suitable subject for this medium. Working on an intimate scale with a limited range of tones, Wendy Mark has created an extensive body of landscape monotypes that range from almost pure abstraction—a square divided in two by a horizontal line that suggests a low horizon, with land or water meeting the vastness of the sky—to slightly more complex compositions that reflect the influence of nineteenth-century artists, notably John Constable (figs. 163 and 164). A painter who reads poetry every day, Mark strives to continue a tradition linking Horace, Leonardo, Picasso, and others who sought to equate painting and poetry. Consequently, some of the greatest admirers of her work are poets, including Pulitzer Prize–winner Charles Simic, who states:

Wendy Mark's monotypes remind us of those moments when we make our world larger by dreaming. Dusky images. Magnificent silent evenings. Overcast landscapes of the soul. The still moment of the eye grafted to the heart Here are blurred images out of old dreams and skies of half-forgotten memories. . . . In an age in which large format is often mistaken for ambition and greatness, it is refreshing to find a true miniaturist working.[9]

For Mark, the transparency of color, the glowing light, and the softened edges that result from ink transferred to paper by pressure lend her landscape monotypes a sense of timelessness and distance, while the intensity of their condensed scale echoes the eloquence of lyric poetry.

While Mark explores the subtle moods of nature, other artists find the monotype a felicitous medium with which to express its drama.

Fig. 165

Idelle Weber, *Untitled*

(Cambridge Series A11),

1992, monotype, 61 × 61

cm (24 × 24 in.).

Whitney Museum of American
Art; Gift of Robert Kelly 96.139.
Photograph © 1996 Whitney
Museum of American Art

For Idelle Weber, the monotype became a vehicle for the rediscovery of the Romantic land-scape tradition, which led to a profound change in her approach to painting. During the 1960s she was an important member of the Pop art milieu, and during the next two decades she painted in a hard-edge, representational style that identified her as one of the leading artists of the Photorealist movement. By the mid-1980s her work was becoming more painterly, but it was not until the early 1990s, during a teaching engagement at Harvard, that she was introduced to the monotype. Weber began a series of tiny black-and-white images inspired by television shots of the Gulf War, which were quickly transformed into imaginary landscapes expressing the drama of nature and natural forces.[10] These experiments led to larger, more ambitious monotype landscapes, as well as a radical transformation of her signa-ture painting style (fig. 165). No longer concerned with descriptive color and carefully ren-dered forms and textures, Weber explored the expressive possibilities of tone by limiting her compositional elements to the meeting of sky and land or water at a distant horizon. Through manipulation of tone, she captured the transience of clouds, wind, atmosphere, and land for-mations in a drama of changing relationships that recall the experiments with variable inking carried out by Lepic and other artists of the nineteenth-century etching revival. Throughout her career as a painter, Weber relied on line as the basis of expression, but the experience of making monotypes released her more painterly instincts, imparting to her work of the 1990s, as John Yau wrote, "a sensuality that is simultaneously solid and elusive, bold and restrained, celebratory and ascetic."[11]

The subtractive method of creating an image retained its appeal in the dark-field mono-type, where allusion rather than depiction conveys the artist's thoughts. Alan Magee, a sculp-tor and painter before turning to the monotype, explains its importance for his work: "The monotype [is] . . . a process perfectly suited to record the life of the spirit—a realm in which dreams, intense and subtle emotions, and even premonitions recolor and reshape my compre-hension of the tactile world of things. Monotype has . . . changed the direction of my creative life, by teaching me about the world beyond appearances."[12] Like Weber, Magee had at-tained considerable success as a representational artist, whose meticulous renderings of such objects as beach stones, a braid of hair, a tube of paint, an upright squash, or firecracker fuses placed him squarely in the tradition of American realist art. His background as an illustrator was apparent in the elegant precision of his line. All of the objects were placed in a neutral space, removed from their function, peaceful and serene.

Magee made his first monotypes in the studio of fellow artist Joseph Goldyne in Sonoma, California. During a cross-country drive from his home in Maine, Magee kept hearing reports of murders and missing persons. When he returned to Maine, he began a series of mono-types, *Killers,* based on that experience; much of his subsequent work has overtones of vio-lence, dislocation, or distortion. The series of monotypes he created in 1990 (fig. 166), begun shortly before the Gulf War, expresses his sense of shock, then resignation, in the face of im-pending conflict. The combination of human and animal features in *Spirit* emerges from the rich, black background as a disembodied head, a surreal death mask with allusions to evil. At first glance the image appears as tangible as a photograph, but on closer scrutiny, the scratched surface where ink has been removed with a stiff cloth reminds the viewer that this is an illusion.

Fig. 166

Alan Magee, *Spirit,* 1990,

monotype, 45.7 × 61 cm

(18 × 24 in.).

Barbara Staempfli, New York

Despite the ease with which a color monotype can be made, many artists have explored the abstract tonal possibilities of the medium by limiting themselves to black and white. Wayne Thiebaud, for example, a consummate colorist and representational painter, created a series of spare yet painterly landscapes in monotype during the mid-1970s in which the dramatic structural elements of the composition are complemented by the gestural quality of the tonal areas. As Thiebaud noted, "An artist must be on guard against the danger of producing something simpleminded rather than simple or making something complicated instead of developing something truly complex."[13] Rather than focusing on the changing forms and moods of nature in the tradition of Romantic landscapes, Thiebaud's monotypes emphasize man's alterations to nature, from a dramatic freeway curving against a blank sky to a steep hillside sliced by roads that seem to defy the law of gravity (fig. 167). Juxtaposed with the lush, painterly texture of the hillside, heightened with a touch of yellow ink, the hardness and linearity of the paved road are emphasized by the stark contrast of its dark edges against white paper, caused by the pooling of ink wiped from the surface of the plate. A traditionally trained artist for whom drawing is the basis of his work, Thiebaud approached the monotype as a form of painterly drawing in which texture, tone, and line are intimately related in a single stroke or gesture.

Fig. 167

Wayne Thiebaud, *Three Streets Down,* ca. 1975

color monotype, 43.8 × 57.2 cm (17 ¼ × 22 ½ in.).

National Museum of American Art, Smithsonian Institution

For several artists, the element of chance or accident continues to be one of the monotype's most intriguing characteristics. While most artists have sought to achieve control over the monotype process, taking advantage of "happy accidents" only when they occurred, John Cage and Tom Marioni isolated this aspect of the process as a fundamental principle of their work. In 1985 Cage created thirteen *Fire* monotypes (fig. 168) by burning a pile of newspapers on the press bed, then placing the damp etching paper onto the flames and running it through the press. Some of the sheets were singed at the edges, and occasionally inks from the newspapers were transferred to the paper, while the brown tonal field expressed the essence of burning, smoldering, and scorching. Each print was branded with either one or two Japanese iron teapots, creating rings floating on the field in patterns determined through chance operations based on the *I Ching.*

Marioni, one of the founders and leading exponents of Bay Area conceptual art, was a longtime colleague and friend of Cage's. In 1992, as an homage to Cage, he made a series of forty-seven lyrical monotypes, called *Process Landscapes,* in which he allowed chance to determine the image (fig. 169). He began by dripping ink along the bottom edge of a copper plate. Dampened paper was then laid on the plate and run through the press. The pressure caused the ink to spread and soak into the paper. After the first pass through the press, Marioni repeated the process with more extended color, and a third time with the thinnest concentration of pigment. Sometimes he used more than one color in a print. This procedure created the effect of receding hills growing paler in the distance or rounded trees rising from a flat or rolling terrain.[14]

The immediacy and directness of the monotype technique account for its appeal to artists throughout the twentieth century, especially in view of the increasing complexity of many other forms of printmaking. Just as Maurice Prendergast and others printed their images with pressure from the bowl of a spoon, Joyce Treiman used a rolling pin on her kitchen table to

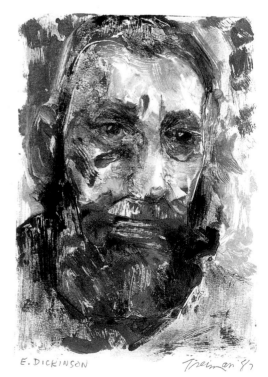

Fig. 168 (above, left)
John Cage, *Fire #9*, 1985,
monotype, 50.8 × 28.6 cm
(20 ¼ × 11 ¾ in.).
Crown Point Press

Fig. 169 (above, right)
Tom Marioni, *Process
Landscape #5*, 1992,
watercolor monotype,
76.2 × 53.3 cm (30 × 21 in.).
Crown Point Press

Fig. 170 (right)
Joyce Treiman, *Edwin
Dickinson*, 1987, color
monotype with hand
coloring and pencil
additions, 17.8 × 12.7 cm
(7 × 5 in.).
Maurice and Margery Katz

print a series of artists' portraits in monotype. Conceived as an homage to
certain American painters with whom she felt a special kinship, Treiman
adopted a head-and-shoulders format for each of the eight portraits, includ-
ing a self-portrait. The printed image served as a sort of underpainting,
which the artist modified with paint, pastel, and pencil to emphasize a partic-

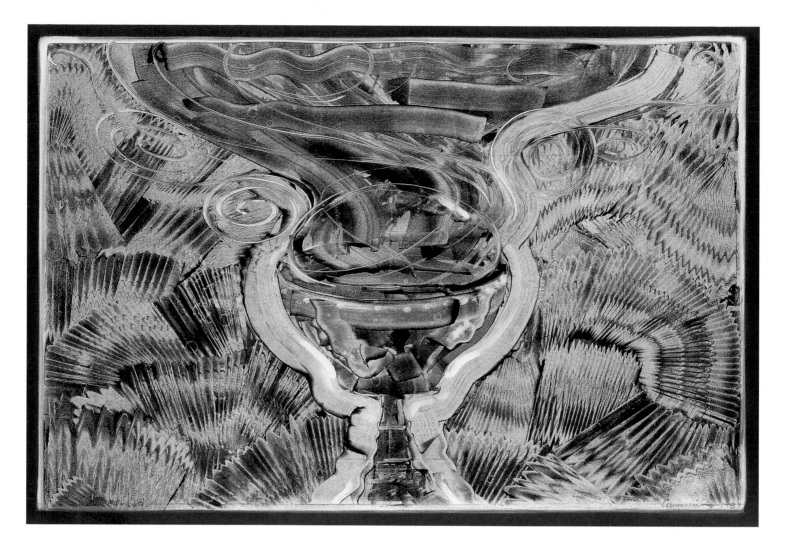

Fig. 171

Robert Cumming, *Untitled (Cup)*, 1987, color monotype, 66 × 96.5 cm (26 × 38 in.).

National Museum of American Art, Smithsonian Institution, Museum purchase made possible by Henry Cabot Lodge

ular trait or mood (fig. 170). The soft, suggestive forms of the transferred image, printed faintly because of the relatively light pressure of the rolling pin, give each impression a sense of distance and nostalgia, brought into focus by the surface additions. Intimate in scale, Treiman's portraits of artists recall the quick but sensitive monotype portraits by members of the Duveneck circle, done from memory rather than from life.

Just as the monotype was acquiring significant recognition and legitimization as a result of several exhibitions in 1978, Richard Field pointed out some of its pitfalls: "Structure is bypassed for tonal effects; thus, in the hands of most artists, the monotype has provided a quick and facile means of achieving painterly results. Line magically becomes encased in atmosphere. A brushstroke is transformed into a floating plane of light, while color itself effortlessly merges with the texture and structure of the paper. Thus the logic of drawing and the syntax of printmaking are shunted aside for less cerebral endeavors."[15] Monotypes have indeed proliferated so dramatically since the 1970s that the profusion of second-rate images often obscures the truly interesting work being done in the medium.

In the hands of an experienced and intellectual artist such as Robert Cumming, however, the visually appealing effects of the monotype process can become the primary vehicle for expressing content. The flamboyant marbling effect in the background of *Untitled (Cup)* (fig. 171), the decorative swirls, and the ostentatiously wiped line that defines the outline of the cup—in fact, a trophy form that signifies triumph or accomplishment—convey the idea of the object as well as its form. Cumming's images have been described as "meditations," an

observation he embraces. "I love ordinary things, the manufactured things of our time; chairs, cups, birdhouses, light bulbs, rulers, etc. With a simple alteration here, one of these object-archetypes can be as temporal as the cast-iron bank or the dirigible; with a simple alteration there, it can be projected into a longer-lived family of symbols."[16] The monotype medium enables the artist to make those alterations from proof to proof, retaining the basic form while embellishing it with different shades of meaning.

Georgia Marsh has condensed these nuances into a single image in her *Natura Naturata* series, in which the almost square format is divided at the center to create a diptych that imposes a conceptual structure onto an elegant image of natural beauty (fig. 172). While the branches of a pitch pine tree unite both halves of the pictorial field, the contrasting treatment of the background in each half calls attention to the artifice of representation, at the same time alluding to the late-nineteenth-century dichotomy of cleanly wiped versus artificially wiped plates. Navigating a fine line between abstraction and representation, Marsh challenges our preconceptions in looking at nature and representing it in art. "I don't think we experience anything without having a code before the experience. . . . Why not look at this idea of abstraction and liven it up a bit? Why not look at this notion of handmade representation in Western culture since nobody likes it much anymore? Why not take another look, rearrange the terms?"[17]

Reassessment and Revitalization

The seeds of the contemporary monotype phenomenon were planted in 1960, beginning with the publication of Henry Rasmusen's *Printmaking with Monotype*. The book summarized the history of the medium from Castiglione to contemporary practitioners, providing a historical context for the work of several highly respected artists and conferring on the medium the stamp of legitimacy and tradition that it had previously lacked. Although the monotypes of Castiglione, Blake, Degas, Gauguin, and others had been discussed earlier in newspaper and journal articles on the medium, and some exhibition catalogues had been published, none of these were readily accessible to the average person, nor had the monotype process received much attention in general books on printmaking techniques.

In 1967 Matt Phillips, who had begun to make monotypes in 1959, mounted an exhibition of Maurice Prendergast's monotypes at Bard College in New York State. This was the first of several shows he organized that included the work of Prendergast, Abraham Walkowitz, and Milton Avery, as well as his own monotypes, which were strongly influenced by those of Prendergast. As Phillips began to exhibit his own work actively after 1960 in Philadelphia and New York, other artists became aware of the history of the color monotype and its expressive possibilities.

The influence of Prendergast and Vuillard is especially strong in Phillips's work of the 1960s (fig. 173), but one already sees his distinctive blend of abstraction, decoration, and rhythmic vitality, which writer Joyce Carol Oates has compared to music and poetry:

One's first and most superficial impression of Matt Phillips' art is that it is delightful in the conventional sense of the word: giving pleasure to the eye and the eye's mind; evoking the sort of shimmering nexus of emotion . . . one associates with certain works of Debussy and Ravel and even Chopin, and in poetry, Wallace Stevens; exciting one's admiration through the very audacity of its ostensibly uncomplicated "prettiness."[18]

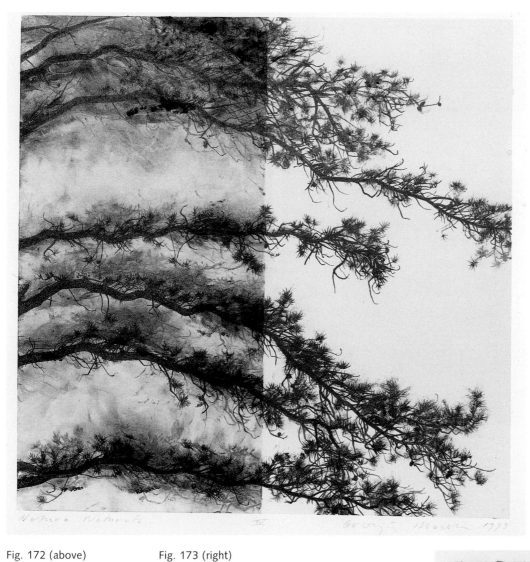

Fig. 172 (above)
Georgia Marsh, *Natura
Naturata,* 1993, color
monotype, 67.9 × 64.8 cm
(26 ¾ × 25 ½ in.).

David M. Maxfield

Fig. 173 (right)
Matt Phillips, *Serenade,*
1965, color monotype
with pencil additions,
39.4 × 29.2 cm
(15½ × 11½ in.).

National Museum of American
Art, Smithsonian Institution, Gift
of the artist

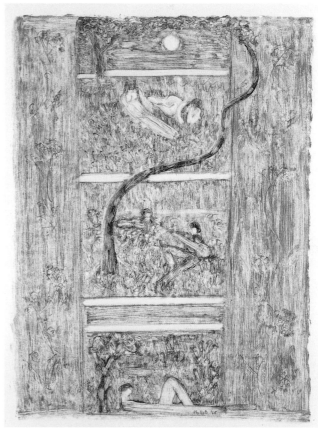

Fig. 174 (opposite)

Matt Phillips, *Among the Waves,* 1971, color monotype, 101.6 × 71.1 cm (40 × 28 in.).

Matt Phillips, courtesy Marsha Mateyka Gallery, Washington, D.C.

After 1970 Phillips began to work on a larger scale and simplified his technique even further. Eschewing the complex textures of fingers or brushes, he began to rely more strongly on wiping the plate with broader gestures, allowing the white of the paper to play a greater role in the composition. Writing about his work, the artist explained: "I like understatement, working obliquely, and utilizing the kind of whites only monotypes permit. . . . The way color comes off in monotype interests me, the whispered look of it."[19] In a videotape made in conjunction with an exhibition of his work at the Chrysler Museum, Phillips stated that he made monotypes rather than paintings because some things were easier to say in a letter than in person.

Having grown up at the seaside, Phillips was especially drawn to water as a subject. The new vocabulary of space, gesture, and form he developed for his monotypes found its most eloquent expression in his beach scenes of the 1970s (fig. 174). In his discussion of Phillips's work, critic Jack Flam observed:

Pattern and absence. Presence and void. Rhythm and silence. These comprise not only the basic formal polarity of Phillips' work, but also provide its spiritual dialectic. The patterns and emptiness are simultaneously set against each other and united by the intervening presence of the blank paper and by the intervening process of the transfer from the printed plate.[20]

Phillips moved away from the more complex textures and details of his monotypes of the 1960s toward a greater economy of means, a more abstract, lyrical expression that recalls the work of Matisse while maintaining the intimacy of Vuillard.

Phillips continued to organize exhibitions of monotypes, notably *The Monotype: An Edition of One* in 1972, which was especially influential because it traveled throughout the United States under the auspices of the Smithsonian Institution Traveling Exhibition Service. Writing about the medium, he placed contemporary monotypes in a historical context and emphasized their expressive potential rather than just supplying technical details, as had many earlier writers. One of the relatively few artists who have adopted the monotype as their primary medium, Phillips has demonstrated that it can be as varied and expressive as any other technique of drawing or printmaking. By 1984, according to Barry Walker, Phillips was "responsible, perhaps more than anyone else, for the prominence of monotype today."[21]

As previously discussed, Eugenia Parry Janis's exhibition of Degas monotypes in 1968 was a show of equal importance, if not even more influential. Seventy-eight monotypes were exhibited, and the catalogue reproduced more than three hundred prints. Although individual monotypes by Degas had previously made their way into museum collections, this exhibition and publication revealed the breadth and seriousness of the French artist's explorations of the medium. Degas worked in both the dark- and light-field manners, often combining them in a single composition; taking ghost impressions and counterproofs, he reworked them with pastel, creating series of related images; he explored the tonalities of black ink in figure compositions and the possibilities of colored inks in landscape monotypes—all of these efforts produced a more extensive and impressive body of monotypes than had ever been achieved. For artists unfamiliar with the monotype, the introduction to Degas's accomplishments encouraged them to explore the medium.

Two of the artists most profoundly influenced by the revelation of Degas's monotypes were Michael Mazur in Boston and Nathan Oliveira in California. According to Mazur, "One look at Degas's *Café-Concert Singer* was all I really needed to get started. This tiny explosive image, a spontaneous gift of the artist's spirit, seemed to have been breathed directly on the paper in

one magical gesture."[22] On another occasion he remarked: "If Degas hadn't made cognates, I probably wouldn't have started doing monotypes."[23] A talented draftsman, trained in both painting and printmaking, Mazur recognized in the monotype a medium that challenged his drawing ability, encouraged an expressive relationship between line and tone, and allowed for the sequential development of an image in which each stage existed as an independent work rather than a proof leading to a final state.

The impact of Degas's monotypes was less direct but equally significant for Oliveira, who had carefully studied Janis's exhibition catalogue as an instructor at Stanford University. According to Oliveira, "It was so beautiful. To think about the association, the printing and transferring, the paper illumination, the power of that paper, the light. It was all very appealing. The fact is that I could also be in a very private, discrete world that I could relate to."[24] As highly regarded artists and teachers in their respective regions, Mazur and Oliveira introduced many artists to Degas's monotypes and encouraged them to work with the process. The concentration of activity in the San Francisco Bay Area and the Boston region during the 1970s and 1980s owes much to the encouragement and example of these two artists.

Joseph Goldyne's education and art bridged the environments of Boston and San Francisco. Having grown up in the Bay Area, he commenced graduate work in art history at Harvard in the fall of 1968, not long after the Degas exhibition at the Fogg Museum. Recalling his personal reaction to these monotypes, Goldyne states: "I missed the show, but the catalogue was one of my first purchases at the museum desk. Well, I was fascinated, though with reservations, about the overall success of the majority of the work. As a matter of fact, my initial concern was whether enhanced delicacy of line and color was possible."[25] His studies in the history of art provided a rich supply of visual ideas, while the space limitations of his studio and predilection for works on paper were well served by the monotype. The possibilities of the medium intrigued him, and although he appreciated the soft tonal values that were possible, he never forgot Degas's conception of the process as a printed drawing.

One of the more remarkable aspects of Degas's influence was the fact that the French artist's monotypes did not inspire imitation so much as they did a serious reconsideration of what the process had to offer. Line remained an essential element of his images even as he explored the subtleties of tone and texture. "For me," says Goldyne, "monotype is a medium that

Fig. 175 (below)
Joseph Goldyne, *Narcissus*, 1978, color monotype, 44.9 × 30.2 cm (17 11/16 × 11 7/8 in.). Private collection, San Francisco

Fig. 176 (opposite)
Ruth Weisberg, *Before the Bath*, 1990, color monotype, 64.8 × 50.8 cm (25 1/2 × 20 in.). National Museum of American Art, Smithsonian Institution, Gift of Gary and Brenda Ruttenberg

is ideally suited for painting, drawing and printmaking in consort. I get to do all in the same process, and the glow of the glazes hovering on fine paper is unequalled in any other medium. . . . And if the monotype is printed properly, the process of transfer does not result in a loss; it bestows a wonderful addition upon the image . . . a rich glow, as if from an inner light."[26] In Goldyne's *Narcissus* (fig. 175), the soft, tonal architectural niche provides the setting for the delicate linear rendering of the flowers and pot in an image that maintains an exquisite balance between the drawn, painted, and printed elements.

Narcissus is one of Goldyne's largest monotypes of the 1970s, yet still relatively modest in size during a period when prints tended to be, as Ruth Fine observed, "bigger, brighter, bolder."[27] Indeed, most of Goldyne's monotypes were emphatically smaller at a time when size was often mistaken for importance. The modest size of Degas's monotypes reminded artists that a small work of art could have as much power as a large one, that intimacy could be a positive attribute, that whispering could be more effective than shouting. Wendy Mark recalls how impressed she was by the power of Degas's image *The Jet Earring,* measuring only slightly more than three by two inches, which gave her the courage to work on a small scale.[28]

The intimacy of Degas's monotypes was due not only to their size but also to his choice of subject matter and manipulation of ink. One of his primary themes is the female figure in an interior setting, engaged in grooming herself. When Ruth Weisberg explored this theme in a group of monotypes from 1990, including *Before the Bath* (fig. 176), the reference to Degas is clear in the figure kneeling beside the large circular basin. The leg of an easel establishes the setting as the artist's studio; hence the figure may be perceived as a model. In fact, the model is the artist's daughter, who often served as a symbol of the artist, "who participates in the sacred generational relationship of mothers and daughters."[29] Recalling Degas's use of the whiteness of paper as a source of light in his dark-field monotypes, Weisberg intensifies the

monotype "High Button Shoes" Joseph Solman

Fig. 177

Joseph Solman, *High Button Shoes,* ca. 1970, color monotype, 30.5 × 20.3 cm (12 × 8 in.).

National Museum of American Art, Smithsonian Institution

light to create a supernatural brightness, which adds a ritual overtone to the simple act of bathing and moderates the intimacy of the moment by suggesting a timeless quality. The limited palette, as well as the distance established by an image printed rather than directly drawn, enhances the contemplative quality of the figure. By alluding to Degas's imagery, Weisberg appears to be questioning her own place in a tradition defined primarily by men. "An artist like me," she states, "whose work refers in technique and universal themes to traditional past art styles, has to ask how this process of reinventing the past unfolds—how artists can continue to make art that is innovative and meaningful while it maintains a relationship with all the information, values, culture that got us here."[30]

Although Degas's monotypes remained the single most influential body of work in this medium, the monotypes of other artists also served as a source of inspiration. In 1968 Joseph Solman undertook extensive experiments with monotype directly related to his study of Paul Klee's trace monotypes from the 1920s. He admired the soft yet taut vibrating quality of their lines and attempted to adapt the diffuse but expressive lines and mottled textures to his own low-keyed expressionist imagery (fig. 177). During the next ten years he produced over five hundred monotypes.

Michael Mazur carefully studied Naum Gabo's woodblock monoprints as well as Gauguin's trace monotypes. In 1984 he began a series of large black-and-white self-portraits in which he experimented with Gauguin's technique in conjunction with more traditional dark-field techniques. Unlike Gauguin, who probably rolled ink on a sheet of heavy paper, Mazur used a metal plate. Drawing on a sheet of thin Japanese paper placed over the plate, he transferred ink to the paper wherever pressure was applied. Sometimes he transferred additional ink to the paper by rubbing certain areas with the heel of his hand, creating dark, shadowy areas around the drawn image. As most of the ink remained on the metal plate, he often wiped away additional ink and printed another impression of the image on the plate by running it through a press, in effect making a dark-field monotype that is a negative of the trace monotype (fig. 178). The bold drawing and wiping of these self-portrait heads give some of them a monumental character reminiscent of a Roman emperor's bust, while other images show the artist as broodingly introspective, with ghosts of previous printings conveying a reflective mood. At times Mazur used white ink on black paper, creating images that suggest x-ray negatives, as if the artist were looking beyond external appearances to find his soul.

Although the immediate motivation for this series was the artist's fiftieth birthday, occasioning reflection on his life and mortality, Mazur also sought to contemplate the nature of the self-portrait, the ambiguities of the monotype, and the role of chance in one's life and art. In comparison with Rembrandt's fascinating body of self-portraits, Mazur's monotype sequence condenses his self-examination into a brief period of time, looking backward and

forward from a single vantage point, enveloping the imagery in the expressive chiaroscuro that characterizes Rembrandt's work. Although Degas's monotypes were the ostensible inspiration for Mazur's monotypes, Rembrandt was apparently on his mind as well.

Yvonne Jacquette began making monotypes in the mid-1970s at the encouragement of her dealer Brooke Alexander after seeing catalogues of monotypes by Degas and Gauguin. She soon realized that by working on a clear Plexiglas surface she could place a drawing underneath and make a series of images, each based on the same drawing. Although this process had been used as early as 1900 by artists such as Will H. Chandlee, they viewed it as a way to reproduce drawings rather than to create a series with variations on a single composition. For Jacquette, the monotype was a good medium for experimenting with different types of light, and she often reworked an image at different times of day. Monotypes became an integral part of her creative process, influencing her approach to painting: "Monotypes showed me I had to paint with broken strokes with some white of canvas coming through."[31]

Several years later, by sheer accident, Jacquette made a second important breakthrough.

Fig. 178

Michael Mazur, *Self-Portrait*, 1986, trace monotype, 71.4 × 51.4 cm (28 1/8 × 20 1/4 in.).

National Museum of American Art, Smithsonian Institution, ©1986 Michael Mazur

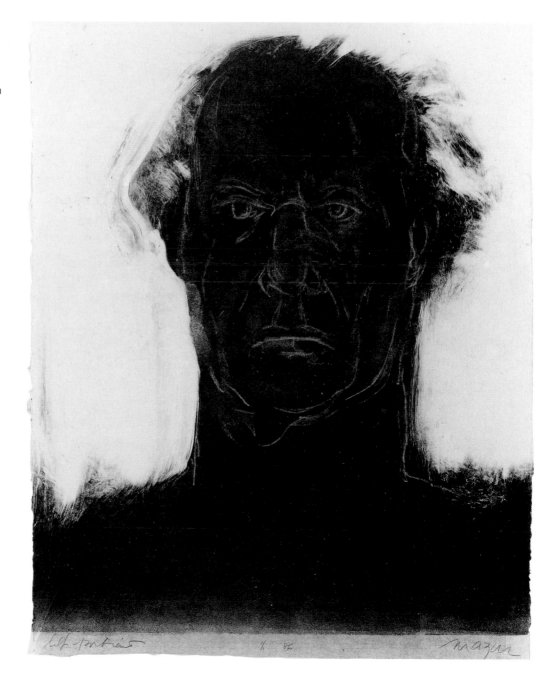

Unwrapping a group of pastel drawings, she discovered that the image had been transferred to newsprint, like eighteenth-century counterproofs, and that this gave a sense of distance to the bird's-eye view she was seeking. To make preparatory studies for her paintings, Jacquette often took airplane rides over urban or rural areas, but she had difficulty depicting the sense of atmosphere and space that separated her from the landscape. In collaboration with the printer John C. Erickson at Vinalhaven Press and later with printer Robert Townsend in Provincetown, she developed a method of making pastel monotypes, transferring the particles of pastel pigment as part of the image rather than adding them to the surface of the printed impression, as Degas had done.[32] In a series of views of islands off the coast of Maine (fig. 179), each impression of the same composition suggests a different mood and time of day through variable color combinations and slight modifications of the composition from one proof to the next.

Sequential Imagery

Of all the reasons why artists have chosen to make monotypes since the 1970s, the possibility for developing sequential imagery is perhaps the most frequently cited, especially by painters. One of the most important lessons that artists learned from Degas's monotypes was the potential for developing sequential imagery on the monotype plate. Nathan Oliveira was struck by this opportunity:

The nature of the monotype—the reversal of image, the reflective nature of paper, the brilliance of paper through veils of ink—had all the qualities of printing I wanted, technically, and it had one other: it left a remnant or ghost of the idea after the impression was made. I could enter back into that image that was still malleable . . . and extend that initial concept to a different state. . . . I found it easier to explore concepts or ideas with monotype. In one day I could go through eight progressive states, each one different from the previous one, each one modifying my initial idea. By the end of the day, I would find myself visually in a place that I couldn't possibly have anticipated at the beginning.[33]

Although the work of Degas inspired Oliveira to explore the medium, he looked to Goya and Rembrandt as sources for his early monotype imagery. He borrowed the composition of Goya's etching *La Tauromachia 21*, on which he based an extensive sequence of transformations. While Goya's series suggests a narrative development, that of Oliveira emphasizes the formal aspects of Goya's composition. The scene shows a bull that has invaded the spectators' stalls and stands with the body of a gored man on its horns. Although certain parts of Goya's composition are recognizable in each of Oliveira's monotypes, many of them retain only the most abstract formal elements of the scene. In three impressions printed sequentially from the same plate (figs. 180, 181, and 182), the disappearance and addition of forms are apparent as the abstract visual drama unfolds. Throughout the series of almost a hundred impressions, printed on a special two-hundred-year-old rag paper, the form of the bull seems to appear and disappear, while the basic diagonal and horizontal elements maintain a sense of the original composition. Areas of smudged and scratched ink create a sense of atmosphere and space that recalls Goya's original scene. Although the abstraction of Goya's composition suggests formal analysis, the experience was a process of discovery for Oliveira: "Through a long series of some ninety sequential impressions—a dialogue with Goya—I found an incredible, rich experience that took me on a great journey and provided me, as it went on, with a unique visual language that grew out of the process itself: a language that I had not anticipated."[34]

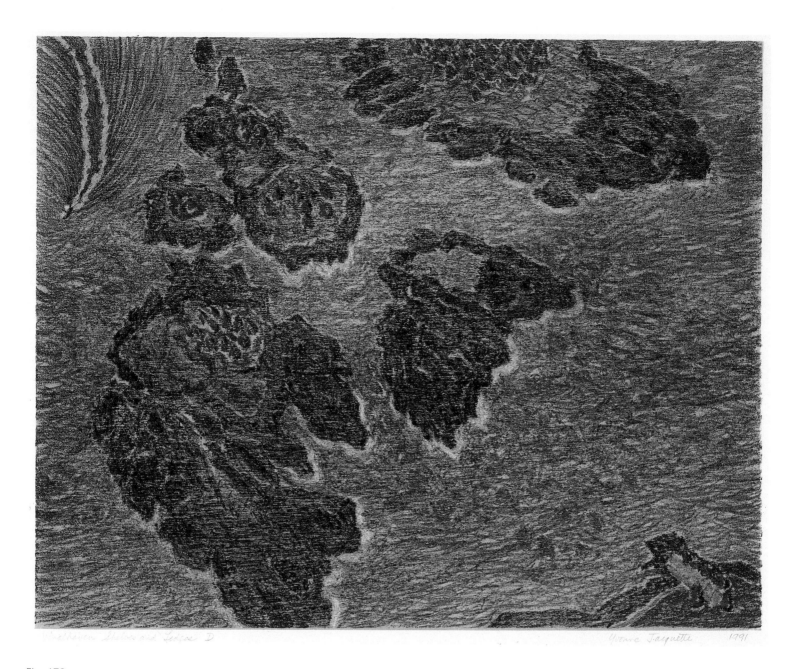

Fig. 179

Yvonne Jacquette,

Vinalhaven Shelves and

Ledges D, 1991, pastel

monotype, 41.9 × 51.1 cm

(16 ½ × 20 ⅛ in.).

National Museum of American
Art, Smithsonian Institution,
©1993 Patricia Nick,
Vinalhaven Press

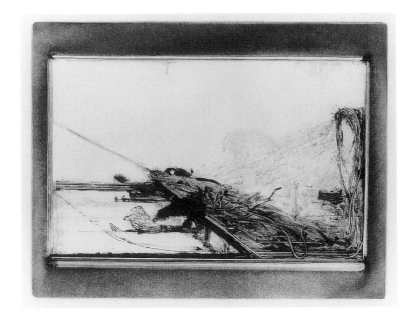

Fig. 180 (top)
Nathan Oliveira,
Tauromaquia 6.20.73.III,
1973, monotype,
27 × 34.6 cm
(10 ⅝ × 13 ⅝ in.).
Mr. and Mrs. Nathan Oliveira

Fig. 181 (middle)
Nathan Oliveira,
Tauromaquia 6.21.73.III,
1973, monotype,
27 × 34.6 cm
(10 ⅝ × 13 ⅝ in.).
Mr. and Mrs. Nathan Oliveira

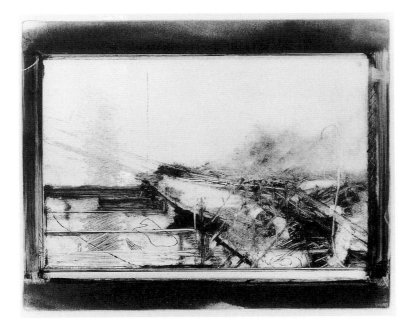

Fig. 182 (below)
Nathan Oliveira,
Tauromaquia 6.21.73.IV,
1973, monotype,
27 × 34.6 cm
(10 ⅝ × 13 ⅝ in.).
Mr. and Mrs. Nathan Oliveira

Oliveira encouraged many of his colleagues to make monotypes and explore the medium's potential for the sequential development of an image. Richard Diebenkorn, for example, had made monotypes during the early 1950s, but it was not until Oliveira sent him the catalogue of Degas's monotypes and one of his own works from the *Tauromachia 21* series in 1974 that Diebenkorn ventured into the medium again. Responding to George Page's invitation to make lithographs at his Santa Monica workshop, Diebenkorn asked if he would be interested in helping him print monotypes. They worked together for ten straight days, completing thirty-six black-and-white monotypes based on the artist's *Ocean Park* series of paintings and drawings. In contrast to other media, the monotype process allowed Diebenkorn to save passages he especially liked and preserve the ghost of previous compositions. One year later he spent a working weekend with Oliveira at Stanford University, where they made monotypes side by side with the assistance of two students. The two artists did not consult each other, but the intensity and ease with which Oliveira engaged the medium influenced Diebenkorn to work in a more fluid, expressive manner than he had done in the more formalist progressions of the Santa Monica series (figs. 183 and 184).[35] He did not take up the medium again until 1988, when he made a series of twenty monotypes in color at the Garner Tullis Workshop in Santa Barbara. Among Diebenkorn's last creations, completed shortly before his final illness, the color monotypes reveal a confidence and spontaneity that remained from his earlier experiences.

Michael Mazur also recognized the potential for sequential imagery in Degas's monotypes, but he developed a quite different manner for the manipulation of cognates. Creating numerous related impressions in a single day, he often made substantial changes in the cognate

Fig. 183 (below, left)
Richard Diebenkorn,
IV 4-13-75, 1975,
monotype, 56.5 × 39.4 cm
(22 ¼ × 15 ½ in.).
Phyllis Diebenkorn

Fig. 184 (below, right)
Richard Diebenkorn,
V 4-13-75, 1975, monotype,
57.1 × 39.1 cm (22 ½ ×
15 ⅜ in.).
Phyllis Diebenkorn

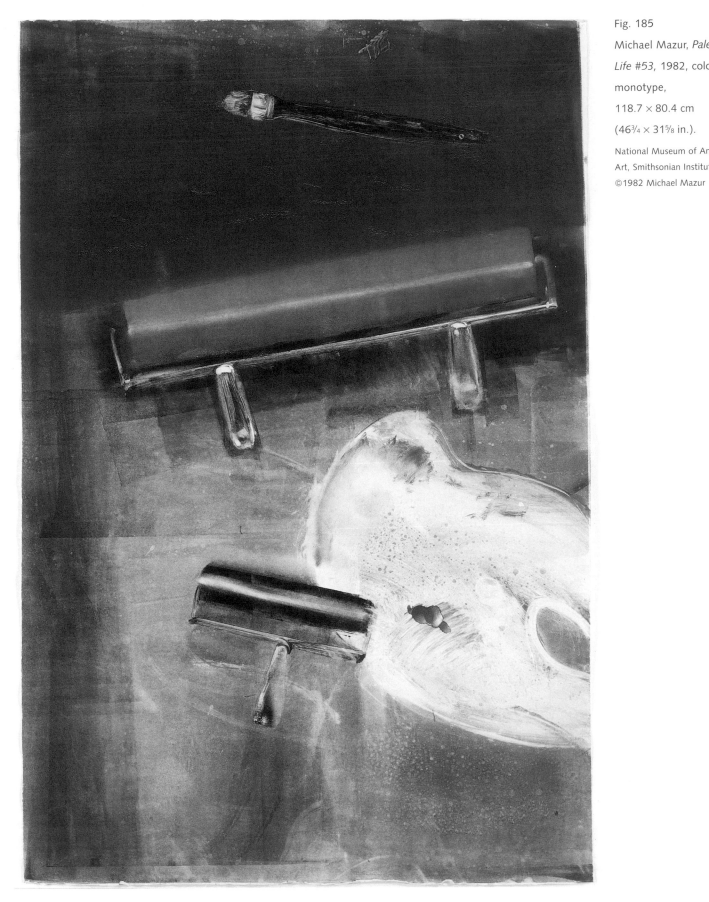

Fig. 185

Michael Mazur, *Palette Still Life #53*, 1982, color monotype, 118.7 × 80.4 cm (46¾ × 31⅝ in.).

National Museum of American Art, Smithsonian Institution, ©1982 Michael Mazur

from one impression to the next by painting onto or wiping away from the image remaining on the plate after an impression had been pulled. In contrast to a variant edition, a monotype sequence as interpreted by Mazur and Oliveira represents a progressive development that records the history of each artist's thought process. According to Mazur,

A monotype sequence is not simply a group of variations. A mono*print,* having some fixed element of matrix on the printing surface, is analogous to a musical theme or motif which, though varied, can be repeated at intervals throughout a piece. A mono*type* is a totally unique image, it goes forward in one direction. Each new image informs, and is informed by, the next.[36]

For both Mazur and Oliveira, the monotype was not simply a new process to be added to the arsenal of drawing and printmaking techniques with which they were already familiar. Simultaneously, working on opposite coasts, they understood that the process had implications and possibilities beyond the obvious surface effects or pleasures of spontaneity that had appealed to so many of their predecessors. Their exploration of the medium had less to do with technical experimentation than with the conceptual challenge it presented to traditional approaches to drawing and printmaking.

Many artists developed sequential imagery much as Oliveira and Mazur had done, reworking the ghost image from one impression to the next. Others explored variations on this procedure, pushing the visual and expressive potential of the monotype in unforeseen directions. Through their understanding of the possibilities, contradictions, and ironies inherent in the monotype process, Mazur, Oliveira, and Phillips created works based on a more complex framework of ideas and expression than was used by earlier artists, who were less cognizant of the implications of this hybrid medium.

In a sequence of images based on the tools of his craft, *Palette Still Lifes,* Mazur reflects on the actual process of creating a monotype, the interplay of painting and printmaking, as well as the relation of illusion and reality. Throughout the series, the image of the large roller provides a focal point for the composition as it moves across the picture plane in successive impressions, at times accompanied by other implements. The individual impressions suggest freeze frames in a motion picture that explores the process of creating a monotype. In *Palette Still Life #53* (fig. 185), the large, solidly modeled roller appears to be the very tool that has laid on the background color, while the palette, brush, and brayer—somewhat less substantial in presence but still central to the composition—remind the viewer that he or she is seeing an illusion of reality created with these implements through the skill and imagination of the artist. The casual arrangement of the tools suggests an image seen in a mirror in a corner of the artist's studio rather than the depiction of a still life, just as the monotype impression is a reflection of the image painted by the artist rather than the image itself. The act of printing establishes a sense of distance that contradicts and counterbalances the spontaneity associated with creating the image on the plate.

During the 1960s and 1970s prints in general moved from the more traditional, intimate hand-held objects to the larger scale of easel paintings. By 1982 Mazur had moved into the realm of the mural in his ambitious *Wakeby Day/Wakeby Night* monotypes, conceived as triptychs that measure more than six by twelve feet.[37] Commissioned to provide a work of art for a large curving wall in a new dormitory at the Massachusetts Institute of Technology in Cambridge, Massachusetts, he viewed the site for the first time and declared: "You need Monet's *Waterlilies!*" Just as Monet had found inspiration in his own garden, Mazur looked to his experiences and memories of Wakeby Lake, the island-studded body of water on Cape Cod

where Mazur and his family had a summer home. The double vision conveyed by the inset within the larger image has been described as "an extended daydream, . . . [an] attempt to recapture the light, cold, shape and experience of a summer landscape recalled in the midst of winter."[38] The inset panel of *Wakeby Night* (fig. 186) suggests a daytime view of the same scene, a device through which the artist expresses the passage of time, the cyclical rhythms of nature, and the multiple layers of a single experience.

Mazur had never done a print approaching the architectural scale of this project, so he turned to printer Robert Townsend for assistance. Townsend was forced to rebuild his press bed to accommodate the enormous size of these monotypes. Working on this ambitious scale was a challenge not only to the printer but also to the artist, who needed enormous ingenuity and heroic physical exertion to create a coherent image as quickly as the monotype process required. He used the roller in a particularly inventive manner, wheeling it across a portion of the wet image, partially erasing the forms, picking them up on the surface of the roller, and depositing them on another area of the composition to create a dematerialized ghost image. For Mazur, the monotype was the most effective medium in which to express the interrelated issues of time, sequence, and memory.

Mazur was one among many artists who have explored the concept of sequential imagery to suggest the passage of time. In California, as early as 1962, Joseph Zirker completed a hundred trace monotypes in the manner of Paul Gauguin. Although he abandoned the trace monotype after completing this body of work, Zirker became one of the most avid experimenters with monotype techniques. During the mid-1970s he grew fascinated with photographer Eadweard Muybridge's serial images of moving figures, recognizing an affinity with the sequential and diffused qualities of the monotype. As Zirker stated, "There is a unique quality in these old photographs by Muybridge which suggests a subtle patina, a soft veil separating us from the

Fig. 186

Michael Mazur, *Wakeby Night,* 1983, color monotype and pastel, 182.9 × 346.7 cm (72 × 136 ½ in.).

National Museum of American Art, Smithsonian Institution, Gift of Mr. and Mrs. Hugh Halff, Jr., Judith Ross, and Kurt & Kim Butenhoff, and Museum purchase through the Luisita L. and Franz H. Denghausen Endowment, ©1983 Michael Mazur

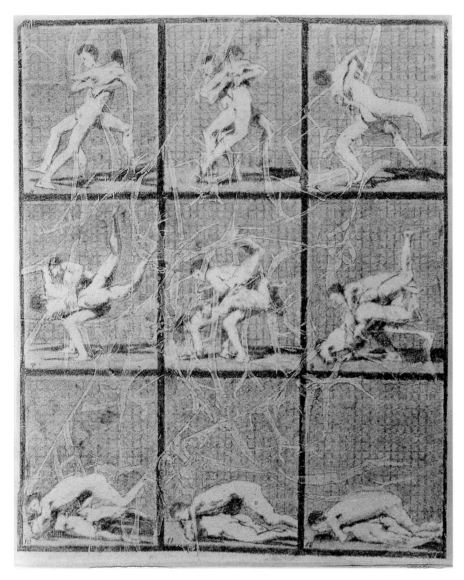

Fig. 187

Joseph Zirker, *Wrestling,*

Graeco-Roman (after

Muybridge), 1976, carbon

and charcoal pencil

monotype, 62.2 × 49.8 cm

(24½ × 19 ⅝ in.).

Smith-Anderson Gallery, Palo

Alto, Calif.

action of another era. . . . The vagueness of detail and haziness of light and dark, became, for me, as much a subject for exploration as the ancient actors trapped in time."[39] *Wrestling, Graeco-Roman (after Muybridge)* (fig. 187) was printed from a surface of carbon and charcoal pencil; he reinforced the sense of distance in time by incorporating two additional surface textures that unite all nine frames in a single image. In 1978 Joseph Goldyne began printing altered progressive images in sequence on a single sheet to portray a narrative progression in time, as in *One, Two, Three . . . All Gone* (fig. 188).

Jasper Johns, who had previously worked successfully with lithography, various intaglio techniques, and screenprinting, turned to the monotype in 1978. Retrieving a discarded drawing on a prepared aluminum plate that he had done the previous year for a series of six lithographs of a Savarin can holding brushes, he painted it with multicolored inks and printed it on an offset press, controlling the pressure so carefully that four impressions could be taken.[40] In a subsequent series of monotypes, also based on the Savarin can, Johns alternated between monotypes and monoprints, printing some of the images on top of lithographic proofs that had been discarded.[41] Placing an impression of the lithograph under a sheet of Plexiglas, he painted the image with colored inks and printed some of them on blank sheets of paper, while others were printed over lithographic images. In contrast to the earlier series, these proofs often varied considerably, as Johns reworked the image on the plate between printings over a

period of four days. An image that originated as a painted bronze in 1960, the Savarin can recurred in several different media during the two decades before the monotype series. In its various incarnations it came to symbolize the artist himself, a self-portrait that is reinforced in the lithograph on which the second series of monotypes is based. The placement of the Savarin can above an impression of the artist's forearm is a direct reference to the *Self-Portrait* lithograph (1895) of Edvard Munch, in which the artist's likeness is placed above a skeletal forearm.[42] In two of the monotype impressions, Johns used his own handprint as a background motif, merging the pattern of his fingers with the decorative hatchings and recalling the fingerprints he had left in his original painted bronze Savarin can with brushes (fig. 189). As one of the leading American artists, Johns's interest in the monotype was a small but important milestone in the acceptance of the medium by the contemporary art world.

For Eric Fischl, the monotype series provided a sympathetic vehicle for the narrative development of his subjects without having to begin each image from scratch. To compose his paintings, Fischl arranged individual sheets of glassine, each with one figure or object on it, in a collage-like fashion. Moving the sheets in different relationships to one another, often overlapping, he developed a narrative scene that became the composition for the resulting painting. However, the evolutionary process that led to the final composition was lost as sheets of glassine were moved around.

In 1986 publisher Peter Blum invited Fischl to make monotypes in the workshop of printer Maurice Sanchez, where he explored thirteen subjects over a period of nine months. Although Fischl had experimented with monotypes the previous year while working on a series of color aquatints, the 144 impressions he produced with Sanchez, *Scenes and Sequences,* represent his first serious engagement with the medium, which provided an ideal alternative to manipulating individual sheets of glassine. Fischl did not immediately recognize the serial potential of the monotype; the first three works were painted individually with brush and lithographic inks on Mylar, a slick surface that permits an especially painterly application of ink.[43] Returning to the printer ten days later, he began a new group of images in which figure and ground seem to merge in a frenzy of dynamic brushwork. Only in this second series did Fischl recognize the possibility of reworking the ghost image, adding and subtracting figures and background in the remaining impressions.[44] By printing the images on an offset press, Sanchez was able to take several impressions of each image with relatively little loss of intensity. By printing each image at a different location on the sheet of paper and running each sheet through the press several times, Fischl could rearrange the figures in the composition much as he had with his

Fig. 188
Joseph Goldyne, *One, Two, Three . . . All Gone*, 1980, color monotype, four images on a single sheet, each image 10.2 × 12.7 cm (4 × 5 in.).
Collection of the artist

Fig. 189

Jasper Johns, *Savarin,* 1982,

color monotype,

125 × 95 cm (50 × 38 in.).

Nancy and Tom Driscoll, ©1997
Jasper Johns/Licensed by VAGA,
New York

drawings on glassine. Moreover, in the monotype series, the record of the evolution remained visible in successive images.

While the monotypes in *Scenes and Sequences* are relatively small in size, comparable to his glassine drawings, Fischl began to work on a much larger scale, more akin to his paintings, when he returned to make monotypes at Sanchez's workshop in 1992 (fig. 190). He began with three basic groups of figures, each printed on a different section of three large sheets of paper. Although the three resulting compositions have the same figures, he created three different scenes, each with its own implied narrative. By printing the images on an offset press, the artist did not have to compensate for the reversal of image that occurs with a traditional printing press. Reworking areas of the background, Fischl was able to make the three individual segments read as one continuous space.

Enrique Chagoya's interest in sequential images led him to print one on top of the other, letting early impressions show through as pentimenti. Born and raised in Mexico City, Chagoya moved to the United States in 1977. Strongly aware of his rich Mexican heritage, he was also very conscious of American popular culture. In *Life Is a Dream, Then You Wake Up* (fig. 191), he printed eleven runs on handmade Amate bark paper, made from a native Mexican plant. Amate bark was used by native peoples in Central America before the use of paper in Europe. The purposeful stressing of the surface by repeatedly running it through a press to the point where it tears refers to the legacy of ancient civilizations. Chagoya used multiple layers of imagery to express the borders of the physical and spiritual, life and death, consciousness and unconsciousness, as well as the various cultures with which he personally identifies. The winking, open, and closed eyes, and the changing expressions and shifting positions of the facial features suggest a brief cinematic sequence that telescopes the passage of time, from seconds to centuries in a single image.

Fig. 190 (above)
Eric Fischl, *Untitled (Group in Water)*, 1992, color monotype, 91.4 × 185.7 cm (36 × 73⅛ in.).
National Museum of American Art, Smithsonian Institution

Fig. 191 (opposite)
Enrique Chagoya, *Life Is a Dream, Then You Wake Up*, 1995, color monotype on handmade Amate bark paper, 108.2 × 118.4 cm (42⅝ × 46⅝ in.).
National Museum of American Art, Smithsonian Institution, Museum purchase made possible by the Morris and Gwendolyn Cafritz Foundation, C. W. Tazewell, and Mr. and Mrs. G. Mennan Williams

The Collaborative Monotype

In contrast to the first ninety years of monotype activity by American artists, contemporary monotypes are frequently made in a printmaking workshop in collaboration with a professional printer. The monotypes by Johns, Fischl, and Chagoya probably would not have been created without the encouragement and assistance of the printers at the respective workshops. This development largely reflects the major shift in American printmaking after 1960, when dozens of workshops opened throughout the country to provide professional printing services for artists. Painters and sculptors were invited to these workshops, encouraged by the opportunity to make prints without having to learn complicated techniques and procedures. As printers became more skillful and the presses became larger and more sophisticated, size was no longer a limitation, especially after the 1970s, when larger-size papers became more readily available.

For many artists, a major drawback to making prints in a workshop was the time wasted while the printer was preparing plates, films, stones, screens, and inks or proofing the states of a print. With more complex printmaking techniques, even more time was wasted. It is not known who first suggested that artists make monotypes during this fallow time, but it soon became a relatively common practice in many workshops. The process was especially intriguing for painters, as

it was so much like making a drawing or painting. In contrast to the complicated procedures being performed by the printer on their editioned prints, the monotype was refreshingly simple and direct, with the artist able to maintain complete control over the creation of the image. Plates, inks, and papers were readily available in the workshop, and a printer could run the image through the press with little preparation and time. Discarded proofs could be used as the basis for monoprints, much as Johns recycled his *Savarin* lithographs. Moreover, a successful monotype could be sold as a unique work of art, usually at a higher price than an editioned print. Unlike the ambivalence that had greeted monotypes in the marketplace before the 1970s, unique, affordable works of art by leading artists found eager acceptance during the art-market boom of the 1970s and 1980s.[45]

As print publishers and workshop directors recognized the creative and commercial potential of unique prints, artists were given the option of making monotypes or monoprints as their primary project. Several workshops were established primarily for the purpose of making unique prints, and many places that had previously specialized in printing editions began including monotypes and monoprints as a regular part of their activity. During the mid-1970s Impressions Workshop in Boston played an active role in experimentation with monotype, but it was on the West Coast that workshops dedicated to the production of unique prints began to flourish.[46]

One of the earliest advocates of the monotype was Paula Kirkeby, owner of the Smith-Anderson Gallery in Palo Alto and a partner in the 3EP Press, founded in 1978 to publish unique prints.[47] Among the earliest exhibitions in Kirkeby's gallery were Oliveira's monotypes of haunting masks (fig. 192), shown in 1970, as well as his *Tauromachia 21* series, shown shortly after they were completed in 1973. As few people were familiar with monotypes, it was a bold move to exhibit them so prominently in her fledgling gallery. Her commitment to the medium helped change attitudes among artists, museums, and private collectors.

Although Matt Phillips had been making monotypes on his own for many years, when he was invited to make prints at 3EP in 1983, he had access to a larger press and the assistance

Fig. 192

Nathan Oliveira, *Mask*, 1969, color monotype, 96.5 × 64.8 cm (38 × 25½ in.).

Private collection

Fig. 193

Matt Phillips, *Large
Reader #2*, 1983, color
monotype (second pull),
129.5 × 101.6 cm
(51 × 40 in.).

Matt Phillips, courtesy Marsha
Mateyka Gallery, Washington,
D.C.

Fig. 194

Steven Sorman, *No Near Room,* 1992, color monotype collage with pastel additions, 102.9 × 118.1 cm (40 ½ × 46 ½ in.).

Rik Derynck

of a printer, which enabled him to work on a much larger scale than ever before (fig. 193). Working with a professional printer also allowed artists to engage in more complex explorations of the monotype process. In *No Near Room* (fig. 194), Steven Sorman began by painting an image on plain paper with a clear polymer medium. "When the polymer dried," states Sorman, "a Plexiglas plate was flat rolled with a color and printed on this painted sheet. A ghost of the polymer painted image was left on the plate and this was used to print another sheet. The first flat printed sheet was then counter printed on a third sheet. . . . The polymer image was dusted with dry pigment and this was counter printed on a piece previously printed in ink. The process was basically one of ghost and counter printing using ink and pigment."[48] Sorman then cut and collaged various sheets for the final work, which he highlighted with pastel on the surface.

In 1972 Garner Tullis and Ann McLaughlin founded the Institute of Experimental Printmaking in Santa Cruz to explore innovations with handmade paper and large-scale prints. Tullis had made his first hydraulic press in the late 1960s and began embossing handmade paper with cast bronze dies to create sculptural multiples. In 1976 the workshop moved to San Francisco and was renamed the Experimental Workshop. Here Tullis built his largest hydraulic press, capable of printing paper measuring six by ten feet under three thousand tons of pressure, and began to print monotypes on handmade paper. Among the many artists who worked with Tullis was Sam Francis, who made an extensive series of monotypes during the

Fig. 195
Sam Francis, *Slant*, 1979,
color monotype with paint
additions, 77.5 × 64.2 cm
(30½ × 25¼ in.).
Los Angeles County Museum of
Art, Graphic Arts Council Fund in
honor of Dr. Richard Simms,
M.80.103

1970s, including *Slant* (fig. 195). In 1984 Tullis dissolved the partnership and moved to Santa Barbara, where he established the Garner Tullis Workshop; McLaughlin continued to run the San Francisco workshop. Nathan Oliveira, who had long been making monotypes on a relatively small scale in his own studio, was enticed to the Experimental Workshop in 1989, where the availability of large presses and papers enabled him to complete monotypes measuring almost five by three feet.

Leaving his son to run the Santa Barbara workshop, in 1987 Tullis established a second workshop in New York, where he had readier access to the artists with whom he wanted to collaborate. He had been printing monotypes for artists since 1961, when he set up two bank-note presses in his Philadelphia living room and printed the casual, after-dinner experiments of Mark Rothko, David Smith, and Barnett Newman, with whom he was studying at the Pennsylvania Academy of the Fine Arts and the University of Pennsylvania.[49] From such informal beginnings, Tullis built one of the most technically sophisticated workshops, capable of printing monotypes that are ninety-two inches wide on handmade paper that is several millimeters thick, which have been run through the press numerous times to create multilayered images with the impact of a painting on canvas.

At Tullis's New York workshop Sean Scully used planks of wood cut in a variety of formats for his plates, which he rearranged in different compositions for each monotype. By manipulating the individual planks of wood as an interchangeable matrix, he could experiment with compositions that might later serve as the basis for a painting. Through multiple printings with different colors, the artist built up his surfaces with rich, nuanced color much as he built up his paintings (fig. 196). Printed on the thick, tactile handmade paper that distinguishes most monotypes made at the Tullis workshop, the large geometric image acquires a density

Fig. 196

Sean Scully, *New York #9,*

1989, color monotype,

87.3 × 119.7 cm

(34 3/8 × 47 1/8 in.).

Garner Tullis, New York

and soft texture that make it seem part of the paper. The delicacy of color and line in the final image belies the repeated printings under tremendous pressure.

Although the concept of collaborative printmaking usually refers to the relationship between an artist and a professional printer, it may also be applied to artists who work together. In the mid-1970s four Seattle artists—Joan Ross Blaedel, Lois Graham, Arlene Lev, and Kay Rood—began to work in the same studio in order to share press time and ideas. In 1977 they attended a workshop with Nathan Oliveira, who inspired them to concentrate on exploring the monotype process. In 1980 they began exhibiting together as "Four Monotype Artists." Each artist works independently in the studio, but by sharing ideas and discoveries with one another and with others in the community, they have revitalized the nineteenth-century tradition of making monotypes as a group activity.

A Proliferation of Techniques

Although technical experimentation has always been an important aspect of the monotype process, in the past twenty-five years the variety of methods employed in this medium has multiplied almost as rapidly and as copiously as the number of artists involved.[50] As more printmakers began to explore the possibilities of unique prints, they turned their technical skills and experience toward discovering new methods of creating monotype images, often in combination with other printmaking, painting, or collage techniques.

Monotypes have been made from, as well as printed on, an increasing assortment of surfaces. During the mid-1970s Matt Phillips printed images on canvas, and during the early 1990s Michael Mazur printed on silk. Helen Frederick, working at the Pyramid Atlantic workshop in Riverdale, Maryland, has printed on wet paper pulp before the sheet has been dried and cured, allowing the monotype image to actually "shrink" into the paper pulp instead of lying on the surface.[51] Frederick points to Joseph Zirker's use of Stabilitones—water-based markers—to create watercolor monotypes as her source of inspiration for experimenting with handmade paper monotypes, which absorb the pigment in much the same way that wet plaster does in a fresco.

Fig. 197

Roger Crossgrove, *Three Athletes (Vaulters VIII)*, 1979, watercolor monotype, 36.2 × 54.6 cm (14¼ × 21½ in.).

Derek and Jane Allinson

Fig. 198

Dennis Olsen, *Pentimento XXII,* 1991, watercolor monotype, 55.9 × 55.9 cm (22 × 22 in.).

Dr. and Mrs. John W. Worsham, Jr.

The use of water-based colors for monotypes is a relatively recent development. Because they dry so much faster than oil-based paints or inks and also bead and pool on smooth, nonabsorbent surfaces such as metal or glass, artists did not consider them for monotype printing. Among the first to experiment with this method was Roger Crossgrove, who, as early as 1949, used water-based paints on a large piece of glass coated with a thin film of a glycerine-starch medium that had been developed by his teacher, Dwight Kirsch, at the University of Nebraska. Keeping the surface sufficiently moist with a water atomizer, Crossgrove printed the image with a sheet of handmade Japanese paper, using the pressure of his hand and a brayer (fig. 197). Monotype became his primary medium after he began teaching in 1968 at the University of Connecticut, where he taught the technique to his numerous students and colleagues.

Watercolor monotypes have become exceedingly popular among artists primarily because of the surface effects and luminosity they are able to achieve, and also because oil-based pigments and thinners have caused health problems for many artists. Moreover, by printing from a dry image onto wet paper—the opposite of the traditional monotype process of printing from a wet image—speed is less of a factor in painting the image, allowing the artist to create more complicated compositions. Dennis Olsen began making watercolor monotypes in 1985 after developing a method of printing from three separate Plexiglas plates, two of which were painted with watercolors and one rolled with a transparent layer of lithographic ink. Because his work requires reflection and contemplation, and because the paint remains soluble on the plate, he can rework the image over a period of days or even weeks, usually spending between

Fig. 199

Mary Frank, *Skeletal Figure,*
1975, monotype and
collage, 167.6 × 52.1 cm
(66 × 18 in.).

The Harry W. and Mary
Margaret Anderson Collection

ten and twenty hours on each image. Using rollers, airbrush, blotters, needles, watercolor crayons, and sponges, along with the traditional watercolor brushes, Olsen can create a prodigious variety of surface textures. The combination of three plates, printed one over the other onto dampened paper, produces a luminous color that cannot be achieved by traditional watercolor on paper. He retains the spontaneity of watercolor along with the precision and patient buildup of oils. By printing the images as monotypes instead of leaving them as watercolor compositions, Olsen can use the residue left on the plates after printing to generate the next image, which retains a trace of the previous one. The appearance of residual images is especially important in a series, titled *Pentimento XXII* (fig. 198), that refers to the vestiges of antiquity encountered in almost every region of Italy, where Olsen has spent a great deal of time. Fascinated with the traces of civilization left on architectural facades that have been rebuilt, modified, partially destroyed, and rebuilt again over the course of two millennia, Olsen captures, as he states, the "unpredictable tension between the 'permanence' of these architectural forms, and the vicissitudes of time and changing fashion which compels society to alter and modify such forms."[52]

Artists have used stencils inserted between plate and paper to keep certain areas of an image from printing, and several have printed on collaged surfaces. Mary Frank, a sculptor who works primarily in clay, sees many similarities between her sculptures and monotypes. Both media can accommodate rapid change and sensitively reflect the physicality of her form-making gestures. *Skeletal Figure* (fig. 199), a monotype depicting a woman lying with her arms across her chest, is actually a three-part collage that has much in common with her contemporaneous sculpture. The stencils she used to make the woman's limbs were pasted on top of the monotype, making the figure look flayed. Over time, the collaged sections curled outward, as if the limbs themselves were moving, though Frank later pasted down the collaged limbs when she prepared the work for framing. It has been suggested that this collage-monotype bears witness to the death of the artist's daughter, and that its framing signifies a final acceptance of her loss.[53] For Frank, the monotype provided an entry into painting as she moved from monochrome tonalities to rich, varied color. Enticed by the sensuosity and responsiveness of the monotype process, her imagery became more painterly as she created dancing figures, lush flowers, and flying horses in bold, nuanced colors, freely combining monotype, collage, and stencil techniques.

The Monotype in the Postmodernist Arena

Mary Frank's unfettered movement between painting, printmaking, sculpture, and collage, combining them at will, signifies a growing acceptance, even a conscious embrace, of hybrid media, suggesting one reason why the monotype has gained popularity in the postmodern era. As Craig Owens states, postmodernist art favors a strategy of "appropriation, site specificity, impermanence, accumulation, discursivity, hybridization."[54] Instead of isolating the distinctive codes of each medium, observes Hal Foster, "postmodernist art exists between, across, or outside them, or in new or neglected mediums (like video or photography)."[55] One might add to the list performance art, conceptual art, Photorealist painting, and artists' books, among others. In this context the monotype has shed the stigma of the bastard child and come into its own as a "favorite son," born of printmaking yet equally popular among painters and sculptors. Similarly, the unique print and the variable edition, seeming oxymorons, have gained favor among artists and collectors.

Because the monotype is intrinsically a hybrid medium, it shares certain characteristics with other media. But more than any of them, it offers speed and spontaneity, even though several contemporary methods of making monotypes undermine these advantages. Immune to modernist standards of purity, the monotype conveys its message through ambiguity, allusion, and contradiction, making it a sympathetic medium for postmodernist expression.

However, as Ruth Weisberg has astutely observed, "In practice . . . artists' attitudes toward media are still largely molded by modernist ideas about intrinsic qualities, and even those who decode or deconstruct are reacting to the immediately preceding code or structure."[56] The popularity of the monotype medium during the past twenty-five years can be understood, at least in part, as a reaction to the codes and standards that preceded it. A surge of interest in printmaking in the 1960s, as well as the proliferation of workshops, encouraged painters and sculptors to participate with the assistance of professional printers. Although artists created the images on stone, plate, or screen, the technological mastery of the printers assured a clean, consistent edition in which the hand of the artist was subsumed by standards more akin to mass production than to handcrafted objects. Large editions were printed to satisfy a burgeoning art market, and the standardized numbering of prints reminded collectors that they had purchased one among many identical works. There was no stray mark or fingerprint to indicate human involvement. Although technical experimentation was encouraged at the workshops, and artists continued to experiment in their own studios, rules had been established for printing and editioning, which they were expected to obey.

Years before the art-buying public began to react against such standards, artists began to question their limitations. The symbolism of the fingerprint reasserted itself, both literally and figuratively. In 1965, during his first formal workshop experience, Bruce Conner decided to mark each of his works with a thumbprint, which he regarded as more autographic and less forgeable than a traditional signature. The printer objected to this unorthodox practice, which violated the unwritten rule that a fingerprint should never appear on a print. Conner recalled: "They were mortally offended that I was signing these things with my thumbprints—they considered it an assault, that I was doing this purposely to intimidate them."[57] He further provoked the printer by insisting on making a lithograph of his thumbprint on the largest stone and signing the entire edition with an actual thumbprint. The printed thumbprint was the reverse of the actual one—a print of a print—forcing the viewer to consider the relation of reality and art, as well as the various levels of representation in a work of art. Although Conner did not make monotypes until many years later, his challenge to the developing standards of printing and documentation anticipates the dissatisfaction with professionally printed editions that many artists began to feel during the late 1970s.

As early as 1963, Jasper Johns had used an impression of his hand and arm as a central motif of his lithograph *Hatteras,* and the following year he isolated his handprint as an image on a piece of paper, which he signed as a work of art. His own finger, hand, and armprints reappear in his work throughout his career, signifying the artist's literal presence in the image. In his *Savarin* monotypes, Johns played off the printed armprint at the bottom of the composition, in some cases obscuring it, in others enhancing it with handprints. He seized upon the errant proofs of his *Savarin* lithograph to create an entire series of unique prints. Hence, rejects from the perfectly printed, uniform edition gave birth to an individualized treatment of each impression, just as many artists of the nineteenth-century etching revival had rejected clean wiping of plates in favor of variable wiping.

Fig. 200

Nathan Oliveira, *London Site 6*, 1984, color monotype, 50.8 × 45.4 cm (20 × 17 ⅞ in.).

National Museum of American Art, Smithsonian Institution, Museum purchase made possible by Mrs. Henry Bonnetheace, Cardine Henry, John Lodge and Venice Workshop Artists

While artists of the 1880s and 1890s left their fingerprints visible in their monotypes in part to distinguish them from the visual codes of the photograph and the standardized reproductive print, which they considered too mechanical and impersonal, during the 1970s and 1980s artists again turned toward a more personal form of expression. Barry Walker observed: "The new interest in monotype may be related to the decline of geometric abstraction and the resurgence of expressionistic painting. Some artists are once again enamored of the physical properties of paint; the individuality of brushstrokes has replaced the anonymity of the airbrush. With its almost inexhaustible possibilities for surface manipulation, the monotype is the closest printed form to the heavy impasto of expressionistic painting. On the other hand, the screenprint, which is the perfect multiple medium for hard-edge imagery, is undergoing an eclipse in popularity."[58]

Walter Benjamin's observation that "that which withers in the age of mechanical reproduction is the aura of the work of art" may also be applicable to the uniform edition of prints.[59] With the increasing production of the hand-colored photograph, the uniquely printed proof, and the edition of one, the artist's presence has been reasserted, the aura restored. Repetitive imagery, characteristic of a uniform print edition, has been superseded by sequential imagery; witness the popularity of video as an art form. Correspondingly, artists have pointed out the cinematic quality of a sequential printing of monotype images, with each proof relating to the one before and after it, but each slightly different.

Various explanations for the popularity of the monotype have been suggested, and each interpretation sheds some light on this complex phenomenon. Eugenia Parry Janis cites a persistent Romantic tradition of graphic variability: "Painterly freedom, which would have seemed antithetical to the idea of the print as a faithful mechanical reproduction (since it alludes to spontaneity, accident, and even a failure to communicate accurately) is now a well-established tradition harboring the cult of temperament. . . . Expressive painterliness in the graphic arts [is] part of a vital romantic tradition which is still playing itself out."[60]

By the early 1980s collectors also began to resist the large, impersonal editions that had begun to flood the art market, and many began to value the unique work in which the touch of the artist was visible. As Richard Field has observed, "The monotype . . . satisfies a peculiar urge toward uniqueness in a society that still craves printed images."[61]

During the 1990s printmaking faces a new challenge from technology, just as printmaking faced the challenge of photography in the late nineteenth century. Computer-assisted imagery, high-quality reproductions on CD-ROM, and works of art transmitted on the Internet have entered the dialogue among media, generating a reappraisal of such issues as originality, duplication, and the role of technology in the creation of a work of art. Is the computer screen simply another surface on which to create an image, and the laser printer only the most up-to-date printing press? Do artists view these new technologies as a threat or as an opportunity?

It is impossible to generalize about artists' reactions, but it is instructive to look at a single artist's response. Nathan Oliveira's monotypes, such as *London Site 6* (fig. 200), may be cited as the epitome of the Romantic, painterly, evocative qualities that characterize many works in the medium. Yet in 1994 he revisited four of his earlier monotypes with a Macintosh computer, using Adobe Photoshop software and a scanner at the Hand Graphics Workshop in Santa Fe. The software allowed him to convert his imagery to a digital format, which he could manipulate at will and print out on a Mylar sheet. The Mylar images were then translated to

photo-positive, copper etching plates, exposed to light, aquatinted, etched, proofed, and further manipulated by the artist, using traditional drypoint, etching, engraving, and burnishing techniques. Finally, the finished plates were hand-inked, wiped, and printed on a manual etching press in an edition of eighty identical suites of four prints each. Bearing only a superficial resemblance to the monotypes from which they were made, these prints show the artist manipulating his imagery with the assistance of the new technology, appropriating it to his own ends. Just as Georges Rouault manipulated photogravure plates of his gouache drawings in the 1920s to create his *Miserere* series of prints, Oliveira recognized the possibilities of the new technology and embraced them for his own purposes.

Computer printers are unlikely to replace printers and printing presses for the production of fine-art prints for much the same reasons that artists and collectors reacted to the impersonal surfaces of many workshop prints of the late 1960s and early 1970s. The monotype is intimately and inextricably tied to a Romantic point of view, which has shown itself to be a strong and persistent source of inspiration for the creation of art, both as a pro-active principle and as a reactive alternative to more formalist ideologies. At a time when many people consider the more traditional forms of painting, drawing, and printmaking to be moribund, the monotype offers rich opportunities for renewed experimentation. Although it is impossible to predict the future of the monotype, it has become a full-fledged member of the printmaking family, with the full extent of its potential yet to be explored.

Notes

Introduction

1. Adam Bartsch, *Le Peintre Graveur,* vol. 21 (Vienna, 1821), 39–40.

2. A baren is a round rubbing tool covered with a bamboo leaf.

3. Charles Love Benjamin, "Daub-O-Links," *St. Nicholas: An Illustrated Magazine for Young Folks* 27, part II (May–October 1900): 580. The author reveals that Chandlee's children called their father's monotypes "Daub-o-links" because of their familiarity with *St. Nicholas*'s famous fictional characters, called Gob-o-links.

4. Harry Esty Dounce, *Guarino: His Monoprints* (Newark, N.J.: Free Public Library, 1917), 7. This appears to be the first printed use of the term monoprint, although it may have been used orally by artists before this time.

5. Henry Rasmusen, *Printmaking with Monotype* (Philadelphia: Chilton, 1960), 57. A similar criticism of the term monotype was made as early as 1887, when the author of a review of Charles Alvah Walker's monotypes objected to the suffix "type," which he felt should be limited to such photographic printing processes as Albertype, Autotype, and Phototype. "Mr. Charles A. Walker's Monotypes," *The Studio* 2, no. 11 (May 1887): 199.

6. Rasmusen, *Printmaking with Monotype,* 51, 57.

7. Roger Marsh, *Monoprints for the Artist* (London: Alec Tiranti, 1969), 9.

8. David Kiehl, "American Monotypes," in *Art & Commerce: American Prints of the Nineteenth Century* (Charlottesville: University Press of Virginia, 1978), 164.

9. *Joseph Goldyne,* exh. cat., Thomas Gibson Fine Art Ltd., London, 1976, 4.

10. Jane Farmer, *New American Monotypes* (Washington, D.C.: Smithsonian Institution Traveling Exhibition Service, 1978), 8.

11. Offset presses, which are sometimes used by contemporary artists to print their monotypes, pick up so little ink from the surface of the image that five or more proofs can be pulled with only a slight diminution of intensity from one impression to the next.

12. Sue Welsh Reed, "Monotypes in the Seventeenth and Eighteenth Centuries," *The Painterly Print* (New York: Metropolitan Museum of Art, 1980), 8. Twenty-two monotypes by Castiglione are known, plus second pulls of two compositions.

13. Reed, ibid., 79. The seven monotypes executed in this manner are thought to have been made with pigment mixed with linseed oil rather than printer's ink.

14. Ruthven Todd, "The Techniques of William Blake's Illuminated Printing," *Print Collector's Quarterly* 29, no. 3 (1928): 25–36.

15. For a thorough discussion of Gauguin's monotypes, see Richard Field, *Paul Gauguin: Monotypes* (Philadelphia: Philadelphia Museum of Art, 1973). Field suggests that the most likely procedure for Gauguin's watercolor monotypes was the simple transfer of a wet image from one piece of paper to another. However, it is also possible that he transferred a dry watercolor image by printing it on damp paper.

16. Barbara Stern Shapiro, "Nineteenth-Century French Monotypes," in *The Painterly Print,* 132.

17. Paul Gauguin, in a letter to Gustave Fayet, March 1902, quoted in Field, *Paul Gauguin: Monotypes,* 21.

18. Gauguin's traced monotypes were not included in *The Painterly Print* in order to clarify the definition of the monotype.

19. Eugenia Parry Janis, "Setting the Tone—The Revival of Etching, The Importance of Ink," in *The Painterly Print,* 18.

20. Lepic, quoted in Janis, ibid., 19. Although Lepic presented *l'eau-forte mobile* as his own invention, a detailed description of making a monotype by Henri Guérard was published by Richard Lesclide in 1875. Richard Lesclide, "Eaux-fortes de la semaine," *Paris à l'eau-forte,* 28 November 1875, 92–93. It has been suggested that Lepic and Degas became interested in the monotype as a result of Lesclide's description. See Douglas Druick and Peter Zegers, "Part II: The Peintre-Graveur as Entrepreneur," in Sue Welsh Reed and Barbara Stern Shapiro, *Edgar Degas: The Painter as Printmaker* (Boston: Museum of Fine Arts, 1984), xxxii.

21. Eugenia Parry Janis gives a convincing explanation that Degas learned to make monotypes from Lepic, in "The Role of the Monotype in the Working Method of Degas–I," *Burlington Magazine* 109, no. 766 (January 1967): 21–22.

22. The exact number is unknown, as they were not documented at the time they were made, and many have been lost or destroyed. Eugene Parry Janis lists 321 monotypes, including impressions reworked with pastel or paint, in *Degas Monotypes: Essay, Catalogue, and Checklist* (Cambridge, Mass.: Harvard University, Fogg Art Museum, 1968), and additional monotypes have been discovered since then.

23. Ibid., 21. René de Gas destroyed approximately seventy monotypes in 1918 when the sales from Degas's studio were being arranged.

24. Ambroise Vollard included Degas monotypes in editions of Guy de Maupassant's *La Maison Tellier* in 1934 and Pierre Louÿs's *Mimes de courtisanes* in 1935. Monotypes created by Degas as illustrations for three stories by Ludovic Halévy, which eventually were collected in the volume *La Famille Cardinal* (1883), were finally published in Auguste Blaizot's 1938 edition of this book, after having been rejected by Halévy at the time they were made.

25. Ida Ten Eyck O'Keeffe, "Monotypes," *Prints* 7, no. 5 (June 1937): 258.

26. Charles L. Benjamin, "Daub-O-Links," *St. Nicholas: An Illustrated Magazine for Young Folks* 27, part 11 (May–October l900): 580–83.

27. Eva Marshall Woolfolk, "Monotyping," *Palette and Bench* 2 (September 1910): 306–8.

28. A. Henry Fullwood, "The Art of Monotyping," *International Studio* 23, no. 90 (August 1904): 149–50; J. R. Miller, "The Art of Making Monotypes," *Brush and Pencil* 11, no. 6 (March 1903): 445–50.

29. Octavia C. Waldo, "Finger Paint for Print-making?" *Arts and Activities* (October 1958): 12–14; Mary F. Merwin, "Blot Painting," *School Arts* (May 1954): 37; Shepard Levine, "Brayer Painting," *School Arts* (May 1954): 38.

30. Mayer described the monoprint as "a painting that has been lifted" and used the terms monotype and monoprint interchangeably. Ralph Mayer, *American Artist* 34, no. 11 (December 1970): 16.

1. American Artists at Home and Abroad

1. Joseph Pennell, *Etchers and Etching* (New York: Macmillan, 1919), 279.

2. Hubert von Herkomer, *Etching and Mezzotint Engraving* (London and New York: Macmillan, 1892), 105.

3. Although Otto Bacher began to study painting with Frank Duveneck in Munich during the spring of 1879, there is no evidence that the group began making monotypes in Munich. During the summer of 1879, the "Duveneck Boys" moved to Polling, a favorite spot for summer landscape sketching, thirty-five miles south of Munich. A drawing by John White Alexander entitled *The American Club, Polling 1879* does not include Bacher among the artists at Polling, and since Duveneck left Munich for Florence in October 1879, it appears that Bacher's contact with Duveneck in Munich was fairly brief and limited to painting. Bacher joined Duveneck in Florence during the winter of 1879–80. See Elizabeth Wylie, *Explorations in Realism: 1870–1880 Frank Duveneck and His Circle from Bavaria to Venice* (Framingham, Mass.: Danforth Museum of Art, 1989), 9.

4. Elizabeth Boott, quoted in Josephine Duveneck, *Frank Duveneck, Painter-Teacher* (San Francisco: John Howell Books, 1970), 87. Bacher was not a regular member of the Charcoal Club, but he joined them on occasion, as did Julius Rolshoven. The regular male members were Duveneck, the sculptor Edward Smith, the painters John White Alexander and Louis Ritter. The female members were Elizabeth Boott; the English daughter of Henry James's friend Lady Hamilton Gordon, the former Laura Huntington, who was married to a Swiss-French banker; and the notorious Irish beauty, Gertrude Blood, later Lady Colin Campbell.

5. The making of monotypes was described by Adelaide Wadsworth in an undated letter to Frank Boott Duveneck (probably in the 1920s). Archives of American Art, Boott-Duveneck Papers, Roll 1150.

6. Bacher's monotype has sometimes been identified as a self-portrait, but comparison with known portraits of Bacher suggests that the subject is another person.

7. The dearth of extant monotypes by Bacher also suggests that he rarely made them, and that the term Bachertype derived from his role as printer.

8. Otto Bacher, *With Whister in Venice* (New York: Century Co., 1909), 117–18. Gertrude Blood acquired a group of the best monotypes made by the group, but they cannot be located. The artists kept some of their own monotypes, which remained with their estates or were donated to public collections by their heirs.

9. Bacher, *With Whistler In Venice,* 116–18.

10. For an excellent analysis of this phenomenon, see Eugenia Parry Janis, "Setting the Tone—The Revival of Etching, The Importance of Ink," in *The Painterly Print,* 9–28. Whistler would have learned how to manipulate plate tone from the French printer Auguste Delâtre, who specialized in the practice of *retroussage*.

11. Unpublished journal of Julius Rolshoven written in the mid-1920s, on microfilm at the University of New Mexico Library, Albuquerque.

12. An inscription on the verso of this work confirms when, where, and how the monotype was made. According to Jim Bergquist, Duveneck gave the prints to Couper's wife and Susan Wales, who jotted information about their making on the verso of some of the monotypes. I am indebted to Dr. Carol Osburne for sharing with me parts of her unpublished manuscript on Elizabeth Boott.

13. John White Alexander, quoted in Norbert Heermann, *Frank Duveneck* (Boston: Houghton Mifflin, 1918), 49.

14. Christian Brinton, in "The Field of Art: Monotypes," *Scribner's Magazine* 47, no. 4 (April 1910): 512, noted that many artists who made monotypes had studied at the Académie Julian, but the possibility that they made monotypes there was introduced by Cecily Langdale, *The Monotypes of Maurice Prendergast* (New York: Davis & Long, 1979), 9, and by David Kiehl, in "Monotypes in America in the Nineteenth and Early Twentieth Centuries," *The Painterly Print,* 46, who speculate that the monotype process was part of the curriculum. However, there is no evidence that the monotype was taught in any of the French art schools or ateliers.

15. In May 1890 the organization moved into its first headquarters at 131 boulevard Montparnasse, the area where most of the American artists had their studios. In April 1897 the American Art Association moved to a larger, more central location on the quai de Conti. By that time the membership had increased to almost five hundred artists, excluding life and honorary members. The organization should not be confused with the New York sales gallery of the same name founded in 1884.

16. *The Quartier Latin* 4, no. 20 (March 1898): 740. The records or archives of this organization cannot be found.

17. A privately published book, *American Art Association of Paris* by E. H. Wuerpel, printed at the Times Printing House in Philadelphia in 1894, does not mention monotypes, so it is assumed that this activity began after that date. Two monotypes in the Alexander estate, a man's head and a jug, are signed J. W. Alexander, Paris 1900, indicating that he made monotypes there as well as in Italy with the Duveneck circle.

18. Henri Frantz, "Une Colonie d'Artists Américains à Paris," *Revue Illustrée* 19, 15 September 1904, n.p.

19. The Pressman, "A Monotype Party at Alexis Fournier's, *Buffalo Artists' Register* 1 (1926): 107–8. Alexis Jean Fournier and his roommate, the Canadian painter Ernest Thompson-Seton, had rooms in the American Art Association building during their student days in Paris.

20. Albert Boime, *The Academy and French Painting in the Nineteenth Century* (London: Phaidon, 1971), 39.

21. Eugenia Parry Janis, in "The Role of the Monotype in the Working Method of Degas—1," *Burlington Magazine* 109, no. 766 (January 1967): 20–28, notes that Degas used the monotype in combination with pastel from the beginning of his experience with monotype. Although she does not mention the *ébauche* specifically as his possible model, her description of how Degas used the monotype to create broad, general shapes to organize the play of light and shadow and to create a unified composition suggests a strong parallel with the academic painter's use of the *ébauche*. Degas's training would have introduced him to this method.

22. Christian Brinton, "The Field of Art: Monotypes," 512.

23. Only a few examples can be located at present, but future research may uncover larger bodies of monotypes by one or more of these artists.

24. A more likely date for Walker's earliest experiments in the medium is 1880. He gave the date of his first monotypes as 1877 in William A. Coffin, "Monotypes with Examples of an Old and New Art," *Century* 53, 31 (November 1896–April 1897): 517. Although the article is signed by Coffin, an artist who regularly wrote for the magazine, it is clear from Walker's letter of 28 January 1896 to Richard Gilder, editor of *Century,* that he would provide the research for this article, as he knew more about the monotype than anyone else. In a letter to Gilder dated 18 November 1896, Walker gives his approval to the editing Coffin has done to his material and indicates that he will allow the article to appear under Coffin's name (Charles A. Walker File, New York Public Library, Box 106). In a letter to Ruel Pardee Tolman, 22 May 1917 (Division of Graphic Arts, National Museum of American History, Smithsonian Institution), Walker confirms that he wrote this article himself, using Coffin's byline, because he did not want the article to appear under his own name. In the same letter, Walker indicates that he made his first monotypes about one year before they were first exhibited at Doll & Richards Gallery in 1881.

25. Sylvester R. Koehler, "Das Monotype," *Chronik für vervielfältigende Kunst* 4, no. 3 (1891): 3. Koehler served as the first print curator at the Museum of Fine Arts, Boston, from 1887 until his death in 1900 and simultaneously as the first curator of the graphic-arts section of the Smithsonian Institution. He purchased four monotypes by Walker for the Smithsonian and donated his own collection of more than 6,000 prints to the Museum of Fine Arts in 1898.

26. Bicknell was represented by four works, but the catalogue does not indicate that they were monotypes.

27. Walker purchased the painting from Bicknell and, with the help of the Boston art dealers Doll & Richards, set up a stock company to obtain subscriptions to cover expenses for making an engraving and publishing the prints. *Paintings of Various Schools* (New York: Parke-Bernet Galleries, 1940, sale no. 206), 24. Further evidence of their contact with each other was Bicknell's presentation to the Malden Public Library in 1881 of an etching by Walker, made in 1880, of his friend the artist William Morris Hunt.

28. This rivalry is confirmed in Montezuma (pseud.), "My Notebook," *Art Amateur* 6, no. 2 (Janu-

ary 1882): 24, which probably explains why Walker gave 1887 as the date of his first monotypes in an attempt to establish priority over Bicknell.

29. Montezuma (pseud.), "My Notebook," *Art Amateur* 7, no. 3 (August 1882): 47. The author notes that during his visit to the exhibition, several of Bicknell's monotypes were sold for ten and twenty pounds each.

30. The work is a pastoral landscape, signed and dated in the plate. Listed and illustrated as no. 36 in *American Masterworks on Paper: 1800–1960,* Susan Sheehan, Inc., 25 October–23 December 1988. Present location unknown. Many of Bicknell's monotypes have the same dimensions, suggesting that they were made on the same plate.

31. On American Barbizon artists, see, Peter Bermingham, *American Art in the Barbizon Mood,* (Washington, D.C.: National Collection of Fine Arts, 1975).

32. "The Monotypes," *Art Journal* 7, no. 12 (December 1881): 379. Rona Schneider, in *The Quiet Interlude: American Etchings of the Late Nineteenth Century* (Amherst, Mass.: Mead Art Museum, 1984), 1, writes that Bicknell exhibited monotypes at Knoedler's in 1881 as well as at the Union League Club, but this review does not mention that his monotypes were shown at Knoedler's.

33. Coffin, 521. Frank Weitenkampf elaborates on this story by describing the monotype as "a head of a girl of a Carrière-like mistiness, inscribed T. Cremona dip. I Ciconi inc," which he showed to fellow members of the Art Club of New York. *American Graphic Art* (New York: Henry Holt, 1912), 134. The reference may, in fact, be to the artist and critic Adriano Cecioni (1836–1886), who lived in Naples from l863 to l867.

34. Sylvester R. Koehler referred to Chase's entries as "curious experiments in printing" and compared them to "smoke-pictures." His explanation of how these prints were made confirms that they were indeed monotypes ("The Work of the American Etchers: XVIII—William M. Chase," *American Art Review* 2, no. 1 [1881]: 143). The models for the "Black and White" exhibitions at the Salmagundi Club were probably the similarly titled shows at the Dudley Gallery in London beginning in 1872 and Durand-Ruel's "Exposition des ouvrages exécutés en Noir et Blanc" in July 1876.

35. Claghorn also acquired four monotypes by Walker, all of which are currently in the collection of the Baltimore Museum of Art. Lepic's prints from the series *Vues des Bords de l'Escaut* are very large compared with most etchings of the time and would have attracted attention for no other reason.

36. Joseph Pennell, *The Adventures of an Illustrator,* 74.

37. One of these monotypes, in the collection of the Art Institute of Chicago (1970.905), is inscribed in the plate "Pennell 9/13/81" and is also signed in ink at the lower right "Jos. Pennell, September 13, 1881." The print is also inscribed at the lower left "no.4," indicating that there were at least four images in this series.

38. Anne Palumbo, "Joseph Pennell and the Landscape of Change," Ph.D. diss., University of Maryland, 1982, 70. The Luray drawings were published in Horace C. Hovey, *Celebrated American Caverns* (Cincinnati: Robert Clarke, 1882), and Pennell's monotypes based on them appear to have been his only foray into this medium.

39. This monotype was probably not in the 1882 exhibition at the Pennsylvania Academy of the Fine Arts, as the title does not match any in the catalogue. No. 175, *Study for a Picture,* or no. 176, *On League Island,* could possibly be alternate titles for this image, but the strong effect of sunrise in this composition would probably have been indicated in the title from the beginning. After Claghorn's death, his collection was purchased by T. Harrison Garrett, and some works may have been sold before it was given to the Baltimore Museum of Art in 1946.

40. Francis Wilson, *Joseph Jefferson: Reminiscences of a Fellow Player* (New York: Charles Scribner's Sons, 1906), 62.

41. James Henry Moser, "Joseph Jefferson," *Washington Post,* 24 November, 1901, cited in Grace Moser Fetherolf, *James Henry Moser: His Brush and His Pen* (Sedona, Ariz.: Fetherolf, 1982), 110.

42. It is unclear from Walker's account of this incident whether he was present during Sargent's visit. A monotype titled *Buzzards Roost,* inscribed from Jefferson to Walker, suggests that Walker

might have been there. The monotype was probably made in 1890, when Sargent was visiting America and when he painted a portrait of Jefferson.

There were five performances of *Lohengrin* at the Metropolitan Opera in 1890; Sargent probably chose the subject of his monotype after attending one of them.

43. For Koehler's role in the revival of American etching, see Clifford S. Ackley, "Sylvester Rosa Koehler and the Etching Revival," *Art & Commerce: American Prints of the Nineteenth Century* (Charlottesville: University Press of Virginia, 1978), 143–50. For additional information on the American etching revival, see Maureen C. O'Brien and Patricia C. F. Mandel, *The American Painter-Etcher Movement* (Southampton, N.Y.: Parrish Art Museum, 1984), and Rona Schneider, "The American Etching Revival: Its French Sources and Early Years," *American Art Journal* 14, no. 4 (Autumn 1982): 40–65.

44. It is possible that members of the Tile Club, including William Merritt Chase and William Hopkinson Smith, made monotypes at their gatherings as well.

45. Richard Lesclide, quoted in Douglas Druick and Peter Zegers, "Part II: The Peintre-Graveur as Peintre-Entrepreneur 1875–80," *Edgar Degas: The Painter and Printmaker* (Boston: Little, Brown, 1984), xxxi.

46. David Kiehl, *The Painterly Print,* 154.

47. The first public exhibition in America of an Impressionist picture appears to have been Degas's *Ballet Rehearsal* (1874), a gouache and pastel over monotype, shown in 1878 at the American Watercolor Society. William H. Gerdts, *American Impressionism* (Seattle: Henry Art Gallery, University of Washington, 1980), 28.

48. The importance of de Nittis for Chase is discussed by Diane Pilgrim, "The Revival of Pastels in Nineteenth-century America: The Society of Painters in Pastel," *American Art Journal* 10, no. 2 (November 1978): 47–48. It is worth noting that de Nittis was a close friend of Adriano Cecioni, the artist whose monotype, brought to New York in 1879, possibly inspired American artists, including Chase, to experiment with this medium. De Nittis's home was a mecca for Italian artists in Paris, including Cecioni. As Degas was a close friend of de Nittis, Cecioni may have become aware of the Frenchman's monotypes during a visit to Paris.

49. "Art News and Comments," *New York Daily Tribune,* 20 January 1884, 4.

50. Chase often mixed a siccative, or drying agent, with his oil paints so that he could work rapidly and finish a painting in one sitting. Ronald Pisano, "Prince of Pastels," *Portfolio* (May–June 1983): 69.

51. Koehler, "The Works of the American Etchers," 143. All the Chase monotypes that have been located are landscapes and portrait heads, with one female nude illustrated as no. 16 in *William Merritt Chase,* Chapellier Galleries, New York, 1969. Only one color monotype by Chase has been located, but it suggests he may have made others.

52. The painting is *At the Shore,* Collection of Mr. and Mrs. Prentis B. Tomlinson, Jr. Ronald Pisano, letter to the Los Angeles County Museum of Art, 2 May 1988.

53. Letter from Ronald G. Pisano to the author, 25 July 1992.

54. These dates are suggested by Ronald G. Pisano in a letter to Hope Davis, 8 January 1992.

55. The subject of *Reverie* is probably Chase's wife, Alice Gerson, and her age in the image is one clue to its date.

56. David Kiehl, in *The Painterly Print,* l48, points out that an image resembling this one hangs in a window in the background of Chase's painting *For the Little One* (Metropolitan Museum of Art). Other scenes of the interior of his home at Shinnecock — *In the Studio* (Collection of Mr. and Mrs. Arthur Altschul) and *A Friendly Call* (National Gallery of Art) — show framed images on the piano and the wall that resemble his monotypes.

57. See Peter Bermingham, *American Art in the Barbizon Mood.*

58. A group of Eaton's photographs can be found at the Historical Society of Bloomfield, New Jersey.

59. Dr. F. W. Kitchel was a friend whose portrait he painted.

60. All diary references are from the F. Luis Mora Papers, Archives of American Art, Roll 3568.

61. Koehler, *First Annual Exhibition of the Philadelphia Society of Etchers* (Philadelphia: Pennsylvania Academy of the Fine Arts, 1882), 8.

62. Charles Rosen and Henri Zerner, *Romanticism and Realism: The Mythology of Nineteenth-Century Art* (New York: Viking Press, 1984), 35.

63. Ehninger, quoted in Elizabeth Glassman, "Cliché-Verre in the Nineteenth Century," *Cliché-Verre: Hand-Drawn, Light-Printed* (Detroit: Detroit Institute of Arts, 1980), 14.

64. J. R. W. Hitchcock, *Etching in America* (New York: White, Stokes, & Allen, 1886), 13.

65. Rosen and Zerner, "The Fingerprint: A Vignette," *Romanticism and Realism,* 2–5.

66. Mariana Griswold Van Rensselaer, "American Painters in Pastel," *Century Magazine* 29 (December 1884): 204–5.

2. Color Prints and Printed Sketches

1. Ida Ten Eyck O'Keeffe, "Monotypes," *Prints* 7 (June 1937): 258.

2. The catalogue raisonné lists 201 monotypes by Prendergast. See Carol Clark, Nancy Mowll Mathews, and Gwendolyn Owens, *Maurice Brazil Prendergast, Charles Prendergast* (Williamstown, Mass.: Williams College Museum of Art, 1990). *Fall Day,* the only monotype dated 1891, is signed and dated in pencil, which could have been added after the fact. The catalogue raisonné dates this print to 1895–1900, based on stylistic evidence. Charles Prendergast identified two monotypes by his brother as having been his first (Williams nos. 1563 and 1564). These are on the same heavy paper that Prendergast abandoned in favor of a lighter, less absorbent Japanese paper.

3. Ellen Glavin, "The Early Art Education of Maurice Prendergast," *Archives of American Art Journal* 33, no. 1 (1993): 2–12.

4. The motif has been identified as a screen. See Richard Wattenmaker, *Maurice Prendergast* (New York: Harry N. Abrams, 1994), 20. However, such large-scale figures rarely, if ever, appear in a screen format. On the other hand, pillar prints and other vertical-format prints (*hosuban* or *kakemono-e*) often featured such figures and were sometimes mounted together as a triptych. Some triptychs were designed as such, with three blocks printed on a single sheet of paper. The straight, horizontal lines of the top and bottom also suggest a print triptych, since a folding screen would need panels at angles to each other in order to stand. Also, the scale of the monograms in relation to the figures suggests the size of a print rather than a much larger screen panel.

5. None of Prendergast's monotypes have actually been mounted in a triptych format, but several are based on a tripartite composition. Wattenmaker, *Maurice Prendergast,* 40, has pointed out that traces of a triptych composition persist in such later monotypes as *The Race* (Williams no. 1669).

6. Quoted in Hedley Howell Rhys and Peter Wicks, *Maurice Prendergast 1859–1924* (Cambridge: Harvard University Press, 1960), 34.

7. *Retrospective Exhibition of the Work of Maurice and Charles Prendergast* with "Anecdotes of Maurice Prendergast" by Van Wyck Brooks (Andover, Mass: Addison Gallery of Art, Phillips Academy, 1938), 36. Few, if any, of Prendergast's monotypes appear to have been made on a press. Although an embossed platemark is visible on some of the prints, it is not sharp and crisp enough to have been created by a press.

8. The other monotypes in this group are Williams nos. 1624–27.

9. The circus scenes are Williams nos. 1590–1602, and the ship subjects are nos. 1586–89. *Dress Rehearsal* (no. 1601) and *Rehearsal* (no. 1602) appear to be ballet rehearsals rather than circus scenes, but they are closely related. One watercolor (no. 593) and one sheet in the Large Boston Public Garden Sketchbook (Williams no. 1477, p. 339) are of circus performers, suggesting that others might have existed.

10. None of the Prendergast monotypes currently known exist in three pulls, but some of the prints identified as second pulls might be third pulls.

11. Brooks, "Anecdotes," 566.

12. The exhibition at Hart & Watson's also included monotypes by Herman Dudley Murphy and Charles Hopkinson. One of the reviews of this exhibition gave credit to Murphy for inventing the monotype process. "The Fine Arts: Gallery and Studio Notes," *Boston Evening Transcript,* 24 April 1897, 4.

13. The exhibition at the Art Institute of Chicago was a two-man show with Herman Dudley Murphy.

14. Prendergast became part of William Macbeth's stable of artists in 1899.

15. Ralph Flint, in *Albert Sterner: His Life and His Art* (New York: Payson & Clarke, 1927), gives 1911 as the date for this exhibition (p. 26), but on the following page he quotes a review by Royal Cortissoz, who refers to the Armory Show, which did not take place until 1913.

16. Ibid., 27.

17. John Spargo, "Eugene Higgins," *The Craftsman* 12, no. 2 (May 1907): 135–46.

18. The image does not clearly correspond to any of the titles listed in the catalogue; the current title was probably given to the work at a later date.

19. "Photo-Secession Exhibitions," *Camera Work* 29 (January 1910): 51.

20. Higgins, quoted in Mary Fanton Roberts, "Eugene Higgins, A Painter of the Shadow World," *The Touchstone* 5, no. 5, (August 1919): 365.

21. I would like to thank Karen Smith Shafts, assistant keeper of prints, Boston Public Library, for her assistance with this monotype.

22. Spargo, "Eugene Higgins," 145.

23. The artists in this exhibition were Arthur B. Davies, William Glackens, Robert Henri, Ernest Lawson, George Luks, Maurice Prendergast, Everett Shinn, and John Sloan.

24. The four monotypes are reproduced in Joseph S. Czestochowski, *Arthur B. Davies: A Catalogue Raisonné of the Prints,* (Newark: University of Delaware Press, 1987), 222–23. Two are dated ca. 1895–1900, and two are dated ca. 1900–1905, based on stylistic comparisons with his other works. David Kiehl, in *The Painterly Print,* 168, specifically relates them to Davies's lithographs of 1895. However, a date between 1919 and 1929 would be equally plausible, as during this period Davies experimented with color printmaking and began to rely more heavily on tone in his compositions.

25. One of his landscape monotypes is identical to a painting *Winter* in the Detroit Institute of Arts and very similar to *May in the Mountains* in the Phillips Collection. Both paintings are dated 1919.

26. One of the six might be a ghost impression of *Landscape—Mountains*.

27. Henri Pène du Bois, "Art Notes of Studios, Shops and Galleries," *New York American,* 7 February 1904, from Robert Henri Papers, Archives of American Art, Roll 887, frame 200.

28. Norman Kent, "The Versatile Art of Everett Shinn," *American Artist* 9, no. 8 (October 1945): 36.

29. It is more likely that Shinn saw such a print as Degas's *Leaving the Bath* (Delteil no. 39), a drypoint and aquatint that Degas printed in twenty-two states.

30. I would like to thank Richard Wattenmaker for identifying the figures in the image as Glackens's wife, Edith, son Ira, and daughter Lenna, who was born in December 1913 and appears to be between three and five years old in this work.

31. Bruce St. John, ed., *John Sloan's New York Scene* (New York: Harper & Row, 1965), 120.

32. The entry in Sloan's diary for 18 March 1907 indicates that Henri and Luks came to dinner at Sloan's home, although no mention is made of monotypes. St. John, *John Sloan's New York Scene,* 113.

33. The latest dated monotype thus far located is *Seated on Couch* (Delaware Art Museum), signed and dated 2/8/16.

34. The scene with male and female bathers has been titled *Adam and Eve,* but there is no indication that Sloan supplied the title. As the work displays no indication of the biblical story of Adam and Eve, and in view of Sloan's lack of interest in religious subjects, it is probable that the title was given to make the risqué depiction more acceptable.

35. Notes recorded in 1949 and 1951 by Helen Farr Sloan, quoted in *John Sloan/Robert Henri: Their Philadelphia Years (1886–1904)* (Philadelphia: Moore College of Art Gallery, 1976), 23.

36. Joseph Stella, "Makers of Wings" (pictorial essay), *The Survey* 41 (1 March 1919): 781–83. A monotype by Stella, titled *Immigrant Madonna,* appeared on the cover of *The Survey* 49 (1 December 1922).

37. Russell Bowman, *Georgia O'Keeffe: An Intimate View* (Milwaukee: Milwaukee Art Museum, 1989), n.p. It is also possible that she made these monotypes in 1912 when she was studying with Arthur Wesley Dow at the University of Virginia, or in 1915, when she was a close friend of Dorothy True and Anita Pollitzer, both of whom have been suggested as models for two of the monotypes. Roxana Robinson, *Georgia O'Keeffe: A Life* (New York: Harper & Row, 1989), 102.

38. A color monotype of several figures sitting in a subway station, signed J. Marin, has been located in a private collection in Washington, D.C. The subject matter and style suggest some of Marin's watercolors of the the mid-1930s, but the signature is unusual for him, and there is no other indication that he made monotypes at this time.

39. The dates on many of Walkowitz's monotypes are unreliable, as many of them appear to have been added after the works were signed. Martica Sawin, in *Abraham Walkowitz 1878–1965* (Salt Lake City: Utah Museum of Fine Arts, University of Utah, 1975), 9, indicates that he made monotypes from 1900 to 1910, but there is no indication that he began the practice before going to Europe in 1906.

3. The Emergence of the Monotype

1. Montezuma (pseud.), "My Note Book," *Art Amateur* 6, no. 2 (January 1882): 24.

2. Lewis H. Meakin, "Duveneck, A Teacher of Artists," *Arts and Decoration* (July 1911): 383.

3. According to Joan O'Brien, daughter of Cincinnati artist Edward T. Hurley, Herman H. Wessel and J. H. Meakin printed Duveneck's etchings for him in Cincinnati. Interview with the author, Cincinnati, 8 July 1993.

4. These two monotypes have not been seen, but because they are exactly the same size, one is probably a second pull. They were shown at the Judy Robinson Art Gallery in Cincinnati in the 1980s. The catalogue for this exhibition is in the Daly artist file in the library of the Cincinnati Art Museum.

5. Joseph Henry Sharp's painting of Ogala Fire was his first posed Indian portrait and is now in the Butler Institute, Youngstown, Ohio.

6. The press was obtained from Charles Ulrich, one of Cincinnati's finest etchers, who left it behind after being sent to prison for using the press to make counterfeit money.

7. Joan O'Brien, interview with the author, 8 July 1993.

8. Quoted in Rosanne M. Truxes, *Robert Bruce Horsfall (1868–1948): American Natural Science Illustrator* (New Brunswick, N.J.: University Art Gallery, Rutgers, The State University, 1974), n.p.

9. Mary Louise McLaughlin, *Etching: A Practical Manual for Amateurs* (Cincinnati: Robert Clarke and Company, 1880).

10. Mary Louise McLaughlin, from a speech presented at a meeting of the Porcelain League, 25 April 1914, reprinted in the *Bulletin of the American Ceramic Society* 17, no. 5 (May 1938): 217.

11. The monotypes are in the collection of the Cincinnati Art Museum.

12. The exact date of Jefferson's visit is not known, but he died in 1905.

13. Gary Clarien, quoted in "Monotypes for All Seasons," *Artweek* 15, no. 39, 17 November 1984, 1.

14. J. B. Millet, ed., *Julian Alden Weir* (New York: Century Club, 1921), 80, quoted in Constance Eleanor Koppleman, *Nature in Art and Culture: The Tile Club Artists 1870–1900* (Ph.D. diss., State University of New York at Stony Brook, 1985).

15. Ibid.

16. J. H. Sharp, quoted in Forrest Fenn, *The Beat of the Drum and the Whoop of the Dance: A Study of the Life and Work of Joseph Henry Sharp.* (Santa Fe: Fenn Publishing Co., 1983), 104.

17. Ibid., 105. These works would now be called monoprints, as they were printed from an etched surface. However, at that time they were called monotypes, no distinction having yet been made between impressions made from smooth or etched plates.

18. Sarah E. Boehme, "The North and Snow: J. H. Sharp in Montana," *Montana: The Magazine of Western History* (Autumn 1990): 35.

19. Four etching plates, still with etching ground on the reverse side, were found among Hennings's personal effects in 1976. One of the plates is dated 1921. Trial proofs were printed from them in 1977. In 1991 the Hennings estate authorized Anchor Graphics in Chicago to print three of the four plates in a limited edition of 100.

20. Hennings appears to have pulled a few proofs from the etching plate of this composition and sent them to friends as Christmas cards.

21. E. Martin Hennings, quoted in Robert Rankin White, "The Life of E. Martin Hennings, 1886–1956," *The Lithographs and Etchings of E. Martin Hennings* (Albuquerque: Museum of New Mexico Press, 1978), n.p.

22. Ted Born, telephone conversation with the author, 5 January 1994. Born was a longtime friend of the artist's, who purchased *Through the Aspen Grove* and another monotype directly from Hennings in the 1930s.

23. Gordon E. Saunders, in *Oscar E. Berninghaus, Taos, New Mexico: Master Painter of American Indians and the Frontier West* (Taos: Taos Heritage Publishing Co., 1985), 108, relates that Berninghaus made his monotypes on a glass surface, which he printed by pressing lightly with a roller. However, Berninghaus's monotypes have distinct plate marks that could come only from a press. Since a glass plate would shatter under the pressure of a press, his monotypes probably were made on zinc plates like the ones he had used as a lithographer.

24. At the time two monotypes were donated to the Stark Museum of Art in Orange, Texas, his daughter, Dorothy Berninghaus Brandenburg, gave their dates as ca. 1940.

25. A tarlatan is a pad of crinoline, somewhat like starched cheesecloth, used for inking and wiping plates.

26. M. W., "Martinez has Picture Exhibit," *San Francisco Examiner,* 5 January 1915, 9. 9.

27. Porter Garnett, "News of Art and Artists," *San Francisco Call,* 29 September 1912, 35.

28. Martinez made three monotypes of this subject; it is not known which impression was shown at the exposition.

29. Arnold Genthe, *As I Remember* (New York: Reynal and Hitchcock, 1936), 69.

30. A sepia monotype portrait of Martinez by Mathews is in the collection of the Oakland Museum. See Therese Thau Heyman, *Monotypes in California* (Oakland: Oakland Museum, 1972), 13. Its inscription, "1890/245 Blvd. Raspail," is confusing, as Martinez was still in Guadalajara at this date. Mathews studied in Paris from 1885 to 1889, then returned to San Francisco. Either the portrait is misidentified or the date is incorrect.

31. George Neubert, *Xavier Martinez (1869– 1943)* (Oakland: Oakland Museum, 1974), 9.

32. Lucy B. Jerome, "Art Lovers View Fine Monotypes," *San Francisco Call,* 16 May 1909, 31.

33. Garnett, "News of Art and Artists," 35.

34. *San Francisco Chronicle,* 3 March 1929, D5, as cited in Gene Hailey, ed., *California Art Research,* vol. 11 (San Francisco: Works Progress Administration, 1937), 1821.

35. All quotes were reprinted in the exhibition catalogue, *The Color Monotypes of Clark Hobart* (San Francisco: Helgesen Galleries, 1915).

36. Grace Hartley, ed., *The Golden Gate Collection of Paintings by George Demont Otis 1879–1962, Painter of America,* catalogue of exhibition at the Golden Gate National Recreation Area Headquarters at Fort Mason (San Francisco: George Demont Otis Foundation, 1977), 1.

37. Ibid., 26.

38. Paul Carey, quoted in *Edward Hagedorn: A Rediscovered German-American Modernist,* exh. brochure (San Francisco: Denenberg Fine Arts Gallery, 1992), n.p.

39. *Etchings & Block Prints of Blanding Sloan 1913–1926,* foreword by Idwal Jones (San Francisco: Johnck, Kibbee, 1926).

40. "Calls Blanding Sloan a Human Volcano," *Art Digest* 3, no. 7, 1 January 1929, 23.

41. John Maxwell Desgrey, in "Frank Van Sloun: California's Master of the Monotype and the Etching," *California Historical Quarterly* 54, no. 4 (Winter 1975): 348, refers to these techniques but does not describe how they were done.

42. William S. Rice, "Monotyping by Another Method," *Art Instruction* 2, no. 7 (July 1938): 21, and idem, "Sandpaper Monotypes," *Design* 41 (March 1940): 14–15.

43. George Stillman, letter to the author, 30 October 1994.

44. Janet Altic Flint, *Provincetown Printers: A Woodcut Tradition* (Washington, D.C.: Smithsonian Institution Press and National Collection of Fine Arts, 1983), 15.

45. These prints are more commonly called Provincetown woodcuts or white-line woodcuts.

46. It is possible that Ellen Ravenscroft made monotypes as early as 1904. A notice in "Among the Artists," *American Art News* 3, no. 57, 10 December 1904, 2, mentions an exhibition and sale of sketches in oil and watercolor, monotypes, and miniatures by Ravenscroft and Margaret McCracken at the studio on Washington Square.

47. Edwin Dickinson Papers, Archives of American Art, roll D93.

48. His full name was Otto Karl Knaths. Within a few years after settling in Provincetown, he began to sign his work Karl Knaths. Work signed Otto Knaths predates this change.

49. A common method of decorating mass-produced ceramic ware, decalcomania involves the transfer of an image from one surface to another by placing the face of an original design (decal) against a second surface and applying pressure. The design is transferred and the backing removed. The Surrealists developed a variant of the process by painting a sheet with gouache, placing a second sheet against it and applying pressure to selected areas, thereby transferring the paint underneath. For a detailed discussion of Margo's use of decalcomania, see Jeffrey Wechsler, *Surrealism and American Art, 1931–1947* (New Brunswick, N. J.: Rutgers University Art Gallery, 1977), 58–62.

50. The other artists in the first annual traveling exhibition of the American Monotype Society were Estellyn Achning, Texas; Martha Fort and Frank Hartley, Georgia; Xavier J. Barile, Colorado; Evelin B. Bourne, Massachusetts; Eliza D. Gardiner, Rhode Island; Bess Grable and Florence D. Harvey, Washington, D.C.; Julius Katzieff, Massachusetts; Herbert R. Kniffin, New Jersey; Patrick O'Brien, Nevada; and William S. Rice, California.

51. Archives of American Art, microfilm N118, frames 692–96.

52. Roger Crossgrove, letter to the author, 25 October 1994. The medium developed by Dwight Kirsch for adding to water-soluble paints and inks consisted of boiled cornstarch or laundry starch, glycerin, and clear honey.

53. William F. Hopson, letter to Howes Norris, Jr., 1 April 1912, quoted in Francis W. Allen, *The Bookplates of William Fowler Hopson* (New Haven, Conn.: Yale University Library, 1961), 5.

54. *Norwalk Hour* (Conn.), 1 October 1931.

55. Seth Hoffman, "The Making of a Monotype," *Bulletin of the Milwaukee Art Institute* 4, no. 1 (January 1931): 12.

56. Ida Ten Eyck O'Keeffe, "Monotypes," *Prints* 7, no. 5 (June 1937): 258–67. Heat softened the oil binder of the paint or printer's ink, facilitating its transfer from plate to paper.

57. Harry Esty Dounce, *Guarino: His Monoprints* (Newark, N. J.: The Free Public Library, 1917), 10.

58. Barnet was also technical supervisor for the documentary film *Techniques 3: The Monotype* (Contemporary Films Production, ca. 1936), in which he demonstrated the technique.

59. Sanford Hirsch, *Monotypes of Adolph Gottlieb* (New York: Adolph and Esther Gottlieb Foundation, 1991), n.p.

60. These works are listed as celloprints in Ingrid Rose, *Werner Drewes: A Catalogue Raisonné of His Prints* (Munich and New York: Verlag Kunstgalerie Esslingen, 1984), 274–78. The term was invented by Rose to indicate that the images were printed from a celluloid surface.

61. The term monoprint was not yet in common usage at the time Charles Smith and Naum Gabo made their unique prints.

62. Yunkers made a few monotypes before coming to the United States, but most of his pre-1947 work was destroyed by fire, so it is impossible to determine the extent of his work in this medium in Europe.

63. See Henry Rasmusen, *Printmaking with Monotypes* (Philadelphia: Chilton, 1960), 47–92, for additional examples of experimentation with unique prints during the 1940s and 1950s.

64. Karen Wilkin, *Mark Tobey* (Milan and New York: Edizioni Philippe Daverio, 1990), n.p.

65. Grosman founded Universal Limited Art Editions, West Islip, Long Island, in 1967, and Wayne founded the Tamarind Lithography Workshop, Los Angeles, in 1959.

66. Richard Field, "The Painterly Print," *Print Collector's Newsletter* 11, no. 6 (January–February 1981): 202.

4. The Contemporary Monotype Phenomenon

1. Michael Mazur, in *The Painterly Print* (New York: Metropolitan Museum of Art, 1980), 57, 60.

2. Lawrence Campbell, "The Monotype," *Art News* 70, no. 9 (January 1972): 47.

3. Ibid.

4. Farmer, *New American Monotypes* (Washington, D.C.: Smithsonian Institution, 1978), 8.

5. Jacob Kainen, quoted in announcement for his monotype exhibition at the Lunn Gallery, Washington, D.C., 1979–80, in Clifford S. Ackley, *The Unique Print: 70s into 90s* (Boston: Museum of Fine Arts, 1990), 6.

6. Robert Gordy, quoted in "Notes on a Permanent Collection," from the files of the Ogden Collection, New Orleans, La.

7. Matt Phillips, *The Monotype: An Edition of One* (New York and Washington, D.C.: Bard College and Smithsonian Institution Traveling Exhibition Service, 1972), n.p.

8. Karl Schrag, interview with August L. Freundlich, 29 November 1979.

9. Charles Simic, "Wendy Mark's Monotypes," *Wendy Mark: The Steamroller Project,* brochure for exhibition at the Arsenal Building Gallery, New York, 1995, n.p.

10. Idelle Weber, interview with the author, New York, 13 November 1993.

11. John Yau, "IN and OF TIME: Idelle Weber's Recent Paintings," brochure for exhibition at the Schmidt-Bingham Gallery, New York, 1994, n.p.

12. Alan Magee, letter to the author, 30 April 1994.

13. Wayne Thiebaud, "Changing Prints," *Vision and Revision: Hand Colored Prints by Wayne Thiebaud* (San Francisco: Chronicle Books, 1991), 13.

14. "Announcing a New Release by Tom Marioni," press release, Crown Point Press, San Francisco, November 1992.

15. Richard S. Field, "The Monotype: A Majority Opinion?" *Print Collector's Newsletter* 9, no. 5 (November–December 1978): 141.

16. Artist's statement by Robert Cumming, June 1991, in *Visions and Revisions: Robert Cumming's Works on Paper* (Madison, Wis.: Elvehjem Museum of Art, 1991),

17. Lynne Cooke, "Interview with Georgia Marsh," in *Reorientations: Looking East,* catalogue for exhibition at The Gallery at Takashimaya, New York, 1994, 27.

18. Joyce Carol Oates, "The Art of Matt Phillips," *Matt Phillips: Twenty Years of Monotypes,* brochure for exhibition at the Marilyn Pearl Gallery, New York, 1980, n.p.

19. Phillips, *The Monotype: An Edition of One,* n.p.

20. Jack Flam, *Matt Phillips,* brochure for exhibition at the Marilyn Pearl Gallery, New York, 1983, n.p.

21. Barry Walker, "The Single State," *ARTnews* 83, no. 3 (March 1984): 64.

22. Mazur, "Monotype: An Artist's View," in *The Painterly Print,* 55.

23. Mazur, quoted in Barry Walker, "The Persistence of Ghosts," *Michael Mazur Self-Portraits* (New York: Joe Fawbush Editions, 1987), 6.

24. "Interview: Nathan Oliveira Talks with Paul Cummings," *Drawing* 10, no. 2 (July–August 1988): 32.

25. "Joseph Goldyne . . . in conversation with Roberta Loach," *Visual Dialog* 4, no. 4 (Summer 1979): 12.

26. Ibid.

27. See Ruth E. Fine, "Bigger, Brighter, Bolder: American Lithography Since the Second World War," in Pat Gilmour, ed., *Lasting Impressions: Lithography as Art* (Philadelphia: University of Pennsylvania Press, 1988), 257–82.

28. Wendy Mark, interview with the author, Provincetown, 12 August 1993.

29. Arlene Raven, "Graven Image," *Art Papers* 15, no. 6 (November–December 1991): 6.

30. Ruth Weisberg, quoted in Marlena Donohue, "Engaging the Viewer," *Rave!,* 10 June 1994, D27.

31. Yvonne Jacquette, interview with the author, New York, 12 March 1993.

32. Jacquette creates her pastel images on luan, a type of plywood veneer, and transfers the pastel particles by spreading a tone base on the paper, which remains wet for about twenty minutes and picks up the particles of pastel.

33. "The Personality of Lithography: A Conversation with Nathan Oliveira," *Tamarind Papers* 6, no. 1 (Winter 1982–83): 9.

34. Ibid.

35. Gerald Nordland, *Richard Diebenkorn Monotypes,* catalogue for exhibition at the Frederick S. Wight Art Gallery, University of California, Los Angeles, 1976, 46.

36. Mazur, *The Painterly Print,* 61.

37. While executing this commission, Mazur created three *Wakeby Day* triptychs and three *Wakeby Night* triptychs. He chose one of each subject for the installation at M.I.T. and considered each of the remaining triptychs to be independent works. The two *Wakeby Day* compositions and one *Wakeby Night* composition are in museum collections. The artist destroyed the other *Wakeby Night* composition after having reworked it too heavily with pastel.

38. Katy Kline, *Wakeby Day/Wakeby Night: Monumental Monotypes by Michael Mazur* (Cambridge, Mass.: Hayden Gallery, Massachusetts Institute of Technology, 1983), n.p.

39. Joseph Zirker, quoted in Farmer, *New American Monotypes,* 42.

40. An offset press employs a rubber roller to pick up an image from the plate and then roll that image onto a sheet of paper placed in alignment, next to the plate. Because the offset press does not squeeze paper and printing plate together under great pressure, only a thin film of ink is picked up by the roller, allowing for several successive impressions with only a modest decline in intensity from one proof to the next.

41. Owing to a discrepancy in the brightness of the paper, these proofs were withheld from the edition of *Savarin,* 1977–81. See *The Prints of Jasper Johns, 1960–1993: A Catalogue Raisonné,* with text by Richard S. Field (West Islip, N.Y.: Universal Limited Art Editions, 1994), cat. no. 220.

42. The reference to Munch is even more specific in the initials E.M., which appear in the lower right corner of Johns's lithograph and reappear in several of the monotype images.

43. For several of his later monotypes, Fischl worked on an aluminum plate, which grayed the colors and did not allow the ink to move as freely. He returned to Mylar for the rest of the series. I would like to thank Eric Fischl for explaining his procedure to me during a conversation at the National Museum of American Art, Washington, D.C., 24 September 1995.

44. Of the 144 monotypes in this series, Peter Blum chose fifty-eight for reproduction in a deluxe facsimile publication, with a text by E. L. Doctorow, entitled *Scenes and Sequences.* An original monotype was included in each volume of the deluxe edition. For a detailed and insightful discussion of this series, see E. L. Doctorow, James Cuno et al., *Scenes and Sequences: Recent Monotypes by Eric Fischl* (Hanover, N.H.: Hood Museum of Art, 1990).

45. For an overview of the surge of interest in unique prints since the 1970s, see Ackley, *The Unique Print: 70s into 90s.*

46. Aurobora Press, founded in San Francisco in 1991, is dedicated solely to the creation of monotypes and monoprints.

47. 3EP stands for 3 Equal Partners, who were Paula Kirkeby, Joseph Goldyne, and Margaret Anderson.

48. Steven Sorman, quoted in Marabeth Cohen-Tyler, *Rumors of Virtue: Monoprints by Steven Sorman,* (Mount Kisco, N.Y.: Tyler Graphics, 1993), n.p. Although the artist's description of the process refers to works produced at Tyler Graphics, he used a similar technique in *No Near Room.*

49. Garner Tullis, interview with the author, New York, 9 November 1995.

50. See Kurt Wisneski, *Monotype/Monoprint: History and Techniques* (Ithaca, N.Y.: Bullbrier Press, 1995), for a good overview of contemporary methods of creating monotypes.

51. Helen C. Frederick, "Monotypes and Handmade Paper: A New Expression of Drawing," *Hand Papermaking* 1, no. 2 (Winter 1986), 3–6.

52. Dennis Olsen, unpublished artist's statement, October 1993.

53. Hayden Herrera, *Mary Frank* (New York: Harry N. Abrams, 1990), 104.

54. Craig Owens, "The Allegorical Impulse: Toward a Theory of Postmodernism," in Brian Wallis, ed., *Art After Modernism: Rethinking Representation* (New York: New Museum of Contemporary Art, 1984), 209.

55. Hal Foster, "Re: Post," in Wallis, *Art After Modernism,* 191.

56. Ruth Weisberg, "The Syntax of the Print: In Search of an Aesthetic Context," *Tamarind Papers* 9 (Fall 1986): 54.

57. Bruce Connor, in Elizabeth Armstrong, *First Impressions: Early Prints by Forty-six Contemporary Artists* (New York and Minneapolis: Hudson Hills Press and Walker Art Center, 1989), 54.

58. Walker, "The Single State," 61.

59. Walter Benjamin, "The Work of Art in the Age of Mechanical Reproduction," *Illuminations,* ed. Hannah Arendt, trans. Harry Zohn (New York: Schocken Books, 1969), 221.

60. Eugenia Parry Janis, "Big Print, Big Screen: W. Snyder MacNeil: Photography, Video, and the Romantic Tradition of Graphic Variability," *Tamarind Papers* 13 (1990): 66.

61. Field, " The Monotype: A Majority Opinion?" 142.

Selected Bibliography

Books and Catalogues

Ackley, Clifford S. *American Prints 1813–1913*. Boston: Museum of Fine Arts, 1975.

————. *The Unique Print, 70s into 90s*. Boston: Museum of Fine Arts, 1990.

Bergquist, James A. *American Monotypes of the Early Twentieth Century*. Northampton, Mass.: Alan N. Stone Works of Art, 1976.

Clisby, Roger D. *Contemporary American Monotypes*. Norfolk, Va: Chrysler Museum, 1985.

Cohn, Terri. *Contemporary Monotype: Six Masters*. Santa Clara, Calif.: De Saisset Museum, Santa Clara University, 1985.

Crossgrove, Roger L. *Monotypes Today III*. Hartford, Conn.: Art Works Gallery, 1979.

Farmer, Jane M. *New American Monotypes*. Washington, D.C.: Smithsonian Institution Traveling Exhibition Service, 1978.

————. *Selected Monotypes*. Exh. cat., Smith-Anderson Gallery, Palo Alto, Calif., 1984.

Fehrer, Catherine. *The Julian Academy, Paris 1868–1939*. Exh. cat., Shepard Gallery, New York, 1989.

Flint, Janet Altic. *Provincetown Printers: A Woodcut Tradition*. Washington, D.C.: National Collection of Fine Arts and Smithsonian Institution Press, 1983.

Fryberger, Betsy G. *The Anderson Collection, Two Decades of American Graphics 1967–1987*. Stanford: Stanford University Museum of Art, 1987.

Heyman, Therese Thau. *Monotypes in California*. Oakland, Calif.: Oakland Museum, 1972.

Hitchcock, J. R. W. *Etching in America*. New York: White, Stokes & Allen, 1886.

Johnson, Robert Flynn. *American Monotypes: 100 Years*. Exh. cat., Marilyn Pearl Gallery, New York, 1979.

Jussim, Estelle. *Visual Communication and the Graphic Arts*. New York: R. R. Bowker, 1983.

Kiehl, David. "American Monotypes." In *Art & Commerce: American Prints of the Nineteenth Century*. Charlottesville: University Press of Virginia, 1978.

Klausner, Betty. *Contemporary Monotypes*. Santa Barbara, Calif.: Santa Barbara Museum of Art, 1976.

Mayfield, Signe. *Directions in Bay Area Printmaking: Three Decades*. Palo Alto, Calif.: Palo Alto Cultural Center, 1993.

O'Brien, Maureen, and Patricia Mandel. *The American Printer-Etcher Movement*. Southampton, N.Y.: Parrish Art Museum, 1984.

Reed, Sue Welsh, et al. *The Painterly Print: Monotypes from the Seventeenth to the Twentieth Century*. New York: Metropolitan Museum of Art, 1980.

Peet, Phyllis. *American Women of the Etching Revival*. Atlanta: High Museum of Art, 1988.

Philadelphia Society of Etchers Memorial Exhibition. Exh. cat., Woodmere Art Gallery, Philadelphia, 1982.

Phillips, Matt. *The Monotype: An Edition of One*. Washington, D.C.: Smithsonian Institution Traveling Exhibition Service, 1972.

———. *Monotypes*. New York: Pratt Graphics Center, 1972.

Plous, Phyllis. *Collaborations in Monotype*. Essay by Kenneth Baker. Santa Barbara, Calif.: University Art Museum, 1988.

———. *Collaborations in Monotype II*. Santa Barbara, Calif.: University Art Museum, 1989.

Prints by Women: A Survey of Graphic Works by American Women Born before World War II. Introduction by Susan Teller. Associated American Artists, New York, 1986.

Rosen, Charles, and Henri Zerner. *Romanticism and Realism: The Mythology of Nineteenth-Century Art*. New York: Viking Press, 1984.

The Unique Touch: Monotypes. Milwaukee: Milwaukee Art Museum, 1989.

Walker, Barry. *Public and Private: American Prints Today*. New York: Brooklyn Museum, 1986.

———. *The American Artist as Printmaker*. New York: Brooklyn Museum, 1983.

Periodicals

Ackley, Clifford S. "The Contemporary Monotype: Superstar? Stepchild? Monoflop?" *Print Collector's Newsletter* 21, no. 4 (September–October 1990): 142–43.

"Art Notes (A. H. Bicknell and C. A. Walker)." *Art Journal* 7, no. 11 (November 1881): 352.

Ballantyne, Kenneth M., and Mary E. "On Monotypes." *Art in New Zealand* 7, no. 4 (June 1935): 197–208.

Breitenbach, Edgar. "Graphic Arts." *Archives of American Art Journal* 9, no. 3 (1969): 1–11.

Brinton, Christian. "The Field of Art: Monotypes." *Scribner's Magazine* 47, no. 4 (April 1910): 509–12.

Campbell, Lawrence. "The Monotype." *Art News* 70 (January 1972): 44–47.

Coffin, William A. "Monotypes with Examples of an Old and New Art." *Century* 53 (November 1896–April 1897): 517–24.

Cohn, Terri. "The Look of Singular Impressions." *Artweek*, 25 July 1987, 4.

Dubuffet, Jean. "Empreintes." *Les Lettres Nouvelles*, no. 48 (April 1957): 507–27.

Field, Richard S. "The Monotype: A Majority Opinion?" *Print Collector's Newsletter* 9, no. 5 (November–December 1978): 141–42.

Gimelson, Deborah. "New York's Surprising Market for Contemporary Monotypes." *Architectural Digest* 48, no. 12 (November 1991): 90–94.

Goodman, C. J. "Monotype: A Singular Form." *American Artist* 45 (January 1981): 58–63.

Guarino, Salvatore Antonio. "Monoprints." *Country Life* 35, no. 5 (March 1919): 49–51.

Heartney, Eleanor. "Monoprints, Anyone?" *ARTnews* 85, no. 5 (May 1986): 172.

Hoffman, Seth. "The Making of Monotype." *Bulletin of the Milwaukee Art Institute* 4, no. 5 (January 1931): 12.

Janis, Eugenia Parry. "Deviation and Its Imperatives—The Plight of the Unique Print." *Print Collector's Newsletter* 21, no. 6 (January–February 1991): 211–13.

Koehler, Sylvester R. "Das Monotyp." *Chronik für vervielfältigende Kunst* 4, no. 3 (1891): 17–20.

Montezuma (pseud.). "My Notebook (C. A. Walker and A. H. Bicknell)." *Art Amateur* 6, no. 2 (January 1882): 24.

———. "My Notebook (A. H. Bicknell and J. G. Low)." *Art Amateur* 7, no. 3 (August 1882): 47.

O'Keeffe, Ida Ten Eyck. "Monotypes." *Prints* 7, no. 5 (June 1937): 258–67.

Phillips, Matt. "About Monotypes." *Prometheus*, newsletter of the Makler Gallery, Philadelphia, March 1962.

———. "The Monotype." *Artist's Proof* 8 (1968): 50–59.

Princenthal, Nancy. "Irrepressible Vigor: Printmaking Expands." *ARTnews* 89 (September 1990): 134–41.

Renault, Malo. "Le Monotype." *Art et Decoration* 37 (February 1920): 49–57.

Roder, Sylvie. "Monotypes for All Seasons." *Artweek*, 17 November 1984), 1.

Ross, Conrad H. "The Monoprint and the Monotype: A Case of Semantics." *Art Voices South* 2, no. 4 (July–August 1979): 89–91.

Schneider, Rona. "The American Etching Revival: Its French Sources and Early Years," *American Art Journal* 14, no. 4 (Autumn 1982): 40–65.

Schwarz, Katherine. "Monotypes: Where are They?" *Print Collector's Newsletter* 9, no. 5 (November–December 1978): 155–58.

Sofer, Ken. "Monotypes from the Garner Tullis Workshop." *ARTnews* 86, no. 9 (November 1987): 210.

Tallman, Susan. "Many Monotypes." *Arts Magazine* 65 (January 1991): 17–18.

Walker, Barry. "The Single State." *ARTnews* 83 (March 1984): 60–65.

Woolfolk, Eva Marshall. "Monotyping." *Palette and Bench* 2 (September 1910): 306–8.

Technical Books and Articles

Ayres, Julia. *Monotype: Mediums and Methods for Painterly Printmaking*. New York: Watson-Guptill, 1991.

Benke, Marjorie. "How to Make a Monotype." *Design* 41, no. 5 (January 1940): 27.

———. "Try Your Hand at Monotype." *Design* (September–October 1953): 20–21.

Biteman, B. "The Magic of Monotyping." *Arts and Activities* (April 1958): 15–17.

Brayer, Yves. "La Technique du Monotype." *Bulletin de la Bibliothèque Nationale* (March 1978): 36–38.

———. "The Monotype." *A.B.C. Magazine* 15 (1939): 189–90.

Cogle, Henry G. "On Making Monotypes." *The Artist* 14, part I (September 1937): 6–7; part II (October 1937): 38–39; part III (November 1937): 70–71.

Ertz, Edward. "Monotyping." *International Studio* 17, no. 67 (September 1902): 172–77.

Fredericks, John Stafford. *The Art of Creating Monotypes*. Los Angeles: H.R. Productions, 1990.

Fullwood, A. Henry. "The Art of Monotyping." *International Studio* 23, no. 90 (August 1904): 149–50.

Haynes, Pauline. "How to Make a Monotype." *American Art Student* 1, no. 7 (March 1917): 5.

Herkomer, Hubert von. *Etching and Mezzotint Engraving*. London and New York: Macmillan, 1892.

Laliberte, Norman, and Alex Mogelon. *The Art of Monoprint: History and Modern Techniques*. New York: Van Nostrand Reinhold, 1974.

Marsh, Roger. *Monoprints for the Artist*. New York: Transatlantic Arts, 1969.

Marxhausen, Reinhard P. "Tin Can Printing." *Arts and Activities* (January 1958): 16–18.

Mayer, R. "Monoprints." *American Artist* 34, no. 11 (December 1970): 16.

McKenzie, Mary Beth. *A Painterly Approach*. New York: Watson-Guptill, 1987.

Merwin, Mary F. "Blot Printing." *School Arts* (May 1954): 37.

Miller, John R. "The Art Of Making Monotypes." *Brush and Pencil* 11, no. 6 (March 1903): 445–50.

"Monotypes." *Art Instruction* 2, no. 5 (May 1938): 17.

Nelson, George. "Notes on the Monotype. A Few Experiments with a Neglected Medium." *Pencil Points* 18, no. 12 (December 1937): 785–92.

"A New Black and White Art." *The Studio* 7, no. 35 (February 1896): 30–36.

Ostertag, B. "Monotypes." *Brush & Pencil* 1, no. 2 (November 1897): 24.

Pennell, Joseph. *Etchers and Etching*. New York: Macmillan, 1919.

Rasmusen, Henry. *Printmaking with Monotype*. Philadelphia: Chilton, 1960.

Sheehan, Steven. "Making Monotypes (Technical Page)." *American Artist* 54 (June 1990): 20, 22, 24.

"Try Your Hand at Monotype: Two Unusual Art Projects for Advanced Amateurs." *Design* 55, no. 1 (September–October 1953): 20, 21.

Waldo, O. "Fingerpaint for Print-making." *Arts and Activities* (October 1958): 12–14.

Wisneski, Kurt. *Monotype/Monoprint: History and Techniques*. New York: Bullbrier Press, 1995.

Books and Articles on Individual Artists

"Art Notes (The Monotypes of C. A. Walker)." *Art Journal* 7 (December 1881): 379.

Auchincloss, Pamela. *Sean Scully: Monotypes from the Garner Tullis Workshop.* Exh. cat., Pamela Auchincloss Gallery, Santa Barbara, Calif., 1987.

Catalogue of Bicknell Prints By A. H. Bicknell. Exh. cat. Boston: J. Eastman Chase

"Clark Hobart: Portrait, Landscape and Monotype Printer." In Gene Hailey, ed. *California Art Research* 12. San Francisco: Works Progress Administration, 1937.

Clark, Carol, Nancy Mowll Mathews, and Gwendolyn Owens. *Maurice Brazil Prendergast, Charles Prendergast: A Catalogue Raisonné.* Williamstown, Mass., and Munich, Germany: Williams College Museum of Art and Prestel-Verlag, 1990.

Cohen-Tyler, Marabeth. *Steven Sorman: Rumors of Virtue: Monoprints.* Exh. brochure, Tyler Graphics, Mount Kisco, N.Y. 1993.

Cole, Sylvan. *Milton Avery: Monotypes.* With memorial address by Mark Rothko. New York: Associated American Artists, 1977.

"David Humphrey Monotype Exhibit." *Darien Review*, 15 October 1931, 237.

Del Deo, Josephine Couch. "The Monotypes of Ross Moffett." Manuscript, 1983.

Desgrey, John Maxwell. "Frank Van Sloun: California's Master of the Monotype and the Etching." *California Historical Quarterly* 54 (Winter 1975): 345–50.

Doctorow, E. L., et al. *Scenes and Sequences: Recent Monotypes by Eric Fischl.* Hanover, N.H.: Hood Museum of Art, Dartmouth College, 1990.

Eitner, Lorenz. *Nathan Oliveira: A Survey of Monotypes, 1973–78.* Pasadena: Baxter Art Gallery, California Institute of Technology, 1979.

Exhibition of Color-Monotypes by Clark Hobart. Exh. brochure, Kennedy & Company, New York, 1916.

Exhibition of Monotypes and Drawings by Mr. Eugene Higgins. Exh. cat., Photo-Secession Gallery ("291"), New York, 1909.

Exhibition of Monotypes by Ellen Ravenscroft. Exh. brochure, Studio 51, New York, 1916.

Exhibition of Recent Drawings and Monotypes by Albert Sterner, April 13, n.d. (after 1931).

Farmer, Jane M. *Familiar But Unique: The Monoprints of Joseph Goldyne.* Washington, D.C.: National Museum of American Art, 1982.

Field, Richard. *Paul Gauguin: Monotypes.* Philadelphia: Philadelphia Museum of Art, 1973.

———. *Matt Phillips: Monotypes.* Exh. cat., William Zierler, Inc. New York, 1973.

Forman, Nessa. "Gauguin's 'Experiments' with Monotype," *ARTnews* 72, no. 6 (Summer 1973): 84.

Gilbert, Lundi. "The Monotypes of Seth Hoffman." *Bulletin of the Milwaukee Art Institute* 4 (January 1931): 5.

———. "The Monotypes of Seth Hoffman." *Prints* 1 (January 1931): 28–35.

Goldman, Judith. *Matt Phillips: Monotypes 1976–1977.* Washington, D.C., and Des Moines, Iowa: Phillips Collection and Des Moines Art Center, 1978.

———. *Jasper Johns: 17 Monotypes.* West Islip, N.Y.: Universal Limited Art Editions, 1982.

Guarino, His Monoprints, An Exhibition. Exh. brochure, Free Public Library, Newark, N.J., 1917.

Helgesen, N. R. "The Color-Monotypes of Clark Hobart." Exh. brochure, Helgesen Galleries, San Francisco, 1915.

Hoffman, Seth. "The Making of Monotype." *Bulletin of the Milwaukee Art Institute* 4 (January 1931): 12.

In the Half Light—Michael Mazur's Monotype Murals. Exh. cat., Hayden Gallery, Massachusetts Institute of Technology, 1983.

Jamieson, M. M., Jr. "Joseph Jefferson's Art." *Brush and Pencil* 1 (November 1897): 23–24.

Janis, Eugenia Parry. *Degas Monotypes. Essay, Catalogue & Checklist.* Cambridge: Fogg Art Museum, Harvard University, 1968.

Johnson, Robert Flynn. *Matt Phillips: Monotypes, 1961–1975.* Exh. cat., Baltimore Museum of Art, 1976.

————. *Matt Phillips: Thirty-Five Years of Monotypes.* Exh. brochure, Harcourts, San Francisco, 1994.

Johnson, Una E. *The Monotypes of Joseph Solman.* New York: Da Capa Press, 1977.

Langdale, Cecily. *Monotypes by Maurice Prendergast in the Terra Museum of American Art.* Chicago: Terra Museum of American Art, 1984.

————. *The Monotypes of Maurice Prendergast.* Exh. cat., Davis & Long, New York, 1979.

Lay, Howard G. "Degas at Durand-Ruel, 1892: The Landscape Monotypes." *Print Collector's Newsletter* 9, no. 5 (November–December 1978): 142–47.

LeClerc, Paul, and Charles Simic. *Wendy Mark: The Steamroller Project.* Exh. brochure, Arsenal Building Gallery, New York, and Kennedy Museum of American Art, Ohio University, Athens, 1995.

Mather, Frank Jewett, Jr. "Paul Dougherty's Monotypes." *Vanity Fair* 12 (July 1919): 44.

Michelson, Annette. *Monotypes de Tobey.* Exh. cat., Galerie Jeanne Bucher, Paris, 1965.

"Monoprints by Bertoia." *Washington Star*, 1 July 1945.

Monotypes in black and white, 1928–1937, by Seth Hoffman. Exh. brochure, Grand Central Art Galleries, New York, 1937.

Monotypes of Harry Bertoia. Exh. cat., Olympia Galleries, Glenside, Pa., 1975.

Monotypes of Adolph Gottlieb. Exh. brochure, Adolph and Esther Gottlieb Foundation, New York, 1991.

"Mr. Charles A. Walker's Monotypes." *The Studio* 2 (May 1887): 199–200.

Nelson, June Kompass. *Harry Bertoia, Printmaker: Monotypes and Other Monographics.* Detroit: Wayne State University, 1988.

Nordland, Gerald. *Richard Diebenkorn Monotypes.* Los Angeles: Frederick S. Wight Art Gallery, University of California, 1976.

Oates, Joyce Carol. *Matt Phillips: Twenty Years of Monotypes.* Exh. brochure, Marilyn Pearl Gallery, New York, 1980.

Oliveira, Nathan. "The Monotype: Printing as Process." *Tamarind Papers* 13 (1990): 58.

Phillips, Matt. *Maurice Prendergast, The Monotype.* Annandale, N.Y.: William Cooper Procter Art Center, Bard College, 1967.

Ratcliff, Carter. "Avery's Monotypes: Color as Texture." *Art in America*, no. 66 (January–February 1978): 48–49.

————. "Mary Frank's Monotypes." *Print Collector's Newsletter* 9, no. 5 (November–December 1978): 151–54.

Russell, John. "Adolph Gottlieb: Late Works and Monotypes." *New York Times*, 17 February 1978, C23.

Sandback, Amy Baker. "Not Fully Repeatable Information: Michael Mazur and Monotypes, An Interview." *Print Collector's Newsletter* 21, no. 5 (November–December 1990): 180–81.

[Stieglitz, Alfred]. "Photo-Secession Exhibitions. Monotypes by Eugene Higgins." *Camera Work*, no. 29 (January 1910): 51.

Walker, Barry. *Michael Mazur: Self-Portraits.* Exh. cat., Joe Fawbush Editions, New York, 1987.

Wolfe, Townsend. *The Artists Series: Monotypes by Joyce Treiman.* Exh. cat., Schmidt-Bingham Gallery, New York, 1990.

Photograph Credits

All works in the collection of the National Museum of American Art, as well as some works in private collections, were photographed at the National Museum of American Art by Michael Fischer and Gene Young. These include the following figure numbers: 7, 16, 19, 20, 24, 33, 46, 55–57, 66, 80, 93, 97, 98, 103–6, 110–13, 115–17, 119, 122, 123, 125, 126, 128, 131, 137, 138, 140, 144, 145, 147–51, 154, 158, 161, 162, 165, 167, 171–74, 176–82, 185, 186, 189–94, 197, 198, 200.

Except as noted below, all other photography was provided courtesy of the owners of the works, with the following photo credits: fig. 6, Clem Fiori; figs. 17, 49, Courtesy of Art Resource, New York; fig. 32, Ponton Photographic Services, Danbury, Conn.; fig. 38, Studio 9; fig. 39, Helga Photo Studio; fig. 51, Boston Photo Imaging; fig. 53, Courtesy of Art Resource, New York; figs. 54, 64, Craig Anderson; figs. 68, 70 (Courtesy of Kraushaar Galleries, New York), 73, 141, Geoffrey Clements, New York; fig. 76, Courtesy of Richard York Gallery, New York; fig. 89, Jean Young; fig. 91, Scott Bowron, New York, Courtesy of James A. Bergquist; fig. 94, Dan Morse; fig. 95, Gordon Adams; fig. 101, Courtesy of Roger Genser, The Prints and the Pauper, Santa Monica; fig. 107, Dennis Wyszynski; fig. 109, American Photo Repro Corp., Los Angeles; figs. 124, 170, Anthony Cuñha Photography; figs. 129, 135, Michael Tropea; fig. 132, Aaron Galleries; fig. 133, Almac Camera; fig. 159, Owen Murphy; fig. 160, Josh Nefsky; figs. 163, 164, Bob Sasson, Courtesy of the artist; fig. 166, Peter Ralston; figs. 168, 169, Colin McRae; figs. 183, 184, 199, Lee Fatherree; fig. 186, Adam Reich, Courtesy of Mary Ryan Gallery, New York; fig. 187, Joseph Quever; fig. 196, Joshua Nefsky.

Index